North Carolina Musicians

North Carolina Musicians

Photographs and Conversations

Daniel Coston

Foreword by Meg Freeman Whalen

McFarland & Company, Inc., Publishers

Jefferson, North Carolina, and London

LIBRARY OF CONGRESS CATALOGUING-IN-PUBLICATION DATA

Coston, Daniel, 1972–
North Carolina musicians : photographs and conversations / Daniel Coston ;
foreword by Meg Freeman Whalen.
p. cm.
Includes index.

ISBN 978-0-7864-7461-5
softcover : acid free paper ∞

1. Musicians — North Carolina — Interviews.
2. Musicians — North Carolina — Pictorial works.
3. Musical groups — North Carolina.
4. Musical groups — North Carolina — Pictorial works.
5. Popular music — North Carolina. I. Title.
ML200.7.N8C67 2013 780.92'2756 — dc23 [B] 2013020469

BRITISH LIBRARY CATALOGUING DATA ARE AVAILABLE

© 2013 Daniel Coston. All rights reserved

*No part of this book may be reproduced or transmitted in any form
or by any means, electronic or mechanical, including photocopying
or recording, or by any information storage and retrieval system,
without permission in writing from the publisher.*

On the cover: Doc Watson, backstage at the North Carolina Music
Hall of Fame induction ceremony in Kannapolis
on October 7, 2010 (Daniel Coston)

Manufactured in the United States of America

McFarland & Company, Inc., Publishers
Box 611, Jefferson, North Carolina 28640
www.mcfarlandpub.com

For Sandra, Mom and Dad, George and Mary King,
Don and Jean Coston, and to all the musicians and friends
I've met and photographed along the way.
Special thanks to all the musicians who allowed me
to interview them for this book.

Acknowledgments

My great thanks to these books and websites, which helped me in my research for this book: *The Charlotte Country Music Story*, by Tom Hanchett; *A Biography of Doc Watson*, by Dan Miller; the North Carolina Historic Theatres website (www.lhat.org/historictheatres/ theatre_inventory/NC.aspx); Carolina Music Ways (carolinamusic ways.org).

Table of Contents

Foreword
by Meg Freeman Whalen

North Carolina is a singing state. Three centuries ago, ballads, hymns, work songs, and fiddle tunes were as integral to Tarheel culture as the pottery that early artisans crafted from Carolina clay. Both functional and decorative, music kept stories alive, held soldiers in step, wooed and wed lovers, praised God, and set toes to tapping.

Music is no less necessary to North Carolinians now than it was then. Lovingly preserved, those early musical traditions continue to thrive, but so do their descendants — bluegrass, jazz, the blues, rock and roll, beach music, gospel — on stages and in studios across the state. *North Carolina Musicians: Photographs and Conversations* pays tribute to the state's rich musical culture through images of its practitioners.

A showcase of photographs and stories by Charlotte photographer Daniel Coston, this book brings together music makers of many genres and generations. Using setting, rather than musical style, as the basis for its structure, the book presents a cross-section of Carolina musicians traveling the road, relaxing at home, recording in studios, and performing in festivals, theaters, and clubs. In these pages, up-and-comers — Chatham County Line, the Avett Brothers, the Carolina Chocolate Drops — find space among their revered elders — Doc Watson, Earl Scruggs, Nappy Brown, Maurice Williams. Rock bands jam with shout bands, fiddlers with bluesmen.

With his photographs, Daniel joins a quest that began in North Carolina more than 80 years ago: to give recognition and respect to our homegrown musicians and the sounds they create. This book is not just a documentary; it is a salute.

Preservation and Exaltation

On a warm day in June of 1928, some 5,000 people congregated in Asheville's Pack Square to celebrate the music and dance of the Carolina mountains. Drawn to the area by the newly founded Rhododendron Festival, the curious crowd temporarily

abandoned the flora to gather around a towering monument to Zebulon Vance, a Buncombe County native and North Carolina's Civil War–era governor, and witness contests among the finest local dancers and musicians. The Mountain Dance and Folk Festival, the first of its sort in the United States, was thus born.

The Mountain Dance and Folk Festival continues to thrive more than eight decades later, but its significance lies beyond mere longevity. Organized by Bascom Lamar Lunsford, the "Minstrel of the Appalachians," this earliest of folk festivals was evidence of a revolutionary cultural movement in which North Carolina became a leader. Lunsford, a lawyer and a banjo player, was determined to infuse old-time Appalachian fiddling and clogging with the kind of dignity previously reserved for symphonies and ballets. Shunning the new term "hillbilly," he sought to legitimize the region's indigenous art forms, expanding the Arts and Crafts movement of the previous decades to include music and dance.

Lunsford sought also to preserve this culture with which he had been reared. In the 30 years prior to his first festival, threats had emerged that jeopardized the purity and durability of Appalachian music and dance. At the turn of the century, scouts from the North Carolina textile industry had lured local mountaineers away from their hillside homes to work in the mills of the Piedmont. World War I had had a similar effect, both by furthering the diaspora and widening the horizons ("How Ya Gonna Keep Them Down on the Farm After They've Seen Paree?") of those who returned to the region. And the proliferation of radio and recordings meant not only that authentic "folk" music could become "commercialized," but that a newly broadened listening landscape might alter traditional music making.

But radio and records were also a way to preserve and promote the music and musicians of North Carolina. In 1922, WBT began broadcasting live music from Charlotte to become the second radio station in the South (after Atlanta). By 1927, the Victor Talking Machine Company had come to Charlotte to record "hillbilly" music, and a decade later Decca came to town, and RCA Victor set up a semi-permanent recording studio in the Hotel Charlotte that remained in operation until 1945. North Carolina musicians like Charlie Poole, the black gospel group Golden Gate Quartet, and Lunsford himself became recording artists with national distribution, while musicians such as Bill Monroe or Mother Maybelle Carter and the Carter Family came across state lines to record in North Carolina.

Meanwhile, in the eastern town of Kinston, J.B. Long, manager of the United Dollar Store, sought out local groups like Mitchell's Christian Singers for the ARC labels group. After moving to Durham, Long arranged the commercial recordings of some of the era's most significant bluesmen — the Rev. Gary Davis, Sonny Terry, and Blind Boy Fuller — sometimes traveling with the musicians to recording sessions in Chicago or New York.

In the decades after Pack Square became home to the first folk music festival

and WBT radio began broadcasting Shelby native Earl Scruggs, the station's own Briarhoppers, and syndicated shows by Rocky Mount–born bandleader Kay Kyser, more music festivals, radio stations, and recording studios sprang up across the state. Asheville's WWNC launched the career of the Blue Sky Boys in 1935. A music camp for boys established in Brevard in 1946 became home to the Brevard Music Center, still hosting one of the finest classical music festivals in the country. Two years later, WPAQ in Mount Airy began live broadcasts of local string bands, which continue to this day. The 1940s and 1950s saw, too, the development of independent recording studios and labels throughout North Carolina, from Blue Ridge Records in the west to Chapel Hill's Colonial Records, which recorded acts in the University of North Carolina's Swain Hall.

And beginning in the 1950s, television stations, such as Charlotte's WBTV and Greensboro's WFMY-TV, made room on their schedules for performances by local musicians. Arthur "Guitar Boogie" Smith's weekly show on WBTV, which debuted in 1951, became the first nationally syndicated country music television show. *Nocturne*, which WBTV broadcast live every Tuesday and Thursday nights from 10:15 to 10:30, featured jazz pianist Loonis McGlohon, while the Harvesters gospel quartet offered salvation on Wednesday nights. Local classical musicians appeared on the small screen, too: in 1955–56, every Thursday night at 9:30, you could see the Charlotte Symphony live on WBTV's *The Carolina Hour*.

Now, nearly every one of North Carolina's 100 counties boasts some sort of festival with music. Whether in the hills of Buncombe County, the halls of Charlotte's United House of Prayer, or on the windy shores of the Atlantic Ocean, North Carolina's music festivals offer her musicians a lively forum in which to practice their craft. While only a few — Mount Airy's WPAQ, Spindale's WNCW, or Gaston College's WSGE, for example — champion local musicians, the state is host to approximately 400 radio stations; public television stations WTVI and WUNC still welcome local music making; and recording studios abound, from Charlotte's acclaimed Reflections Studios to Kernersville's Fidelitorium to Overdub Lane in Durham.

Stages of Plenty

Music making in the Carolinas began in the homes, churches, and crossroads. Informal, often domestic gatherings drew people around parlor pianos, and fiddlers and pickers played in farmyards and living rooms. With the post–Civil War popularity of the wind band, it was possible to hear marches and overtures in 19th-century town squares.

By the late 19th century, nearly every town in North Carolina had some sort of theater, usually called an Opera House, which was the center of entertainment in

each community. Theatres in the state's largest cities — Wilmington's Thalian Hall Opera House (1858), Brown's Opera House in Winston-Salem (1880), Charlotte Opera House (1874), Greensboro Grand Opera House (1901) — boasted shows several nights a week; venues in smaller towns like Albemarle, Franklinton, Elizabeth City, Lumberton, Asheboro, Siler City, and Salisbury were open less frequently. But, while the performances included everything from dog acts to Shakespeare, magicians to Puccini operas, most of the acts were traveling the circuit up and down the East Coast. Rarely were they local. And when theaters did host local music making, it tended to be glee clubs from nearby colleges or performances organized by local music clubs, such as the First Grand Music Festival of the State of North Carolina, hosted by the Charlotte Philharmonic Society at the Charlotte Opera House in the summer of 1890.

The development of the film industry inspired a whole new round of building in North Carolina. Theaters such as Raleigh's State Theater (1925), Asheboro's Sunset Theater (1930), Elkin's Reeves Theater (1935), and the Carolina Theatres in Durham (1926), Charlotte (1927), Greensboro (1927), Chapel Hill (1927 — later the Village Theatre) and Winston-Salem (1929) not only featured the best of the silver screen (and, before its demise, vaudeville), but were sometimes concert venues for popular bands and even orchestras: the Charlotte Symphony performed its very first concert in the Carolina Theatre in 1932; Greensboro's Carolina Theatre had its own orchestra.

Meanwhile, in the 1920s and 1930s, farmhouse fiddlers began to host square dances and other musical gatherings in school buildings, whose music rooms and auditoriums were often more welcoming to local musicians than the commercial theaters were. In Rocky Mount, tobacco warehouses were home to the annual "June German" balls, where thousands of patrons danced all night to big bands — whites one night and blacks the next. And as the swing era made jazz America's popular music and the jitterbug the dance craze, nightclubs and dance halls, such as Charlotte's Excelsior Club (1944), established "house bands" to entertain patrons.

In the 1950s and 1960s, as rock and roll shook up the entertainment world and the folk revival brought "American roots music" to a broader audience, clubs across the state nurtured local bands and, in some cases, became the breeding grounds for new styles of music. Cities built auditoriums and coliseums which, like the old "opera houses," have since served as all-purpose hubs of entertainment.

While many of the early venues are gone, a few remain and are still home to music making. The historic theaters in Asheboro, Greensboro, and Durham, for example, host concert series that include both touring national acts and North Carolina musicians. A movie theater from the 1950s through the 1980s, the Visulite Theater is now one of Charlotte's busiest live music venues. The Excelsior Club might feature a disc jockey more often than a band, but you can still hear live jazz there once or twice a month. And new stages continue to open.

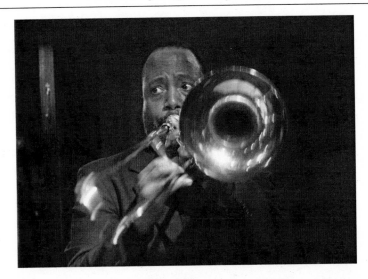

Tyrone Jefferson playing at the Excelsior Club in 2012. The Excelsior opened in 1944 and remains an important hub for Charlotte's African American community. Jefferson was the musical director for James Brown for a number of years.

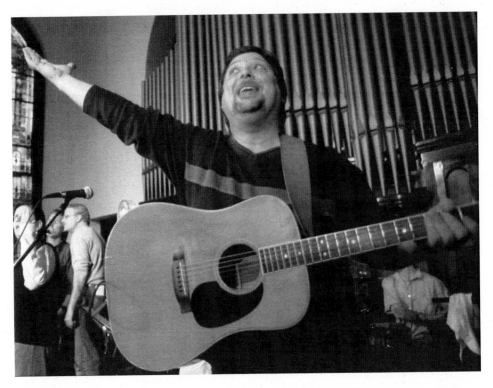

John Tosco gestures to the crowd at the end of a song. Tosco Music Party, Charlotte, September 2000.

The state's club scene offers nearly every kind of setting and every kind of music, from the 1,200-capacity Orange Peel Social Aid and Pleasure Club, a former skating rink in Asheville, to the Soapbox Laundro-Lounge in Wilmington, where you can wash your clothes between sets. Two North Carolina clubs deserve special mention, however, both because of their longevity and their significance to Daniel Coston's photography: the Cat's Cradle in Carrboro (1969) where bluegrass bands like the Red Clay Ramblers played each week in the 1970s and where alternative rock bands Ben Folds Five and the Squirrel Nut Zippers got their start in the 1990s, and the Double Door Inn in Charlotte which, since it opened in 1973, has been the region's foremost blues club.

And, as if to come full circle, parlors and porches have once again become the setting for planned music making. House concerts bring people in by the tens, rather than the hundreds, for an afternoon or evening of string quartets or old-time fiddling — sometimes becoming institutions that, like Aberdeen's The Rooster's Wife or John Tosco's Music Party in Charlotte, outgrow the living room and have to find larger quarters.

Carolina Ramblers

Musicians tend, by nature, to be wanderers. To make a living, they stay on the road, and most North Carolina musicians travel well beyond the state's borders to play in clubs and theaters far from home. It's a rare treat, then, to find them at rest, strumming or picking or singing for themselves. Daniel ends his celebration there, in private sanctuaries where the road-weary rejuvenate.

Himself a North Carolina rambler, Daniel keeps the highways hot, sometimes driving hundreds of miles, criss-crossing the state, to shoot a big arena concert and a late-night club show in the same day. That's where Daniel's book begins. His photographs peek into studios to watch bands lay down tracks. They document festivals large and small to capture moments of profundity — Doc Watson and Earl Scruggs picking on the main stage of Merlefest — and giddiness — the Olla Belle Reed Festival's 2007 record-setting 24-hour jam session. And while the styles of music celebrated have expanded beyond mountain music to include everything from hymn-swingin' gospel to alternative rock, Bascom Lamar Lunsford's ideals — preservation and exaltation — continue to lie at the heart of these images.

Freelance music writer and former arts editor for Charlotte *magazine, Meg Freeman Whalen has taught in the music department at Queens University of Charlotte since 1994. She is the director of communications and external relations for the UNC Charlotte College of Arts + Architecture.*

Introduction

I always had an interest in music, but I didn't know how to interact with it. My parents did not have a lot of records growing up, but what they had was fairly diverse and that exposed me to a lot of different sounds. I heard rock and roll on the radio, and folk songs and western music from my grandparents.

In the fifth grade, my parents moved me from the Finger Lakes region of New York to the outskirts of Charlotte, North Carolina, which was just beginning its boom era. I felt like I'd been dropped onto another planet, and one that was sometimes hostile to me. Fifth graders are not always the best in expressing empathy for wayward travelers.

Soon after, the Briarhoppers played the gymnasium of my elementary school. The quintet had been the house band on WBT Radio in Charlotte for many years, reaching an audience that stretched across the eastern half of the United States. The music, their humor, it all instantly felt very familiar to me. My fellow students looked at me strangely when I said that I wanted a copy of one of their albums, but they always looked at me that way. But for one of the first times in my life, I didn't care what they thought. I knew I liked it. Eventually, my parents did order two of their albums, which I still have.

I spent much of my teen and college years aspiring to be a filmmaker, before time and other interests led me elsewhere. By default, I became a features writer for a Charlotte-based magazine. We were all young and enjoyed our first taste of media. Through that, I began hearing the names that dominated the landscape of North Carolina music. But I soon got restless, feeling like there was another way of communicating with the music that I was starting to discover.

I soon began to take photographs for my stories, either when the magazine's photographer couldn't make it, or out of just wanting to play with the camera. Gradually, I began taking my father's Canon AE-1 camera out of the closet more and more. Within a month, the magazine's photographer had quit, and every band I shot early on hired me. There was never a defining moment with photography for me. It was

more like finding a voice that I had been looking for, increasingly enthralled in the discovery of discussion.

I realized early that my interest in this music came from the fact that I am not originally from this area. I carried — and still carry — somewhat of an outsider point of view, but that in turn drove me to discover more about the music around me. That is what I see in a lot of my photographs: someone enjoying the company of friends and strangers, and continually discovering new music along the way.

What drew me in, and still drives me to document it, is the ongoing history of the music. All guitarists and genres lead you to Doc Watson. Every banjo player leads you to Earl Scruggs. The further you dive in, the more you find the music leading you forward, to the music of the Avett Brothers, the Carolina Chocolate Drops, Chatham County Line, and many more. The history and music of North Carolina is always changing, always growing, and thankfully never ends.

When Meg Freeman Whalen first approached me with the idea for this book, I was instantly intrigued. I had traveled all over the world and worked with many people in many places, but I had not gotten to many of the notable towns and festivals across the state. It was like a void that I knew needed to be explored, discussed, documented. From there, Meg and I spent the next three years working toward the results you see now. This book spurred me on in a way that I had not felt since my early days of taking photos, and completed the circle that I began in 1996, and in turn started a few new ones.

Now more than ever, the music of North Carolina is everywhere. In nine years I have seen the Avett Brothers go from playing wine bars to the fabled Glastonbury Festival in England. The Carolina Chocolate Drops have starred in movies, Chatham County Line has sold multiple gold records in Norway, and artists such as Ryan Adams and Ben Folds continue to have a global following. The music of your backyard has been taken by others the world over as their own. The title of this book may say North Carolina, but it is music that fans everywhere are taking notice of.

Even if you've never met them, you've known about these musicians all your life. These are your friends, your neighbors. They are the sounds of your town and the sights on many stages throughout the state. They give voice to the good times, and the bad times. They are there in quiet times, and in moments of celebration. They stand apart, and yet all together in the place we call North Carolina. This book hopes to highlight the rich diversity of the musicians of this state, and to share with you as many pieces of that tapestry as possible. Join in, and enjoy.

In the Studio

The recording studio seemed like such a mysterious place. As a child, I devoured my parents' record collection. I wanted to imagine every detail of the Beatles recording *Abbey Road*, and what kind of a place Abbey Road Studios must be like. How big was the recording studio? Who were these people that were listed or thanked on the album sleeve? What is a record producer, and what does a record engineer do? And are these people as cool as the Beatles themselves? They must be, I thought. They got to work at a recording studio.

The first couple of recording studios that I photographed were smaller rooms. Someone's back garage in Morganton, a basement converted into a recording studio on the outskirts of Charlotte. In the early months of 1997, one of the first bands that I ever worked with, Mercury Dime, booked time at Mitch Easter's recording studio.

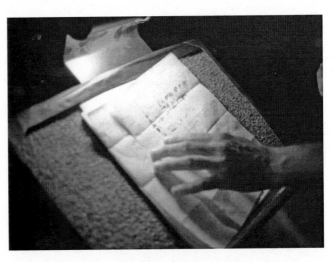

The hand of Dave Wilson, of Chatham County Line, as he looks over his notes before recording a song, Echo Mountain Studios, Asheville, June 2008.

Fidelitorium Studios (Kernersville)

For any rock-and-roll fan in North Carolina, the name Mitch Easter means a lot. Mitch began playing in his native Winston-Salem in the late 1960s. By the early

1980s, he had built his own recording studio in his garage, and one of his first clients was a young band from Athens, Georgia, called R.E.M. Mitch would go on to co-produce R.E.M.'s landmark first two albums and has remained the go-to producer for numerous national bands. Easter has also continued to write and record his own songs, first with his influential 1980s band, Let's Active, and now under his own name.

Easter had just bought a house in Kernersville and had bigger plans for the space. But first he had to set up a studio. He did it by wiring all of the rooms in the house for recording. Drums in one room downstairs, guitars and basses downstairs, Hammond organs positioned underneath the stairs. For a young music fan, the setup was awesome. I really *am* at Mitch Easter's house!

The band members each set up in a different room in the house but could hear what each other was doing via headphones. Separating everyone allowed each instrument to be recorded, without interference from another. Sometimes the larger studios can feel cold and cavernous. This setup didn't have that issue, because you were literally in someone's house. Like myself, the band was excited to be there, and this good feeling carried through the entire recording.

Mercury Dime went on to record *Darkling*, which is still one of the best records I have ever had the good fortune to work on. Many of my photos in Mitch Easter's became the album's artwork. I have since returned many times to Mitch's studio, which now has its own space on the property. To this day, photographing a recording session at Mitch's is like a day to play, have fun, and watch some music get made.

I recently returned to Easter's current studio to photograph a recording session for Temperance League. This quintet from Charlotte is not only one of my favorite new rock-and-roll bands; their band members are also some of my best friends. I've known their guitarist, Shawn Lynch, for as long as I've been taking photos. Their singer, Bruce Hazel, is someone that I've known and photographed for over ten years. So a day in Easter's studio with these guys was an easy gig to say yes to.

Another band that I've photographed at Mitch's studio is the dB's, one of the most legendary bands in North Carolina. The ties between Easter and the band go way back. Throughout their high school days in Winston-Salem in the early 1970s, Easter and the others put together bands and learned the recording process while working on each other's albums. Rittenhouse Square, Little Diesel, Sneakers — all were bands that didn't get a lot of attention back then but whose records are now sought-after items for fans. Watching all of them interact now is something to see, the kind of friendship and understanding that only comes from knowing one another for that long.

I count myself very lucky to have been given the chance to photograph the dB's, having been a big fan of theirs for years. The chance almost ended before it began. Several years ago, Stamey asked me about photographing a dB's session. Naturally, I

Bruce Hazel (left) and Shawn Lynch of Temperance League work on a new song. Fidelitorium Studios, Kernersville, June 2012.

was thrilled and I said yes. Just before the session, however, Stamey wrote to say that perhaps that day wasn't the best, and maybe that session wouldn't be good for photos.

At that time, I was at an odd place with my photography career. My heart sank when I got the e-mail. I was convinced that if I didn't photograph that session, then I would probably never get the chance again. I simply pretended that I had never gotten the e-mail and drove up to the studio. My plan was to shoot quickly, wave at the band from the main control room, and leave. The band noticed that I was there, but they were recording and never had to chance to say hello, or ask me to leave. I shot as fast as I could and left. Some time later, Chris Stamey sent me an e-mail. "How did the photos turn out?" To my good fortune, the band liked what I got, and I've taken photos of the band ever since. When the dB's new album came out in 2012, I was beyond thrilled, not only to have my photos in the album, but also to have been a witness to the creation of that work. It's a very good feeling to see that, no matter how long the project took to come to fruition.

Along with Mitch Easter's studio, there are a number of recording studios in the Winston-Salem/Greensboro region, which are just down the road from Kernersville. There's Electromagnetic Recorders, in Winston-Salem, which I'll talk more about

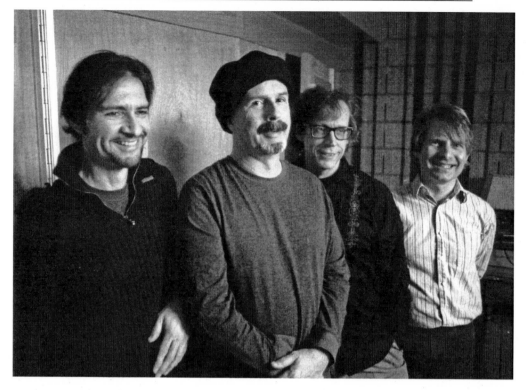

The dB's (left to right: Gene Holder, Peter Holsapple, Will Rigby and Chris Stamey), Fidelitorium Studios, Kernersville, January 2007.

shortly. Also in the Winston-Salem area are Ovation Sound, Roland Professional Sound, Old Town Recording Studio, and Treehouse Mobile Studio. There's Underground Sound Studios in Greensboro, along with Earthtones and Soundlab Recording Studio.

My plan for shooting in the recording studio is simple. Stay out of the musicians' way and get photos quickly. Very often, the musicians have a limited time frame to record and complete everything. Sometimes they have days to do all that, and sometimes they have just a few hours. I don't want to disrupt the recording, so I pick my moments between takes, usually using a zoom lens to shoot from a distance. The less they worry about me, the better the photos are going to be, as well.

Every musician prepares differently before they enter the recording studio. "I'm a pretty meticulous songwriter," says Caitlin Cary, formerly of Whiskeytown and now with the Small Ponds. "I would feel very uneasy if I didn't have all the songs I needed for a record written, revised, arranged, et cetera before going into the studio. With that said, the energy of working in the studio can and has fostered spontaneous writing. In fact, the closest I've ever come to having a hit was with my song 'Shallow Heart,' which was written and recorded in the studio. And of course on lots of songs

arrangements have been changed, lyrics tweaked, bridges added. Songs can change a lot during the recording process, and that's often a really good, exciting thing.

"I certainly hate feeling rushed, and I enjoy the process of adding parts and layers in the studio, and it's a great luxury to have time and money to really flesh things out. On the other hand, it happens very often that the first take is the best, even if you don't know it until after the tenth. And also it's true that sometimes what you want is just the bare-bones, 'live' version of a song, to capture the spontaneous moment. Assuming an unlimited budget, I guess I'd tend to prefer a pace of something like one song a day. That's rare now, though, of course!"

When I asked my friend Sara Bell about how often she gets to record, she responded, "Not often enough! I love being in the studio. My friend Kendall Meade just posted something on Facebook that I love. 'Oh music, I will always happily lose sleep for you.' There are times when you emerge from a dark windowless recording studio after 16 hours or so and have no idea if it's day or night. I could do that day after day for hours at a stretch and not even feel tired. It's the only job I've ever had where that happens!

"It seems to be best to have at least the skeleton of a song ready when you go into the studio. But it also can depend on a lot of factors. I had one particularly abortive recording experience when nothing was ready. The songs weren't very well formed, the band was in limbo, the studio equipment was kind of falling apart, and that caused things to clog up pretty fast. But if the musicians you are playing with are very sensitive 'feel' kind of players who can quickly find their place with everyone else and with the song, then something great can happen on the spot, the same way that sometimes the first time you play a song with a band can feel like the best.

"If I was a rich rock star, I would ... build a studio at the beach somewhere, where everybody would be really happy to hang out, spend days tracking and working on sounds, layer the tracks with as many parts that you can conceive in the orchestra of your dreams, and then spend months listening and contemplating and chiseling down, and winding up with several completely different versions of a song just because. Of course, I have bandmates who disagree completely on this method. And of course I pooh-poohed this kind of record making when I was a young punk. But it's a pretty luxurious way to make music. I am jealous of people who have a more 'live in the moment' approach, but I always feel the weight of permanence with recording and wanting to have enough time to really get it right. There is also the foolproof method of being on the road for a long time playing the songs over and over and then banging them out live in the studio in a couple of hours. This is best when you are a poor artist."

As to the advantages of having your own recording studio, Bell adds, "I can only speak to the advantage of having a very generous drummer who has a studio, and it's pretty great. It's the next best thing to the multi-million-dollar oceanside studio with

separate apartments for every band member. It's, I feel, so fortunate to have worked with Jerry [Kee, of Duck Dee Studios] for so many years and be able to benefit from his incredible engineering skills and his amazing collection of instruments and equipment and to be able to work at a semi-leisurely pace, where you aren't worried about time and money. I think we have developed an ability to communicate over the years, and that helps too. And Jerry is very patient. He is willing to try just about anything, and he is very adventurous about letting me indulge in whatever kooky idea that comes into my mind."

Reflection Studios (Charlotte)

Reflection Studios in Charlotte is run by Wayne Jernigan, who has led the studio since its beginning in 1970. Jernigan is not only a studio owner; he is also a musician. Jernigan spent four years touring all over as the drummer for the legendary country singer Ernest Tubb, and he has tales of traveling with the biggest names in music to back that up.

Several years ago, I was asked to photograph a Reflection session with Volatile Baby, which was a great all-female vocal trio from Charlotte. Their special guest that day was Carlene Carter, daughter of June Carter Cash, and stepdaughter to Johnny Cash. At the end of the session, Wayne and Carlene started trading stories. Jernigan and Ernest Tubb had done numerous shows with Johnny and June, and it was one of the few times I might have traded my camera for a tape recorder.

One person I always like working with on his recording sessions is Don Dixon. Don Dixon co-produced those R.E.M. records with Mitch and has gone on to be a producer for hire for numerous great bands. Don formed his first band in North Carolina in 1969 while still attending UNC–Chapel

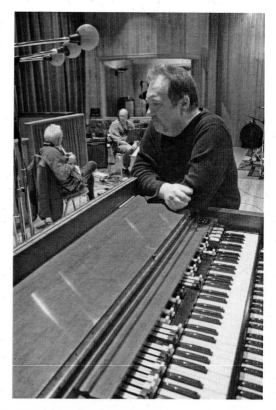

Keyboardist Mark Stallings rests between takes. Truetones recording session, Reflection Studios, Charlotte, April 2011.

Hill. That band, Arrogance, which was one of North Carolina's most popular bands in the 1970s, still occasionally performs today. Don also still records and performs with his wife, Marti Jones, whenever time allows.

On several occasions, I've photographed Don working at Reflection Studios in Charlotte. This is where Don and Mitch Easter recorded those early R.E.M. albums, which are now recognized as landmark albums for the band, as well as for the then-burgeoning alternative rock scene. Reflection features a huge room for recording, the kind that you imagine the Beatles themselves working in. Major acts from all over the world have recorded there, and it is still in action today.

One of the joys of photographing these sessions with Don Dixon is watching him pull together the music and musicians. Dixon likes to have the band record together, with all of the tracks laid down at the same time. It's a lot more work, but the overall sound can be better, a group of musicians playing live in the studio, with as few overdubs as possible. Watching a song take shape and seeing it come to its final version is still something I look forward to during a session.

Dixon usually starts by gathering all of the musicians together in the center of the room. Either he or another musician will play the song so that everyone else gets an idea of how the song will go. All of the musicians then discuss what they are going to play, and rough ideas begin to take shape. Dixon then gets the musicians back in place, and they start recording. While it is easier now, via digital technology, to record all of the instruments one by one, there is something different that comes from everyone playing together, just like a live performance.

Photographing sessions at Reflection also taught me a good lesson. Always give the studio manager your contact info and let him know that you're available on short notice if necessary. Some of my biggest photo sessions in recording studios have happened when an artist walks into the studio and asks if a photographer is available. This has often happened at Reflection. One night it's photographing a vocal session with legendary producer Bill Szymzyck. The next day, it's the singer Fantasia, recording a gospel album with her mother. The trick is to be prepared, be professional, and do the best you can.

Interview with Don Dixon

COSTON: *How did you start playing music?*

DON DIXON: Like most good southern boys, I began singing in church as a preteen. There was a piano in the house so I pecked around on that a little, teaching myself a few basics. I took up the trombone in seventh grade and began playing my sister's gut string guitar about the same time. Later that year, I saved my nickels and bought a Silvertone bass so I could be like Paul McCartney and Norm Sundholm.

What got you into engineering and producing?

At age 14, I began exploring the recording process when I bought a used Pentron tape recorder from the surgeon that lived next door. At age 16 I had begun doing some session work as a bassist for Loonis McGlohon and became enchanted with what went into making a real studio recording, so I worked on a wildlife refuge the summer of 1968, using the money I earned to buy a Panasonic recorder with "Sound-on-Sound." In college I continued recording both as a sideman and with my band Arrogance, and the success of some of these recordings led to my interest in producing.

What were some of your first gigs as an engineer and producer?

The early Arrogance records, regional R & B (Toby King), gospel (Shirley Ceasar), rock (Greer, Fast Annie), singer/songwriter (Treva Spontaine).

For the laymen out there, what is the difference between producing and engineering?

The producer's job typically consists of working with the artist to develop the style (instruments to be used and the rhythmic approach to each track), substance (the songs), and vision (the overall desired effect) of the session, while the engineer works with the producer and artist to create the sounds necessary to bring that vision through the speakers and into the listener's life.

What have been some of your favorite artists and records to produce?

One of the most joy-filled recording experiences I've had was Marti Jones' first LP, *Unsophisticated Time.*

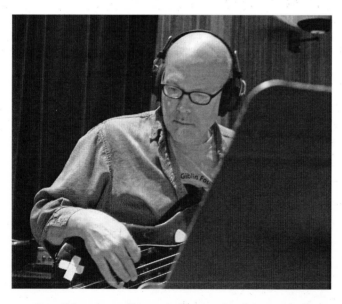

Don Dixon recording at Reflection Studios in Charlotte during a session for the Truetones in 2011. Don has played on and produced numerous records at Reflection over the years, including co-producing R.E.M.'s first two albums in the mid–1980s.

How do you balance producing other artists and playing with your own band(s)?

I work in broad chunks of time. I'll tour for a while, write for a while, record myself for a while, produce other people for a while.

Talk about the North Carolina music scene.

I feel lucky to have lived in North Carolina when I did. So many of my friends from back then are still dedicated, active musicians. Mitch Easter, Jamie Hoover, Jim Brock, Peter Holsapple, Chris Stamey, Will Rigby, Bland Simpson,

Jim Wann, Mike Cross, Rob Ladd, Jack Herrick, Chris Frank, Clay Buckner. I have to stop. There are too many to mention.

At the end of the day, what do you hope that listeners get from the CDs that you've produced or engineered?

I want the listener to feel connected. I'm not concerned at all with whether they're having fun or not. I want them to feel connected, even if it hurts.

Studio East (Charlotte)

By the time that Arthur Smith opened the Arthur Smith Studios in the 1950s, Smith was already a legendary recording artist, songwriter and TV star. The studio boasted a system that was technologically ahead of its competitors, and opened its doors to all comers, both black and white. In 1965, James Brown and his band stopped into the studios to record "Papa's Got a Brand New Bag" on his way to a show. In 1989, John Mellencamp recorded at the studio to work at the same place where that famous song had been recorded.

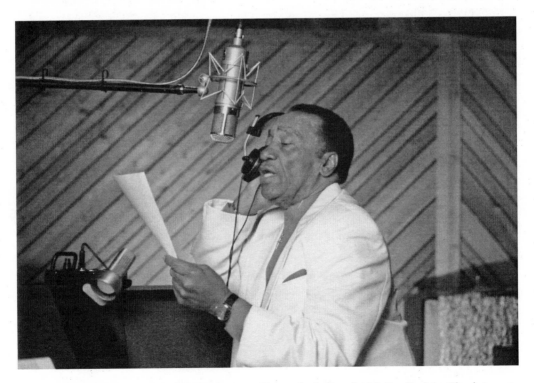

Maurice Williams recording at Studio East (formerly Arthur Smith Studios) in Charlotte in 1999. Maurice has recorded at the studio since the 1960s.

Arthur Smith sold the studio to Tim Eaton in the 1980s, and the space was renamed Studio East. The studio now handles many gospel recordings, as well as recordings for karaoke players. However, some of the greats from those older days of the studio still come to record there.

One of my all-time favorite shoots in a recording studio was working with Maurice Williams. Nearly everyone knows the chorus to "Stay," which was a number-one smash for Williams in 1960. But it was not the first hit that Williams had written. In 1957, a Canadian group called the Diamonds took an early song of Williams', entitled "Little Darlin'," and took it to number two.

When Williams hired me to photograph him, he was in the middle of recording at Studio East. The idea for the shoot presented itself with ease. Wear a suit you like, I suggested, and let me photograph you at work. I have always loved the look of studio photos from the 1950s and 1960s, particularly of jazz musicians. The artists looked smart, astute, hardworking, but regal. This was what I wanted for Maurice. I was still shooting with film at the time, so I used different film exposures to get the look I wanted. Maurice liked the photos, and I had a fantastic time.

You also can hear some great stories at recording sessions. At one of Williams' recording sessions, he and I were talking about various older acts, including Otis Redding. Williams turned back to the band and said, "Do you all know how to play 'Wildwood Flower'?" I knew this song through my photos of the Carter Family. Williams taught the band the song, and the band ran through it.

At the end of the session, Williams turned back to me and said, "I went to see Otis Redding play in Charlotte in 1963. He needed some advice, and we talked after the show for hours. At his show, he entered the stage with the band playing 'Wildwood Flower.' I remembered that while we were talking."

Hooverama (Charlotte)

When I first moved to Charlotte, the biggest group in town was the Spongetones. The group, which took its influences from mid–1960s Beatlesque pop, played to huge crowds throughout the Southeast. Years later, after having only been taking photos for a few months, I got the chance to photograph the Spongetones' guitarist, Jamie Hoover, at the recording studio that he operated, Hooverama. Near the end of the shoot, and searching for a new idea, I got the silly notion to have him hold out headphones toward me for a photo. I thought it looked somewhat dynamic. On the last shot, I held my camera upside down, to have the flash angle come from underneath. The angle produced a shadowlike curve over Hoover's head. I remember getting that roll back from the printers and being floored with how that shot looked.

I'd like to think that I'm a much better photographer now, but when something

is completely new to you, you're more open to trying different ideas. The more you do anything in life, you develop ideas on how you might go about doing something. You get better at doing that thing, but you sometimes discard the more unusual notions that you had when you started. I'm not sure I would have thought to try that idea now, but it does remind me to keep my ideas, and the possibilities, open to interpretation.

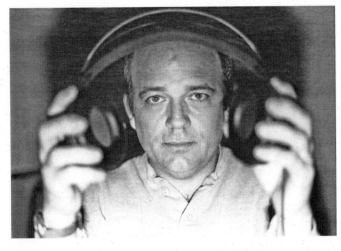

Jamie Hoover poses with a pair of headphones. Hooverama, Charlotte, February 1997.

Sometimes that perfect angle doesn't hit you until you've been there for some time. I was taking some photos of Randy Franklin, who was recording his first solo album at Jamie Hoover's current studio. I had to leave during the afternoon to go to another gig. As I turned to say good-bye to Randy, I realized that he was standing next to a window, with lots of natural light coming in, as he was preparing to record his vocals. It was the shot I'd been searching for all day. "Look at me, but don't move" was my only direction to him as I leaned in for the photo. Thankfully, Randy knew what I meant and held his pose.

Old House Studios (Gastonia)

You can also shoot so many different artists in one studio, as I have with Chris Garges at Old House Studios in

Randy Franklin, Hooverama, Charlotte, April 2012.

Gastonia, North Carolina. Whether it's a great band like the Popes reconvening after 20 years to rehearse and record, or a new outfit such as Tiny Boxes recording their first release, I still enjoy that thrill of discovery. Starting out as a photographer, I loved those photos of Frank Sinatra recording sessions or Beatles sessions. I loved seeing a visual equivalent of that moment in the studio, when the music is being made. It's something I still look forward to doing, and quite frankly, I wish I could photograph a lot more studio sessions. I'm a little more realistic about these rooms where the "magic" happens, but I still look forward to the next good idea, or the next good song.

Interview with Chris Garges

COSTON: *What got you into engineering and producing?*

CHRIS GARGES: I was in a band in high school called Relayer (that included Bruce Hazel and Justin Faircloth) and we decided to record an EP. Our bass player, Joe Wilkie, had a connection at Jay Howard Production Audio and so we went there to record. (Jay Howard Production Audio would actually become my freelancer "home

The Popes (left to right: Henry Pharr, Steve Ruppenthal, John Elderkin and Chris Garges), Old House Studios, Gastonia/Charlotte, January 2012.

Bon Lazaga of Tiny Boxes, Old House Studios, Gastonia/Charlotte, January 2012.

base" studio for several years before I took over at Old House.) Lucky for us, we got to work with David Floyd, who is an absolutely amazing recording engineer in Charlotte. David had a reputation for being particular, but he was incredibly patient and good to us high school kids. I remember being really fascinated by the process, and David was good about explaining things. So after five or six days of working on this stuff, we had a cassette to sell to people, which I thought was terrific. You could do all of this work and have something to show for it, which was different from playing a gig and just having the memory. But the process of recording and the creation of sounds was interesting to me, so I looked into it further. I would borrow Tascam four-track recorders from Joe Wilkie or Justin Faircloth and just make these demos all the time.

When I got to Miami, I spent a bunch of time hanging around the music engineering majors and soaking stuff up, even though I was a studio music and jazz (performance) major. I did a bit more "guerilla recording" stuff in Miami and then basically talked my way into a job at a studio when I moved back to Charlotte. I joined a band with a guy named Eddie Z, who owns a rehearsal building in Charlotte called the Playroom. At the time (the mid–1990s), the Playroom was over on Graham Street downtown and there was a recording studio in there. Eddie needed an assistant, and

I knew just enough to be able to help him out. He showed me a bunch of stuff and was kind and trusting enough to eventually let me run the place for a while. I worked for Eddie for about three years.

What were some of your first gigs as an engineer and producer?

My first few years at the Playroom were really important. I did a lot of recording with Mike Shannon, who was eventually in Big Bus Dream, and Mike was really good to me and fun to work with. The first record I actually produced was for the band Static, who I wound up playing with several years later. They were young and they won the recording package in a raffle. I asked Eddie if I could produce that record and he said yes. I'm really thankful that all happened because all of those guys have remained very good friends of mine over the years.

What is the difference between producing and engineering?

Well, engineering is the technical side of recording. Setting up mics, operating the recording devices, making sure there's no unintentional noises or distortion or stuff breaking. Producing is a more nebulous thing. Traditionally, a producer's job was quality control for a record label. Their job was to make sure that the artists were submitting a record that was going to make money for the label. That primarily means something that is somehow marketable to someone and done within the budget allowed. Over the years, that has frequently morphed into a quality-control job that often inflates the budget — not always, but often enough to mention. But where the engineer is supposed to fix mechanical problems, the producer's job is usually to help guide the artistic decisions. Is that note out of tune? Are the musicians playing with an appropriate amount of energy for the song? Was that take worth keeping? Sort of like a movie director.

I always go into a recording project just assuming that I'm going to just engineer, unless the band specifically asks me to be the producer or to help out with the producing end of things. Eventually, certain suggestions come up in either scenario that cross the line, but those are the basic differences.

You did some work at Arthur Smith/Studio East studios. Talk about that and the musicians you worked with there.

It had been called Studio East for about 15 years when I started working there, but the Arthur legend still loomed large because he's such an important figure in entertainment in the South and quite a character. Arthur's nephew, Tim Smith, was another mentor of mine growing up, so I knew all about Arthur and partially because of Tim I managed to do a fair amount of recording with Arthur some years after that at Arthur's home studio. Studio East was a great room at the time. It was a large studio with a lot of great history. I was there for about two and a half years, and most of what I did there were soundalikes, like recreating hit songs for karaoke or com-

mercials and that kind of thing. That was their bread and butter. But I also brought in bands that I knew and would record them there. It was pretty well equipped, and I had a lot of fun experimenting. Probably the most memorable work I did there was with the late, great General Johnson. He was at the studio almost every Thursday when he would come up from his home in Atlanta and record before going out and doing gigs over the weekend.

Working with General was amazing. He was always really protective about his age, but you know he was very, very young when he got his first record deal. And all that stuff with the Showmen was really early experience for him. So he had been at it a really long time. He understood the process and always had a vision for whatever he was doing. He always pushed everybody. He was good at figuring out people's strengths and making use of that. If he had a song that he wanted Danny Woods to sing, he would cut the track and add a scratch vocal to it for Danny to learn. But he would do the scratch vocal while imitating Danny. And he could do it! When he was producing, he would be up dancing in the control room, and he was always full of energy when he was working. A friend of mine in LA did a session with Quincy Jones, and his stories about Quincy sound *very* similar to my experiences with General. He was very particular about things, but he was right. He had a great wit and was a phenomenal storyteller too. General inadvertently gave me one of my favorite compliments. The first time I ever mixed anything for him, he didn't use my mix but had Joe Kuhlmann remix the song instead because he thought my version sounded "too rock." Mission accomplished! Playing drums on the remake of "Give Me Just a Little More Time," the one that's on his anthology, is one of my proudest achievements. I never got credited for it and the entire rest of that album is programmed drums, but I'm happy to have been able to do that.

What led you to form Old House Studios?

Well, I didn't really start it. Old House was converted from an 1870s Gaston County farmhouse into a studio by David Black and Scott Applegate. It was a really great studio, and right before I left Studio East, when I started doing more freelance stuff, Old House was one of the places I started taking projects. David Black and I became good friends and I liked working there. When David passed away in 2005, Scott and David's wife Janet asked if I would be interested in continuing to run the studio, which I did for seven years.

In 2012, I bought the studio from Janet and Scott and moved all the equipment to Charlotte. It was always a very comfortable and well-equipped, musician-friendly studio, and we're working hard to keep the same kind of vibe at the new location.

What are the advantages of running your own studio?

Not having a boss! No, really, I like that I can be responsible for stuff and take care of things like they should be taken care of. I can't stand having broken equipment,

and that has been an issue at every studio I've ever worked in for any period of time. If it breaks, get it fixed! But I also like, for instance, always knowing where the flashlights are and where the extra batteries are and knowing that if I get out of the studio late one night and don't have something booked the next day, I can just leave everything up and not have to tear it down for the next guy. And of course, buying gear is always fun. I've only got so much room in my house, so having a studio in which to store it becomes an important factor. But having my own place also means I've got a little bit more flexibility to provide certain things for clients that might not necessarily be possible if I'm working at someone else's studio. I still do that on occasion when it makes sense, but I really, really like working at Old House.

What have been some of your favorite artists and records to produce?

I wholeheartedly endorse Mike Strauss and Sunshone Still. I've done multiple records for both of those southern artists, and they are both an absolute joy to work for. Their records are rewarding on so many levels, and they're just plain good people. I'm very proud of the work I've done for both of them. With Mike, I've just engineered. With Chris (Smith, of Sunshone Still), I recorded some early demo stuff for him, but I mixed the first two Sunshone Still records, and he was kind enough to give me a co-producer credit on the latest one (*ThewaytheworldDies*).

I did a beautiful jazz piano trio album for bassist Ron Brendle entitled *Photograph*. It features pianist Frank Kimbrough and drummer Al Sergel. We recorded it with a remote recording setup in a church in Charlotte, and the whole session, setup and all, took less than three hours. It was amazing. I've done some really good recordings for pianist Chad Lawson. I also got to spend three amazingly intense days in the studio with Oteil and Kofi Burbridge, Kenny Soule, Ron Brendle, and Scott Sawyer for Scott's album *Go There*, which I engineered and co-produced. That was a totally magic experience. And *Burning in Hell* by David Childers and the Modern Don Juans is another favorite.

Talk about the North Carolina music scene, its diversity, any specific musicians you like working with, as well as being a part of the North Carolina scene.

North Carolina has an enormously rich history of great music. Even stuff that isn't generally associated with North Carolina can be traced back here. I mean, several of the most gigantic jazz innovators of the 20th century were from North Carolina, even if they left for New York or Philly before figuring out their thing. Arthur Smith was a pioneer in recording in the South. He had the biggest, baddest studio around for a long time. Not just in North Carolina, but basically the biggest place between like Austin and Philadelphia, or something like that. And he had one of the first mixing consoles with pan pots on each channel. That was a big deal.

WBTV was one of the first and largest TV stations in the country, and many people don't know that RCA Victor had a huge office and sort-of recording facility

in downtown Charlotte for most of the 20th century. And although there have been trying times, Charlotte has maintained a symphony orchestra for 80 years. The Arts and Science Council is an extremely successful example of an arts support group in the United States, as well. Even when I was a kid, there was lots of live music in Charlotte and a lot of good original music. I was playing gigs with other junior high school kids in Charlotte in the late 1980s. There were those kinds of outlets. And for as weird as Charlotte can be about tearing down old architecture, you have to give credit to places like the Milestone and the Double Door Inn for their longevity and ability to survive some really tough times.

Outside of Charlotte, there's a rich history of pop and college-oriented music in the Raleigh and Chapel Hill areas. Black Mountain was an amazing haven of arts development in the earlier part of the 20th century. And this is all modern stuff compared to the generations of passed-down folk music like bluegrass and gospel that are a key part of North Carolina's history.

As far as people I like working with, the list is *huge*. I'm extremely fortunate to work with the people I work with. In particular, I have to mention bassist Ron Brendle, one of the most fantastic musicians and cool people I've ever met. I've played in a trio with Ron and John Alexander called Big Octave for something like 12 years. "Johnny A" is a terrific saxophone player and composer, and those two guys really have a great grip on the concept of trio playing without a chordal instrument. They can also play a huge variety of styles. I've learned a lot from those guys. Guitarist Troy Conn, who is in Bunky Moon with Ron Brendle and me, is another stellar, stellar musician and great guy to be around. My bandmates John Elderkin and Steve Ruppenthal in the Public Good are really terrific songwriters and brilliant guys. They were in the Chapel Hill band the Popes, and later in the bands Stumble and the Lovely Lads in Atlanta. I was a huge fan of all those bands, so for me to be playing with those guys is like a dream come true.

For several years, I was a frequent drummer in Don Dixon's live band with guitarist Jamie Hoover, and being on the road with those guys is great. Some of my fondest memories on stage have been with those guys, and I owe a lot of my career and playing personality to them. And of course, my dear friend, mentor, and bandmate Mitch Easter is one of the coolest people I've ever met. I'm fortunate to have played in his band since late 2006, and I have the utmost respect for him. He is absolutely astounding at what he does both playing-wise and recording-wise, and he is one of the most knowledgeable people I've ever been around. It would also be a travesty to not mention drummer/percussionist Jim Brock, one of my heroes, mentors, and friends who is a beautiful soul, as well as an extremely gifted and largely underrated musician.

At the end of the day, what do you hope that listeners get from CDs that you've produced or engineered?

I hope that there's something that someone will like about an album enough to play it over and over again. I have so many albums that I was obsessed with as a kid (and still am), and I hope that someone, somewhere can get that same kind of enjoyment out of at least one record I do in my lifetime.

On the Radio

Many of the best recordings you hear in North Carolina don't come from a recording studio, per se. Throughout the state, a number of radio stations have spent years recording the musicians that pass through their town, as well as documenting the local music scene. The traditions for this go back to WBT Radio, which regularly hosted local bluegrass groups, as well as touring acts such as the original Carter Family. That tradition continued through stations such as WPAQ in Mount Airy. Since 1948, the station has hosted the best and brightest stars on the national stage, as well as giving recognition to the many great musicians that lived near Mount Airy. WPAQ is still on the air today, as are many stations that feature the music of this state.

In 1989, WNCW signed on in Spindale, North Carolina, on the campus of Isothermal Community College. On almost any given day, you can hear an artist performing live on their station, often recorded as part of their Studio B series. WSGE, based at Gaston Community College, and WGWG, located on the campus of Gardner-Webb University, also have their own music series.

The Triangle area has an amazing series of college-based radio stations. WKNC, based at North Carolina State University, broadcasts a remarkably diverse programming schedule. The same can be said for WXYC, which is run by UNC–Chapel Hill, as well as Duke University's WXDU. These three stations sometimes remind me of the joy of driving through a town and discovering something cool on the radio that I hadn't expected to hear. Special mention should also go to WQFS, which is run by Guilford College, as well as WUAG, which is operated by UNC–Greensboro. The eastern North Carolina region also has WRVS-FM, which is run by Elizabeth City State University, and WUAW, which is run by Central Carolina Community College, near Erwin, North Carolina.

WTVI Studios (Charlotte)

When one discusses the recording of music, one avenue that usually gets left out is the television studios. In the 1950s and 1960s, many local television stations featured music programs. Teen shows, often featurings local rock-and-roll bands, were not uncommon. Now they are almost impossible to find. That being said, television has

had an impact on the music of North Carolina and on those who starred in those programs.

Charlotte has a remarkable history of putting the music of this state on television. *Carolina Calling*, *Kilgo's Canteen*, and *Villagers* were all broadcast from Charlotte during the 1960s. Another show from that era was *Groovy for Granny*, a music show on the city's fledgling PBS station, WTVI. The station has since featured many great musicians from this state, right up to the present day.

One of the nicest gentlemen I have ever met was Loonis McGlohon. Loonis was a quiet, unassuming piano player that had done it all. After playing with Jimmy Dorsey and Jack Teagarden, he returned home to Charlotte to work at WBT radio. When the station began to cross over into television, McGlohon took part in WBTV's first music programs. It was fitting then that I first met him in a TV station, when he appeared at a pledge drive for WTVI. I had been hired to run one of the studio's

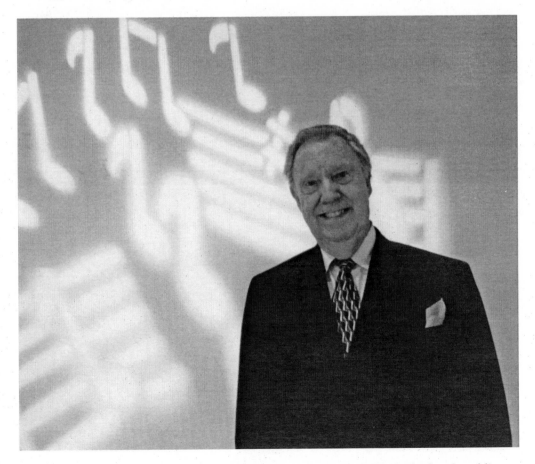

Legendary composer and pianist Loonis McGlohon posing at WTVI, Charlotte's public TV station, in 1998. Loonis was at the studio to help the station's fund drive.

TV cameras, but even then, my camera was always in my car. The set for the show was a huge wall of musical notes. After the show, McGlohon waited for me to grab my camera so that I could take some photos of him.

I was lucky enough to have some extended conversations with McGlohon. Once, I had just finished photographing some people on the street for a local magazine when I saw someone wave at me. It was Loonis, who was on his way to the Levine museum for a meeting. We talked about all things music, yet Loonis was still a modest man. He never told me that he had written hundreds of songs, that he had played with the greatest singers on stages all over the world, and that Frank Sinatra had recorded songs that McGlohon had written. I looked forward to seeing Loonis every time I could.

In February 2002, I got offered the chance to do photos for the Down from the Mountain tour. This was a show based on the soundtrack of the movie *O Brother Where Art Thou?* which would eventually win eight Grammys. When the legendary Ralph Stanley stepped up to sing the centerpiece of the soundtrack album, "O Death," a chill went through me. That song hit me that night in a way that I was unprepared for. Later that night, I found out that Loonis McGlohon had died that evening. I still get chills when I think about that night.

When you look back to the beginning of musicians on television, there was one in Charlotte that rose above all others: Arthur Smith. After having a nationwide country hit with "Guitar Boogie," Smith came to WBTV in 1951 and began the show *Carolina Calling*. The show ran for 32 years, eventually reaching over 90 markets across the country. Along the way, a song that Smith put together in the 1950s became a huge hit in 1972, when it was renamed "Dueling Banjos."

Smith revived *Carolina Calling* in the early 2000s. When the show's final season was taped in 2004, I wasn't hired to work on the show, but I wasn't going to let that opportunity pass me by. I

Arthur Smith looks on during the final day of filming of his *Carolina Calling* at WTVI in Charlotte in 2004. *Carolina Calling* began at WBTV in the early 1950s.

called my friends at WTVI, who were kind enough to let me tag along on the tapings. I then introduced myself to Arthur and his son, Clay, and I was along for the ride. At the time, I didn't know that it would the last time that Arthur and *Carolina Calling* would be in front of the cameras, but I knew that time was moving quickly. Blink, and the world moves on. I'm really glad to have been there for those final shows.

What has been my favorite experience with musicians in a TV studio? Several years ago, a group of people in Charlotte put together a show where they combined musicians from different backgrounds and let them collaborate on various songs. Formal vocal choirs performing with church singers, some of whom brought in the pews from their church to sit on while singing. My friends in Carolina Gator Gumbo, a Charlotte-based cajun band, performing with a Tejano group that spoke little English and used a style of guitar tuning that was unknown to many of us there. Every day, every show was a different adventure. It was a great experience, watching musicians meet, play and come together on the common language of music. And I will always have my photos of those shows. My photos are my notepad, my tape recorder of the people and places I've met and listened to.

Si Kahn is known to many around the world. Musician, songwriter, playwright,

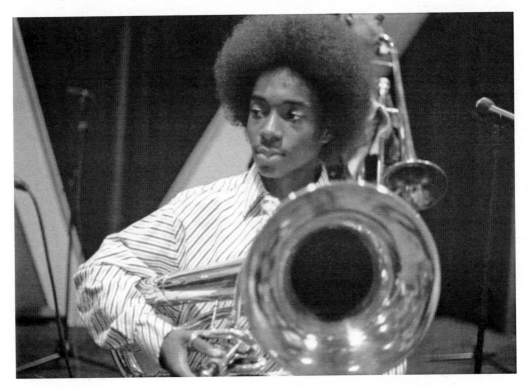

Tuba player from a shout band, *Crossroads* TV taping, WTVI Studios, Charlotte, June 2007.

social activist, and all-around busy guy, he also resides in Charlotte. "When I'm writ-ing songs, as opposed to recording them, I work at home or on the road using Garage-band on my MacBook Air to lay down song ideas, usually a cappella," Kahn says. "Guitar licks, snatches of lyrics and, eventually, a guitar/vocal version of the song to send on to the next stage. In the case of a CD, that's the producer. For musical theater, it's the arranger/orchestrator and/or musical director.

"If I don't sing a song at least 40 or 50 times, I haven't yet figured out the best way to sing it. So I try to make sure I've done that with a song before I try to record it. There are exceptions, but that's pretty much my practice. The more time in the studio, the better the recording. It's usually cost that limits the available time, not a desire to get done and get out. That said, I do tend to do my vocals fairly quickly. Usually I can nail a vocal in one or two takes, as long as I can go back and "punch" in a word, a phrase or a line that didn't turn out quite the way I wanted it. Having an engineer with good hands and good ears is absolutely necessary to being able to do that well.

"For me, working with a professional recording engi-neer is an absolute must. Recording engineers, like Chris Garges and Jens Kruger, are also top-of-the-line musi-cians. So they don't just man-age the recording equipment; they help me with suggestions for how to present a song. They let me know when I'm tiring and need to take a break, and when I've done a song as well as I can, so it's time to quit trying. They contribute ideas for the music and lyrics. Personally, I'll never make a recording entirely on my own, if I can help it."

When I ask Kahn about some of his other favorite recording studios, he adds, "I've had a good time perform-ing live at WNCW, in Spin-dale, North Carolina, and

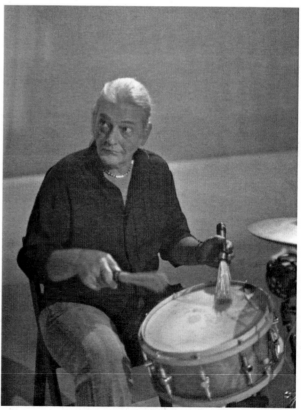

Drummer Jim Brock looks around during filming of a Christmas television special at WTVI in Charlotte in 2007.

WTVI, in Charlotte."

I can't leave Charlotte without talking about some of the other great studios in town. Sioux Sioux Studios, Gat3, Catalyst Recording, Studio B Mastering, Charles Holloman Productions, Jay Howard Audio, Apex Studios, Asylum Digital, Grooveshark, Jay Howard Audio, Fred Story Productions, and Satellite Recording Studios.

Recording Away from a Studio

One of the first bands that I ever photographed was a quartet named Lou Ford, who had an amazing mix of country and rock, fused with a gifted sense of melody. The core of that band was two brothers, Alan and Chad Edwards. The first time I photographed them in a studio, it was Reflection Studios, in their huge main room. One of my photos of that session, a long exposure taken through the glass in the control room, was used in their fist album, *Sad But Familiar*.

I still take photos of the brothers Edwards, albeit now in a different band, and in a different recording environment. Now helming the Loudermilks, which shares some of the same sensibilities as Lou Ford, the band recently recorded their new

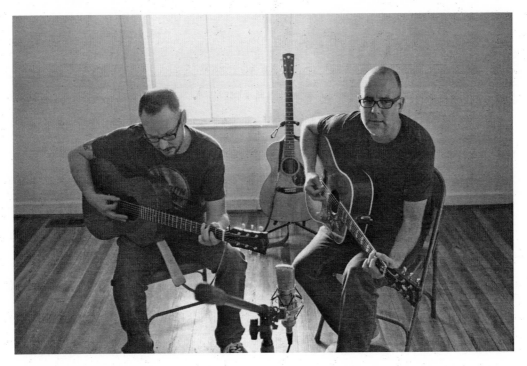

The Loudermilks, Chad (left) and Alan Edwards, recording in an empty house in Wingate, May 2012.

album in an empty house, which sat on the outskirts of Wingate, North Carolina. The band put together the necessary recording equipment and recorded in the old living room of the house — no nearby distractions, just a few microphones, and an armload of songs. It doesn't always matter where you record, just as long as the end result is what you set out to achieve.

I've photographed recording sessions in all sorts of places: in a musician's bedroom as they used their four-track recorder to demo a new song; on the porch of Dolph Ramseur's house, with cars whizzing by. Ramseur had brought a great musician named Martin Stephenson over to record, and Ramseur called on some of the best musicians in the state to join in. Dolph had also rented a special microphone for the session, and it was the only microphone they used. This gave the recording a feeling that you were on the porch with all these musicians. It was a fun process to watch unfold.

Some people may know Ramseur's name from his longtime work with the Avett Brothers. In 1999, I fell in with a group of friends that had a band called the Memphis Quick 50, a fun band, a noisy mix of rock and country. Their bass player was Bob

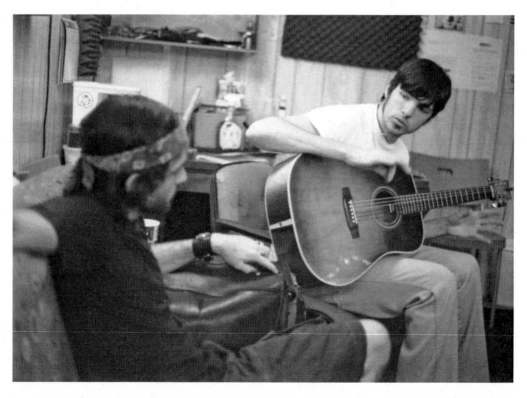

Avett brothers Scott (left) and Seth recording *Four Thieves Gone*, Electromagnetic Recorders, Winston-Salem, September 2005.

Crawford, a really nice guy that shared my background in video production. One night in 2001, he pulled me aside. "I've started playing with this duo of brothers," he said. "Come out to see us play." I soon did, and I ended up doing some of the first photo shoots that the band ever did. To this day, I have never tried to give a visual impression of a band that is different from how they are, or what they didn't want to be. I learned early on to give them the space to be themselves and let my camera follow that.

When the Avett Brothers were just starting out, they often recorded in their father's woodshop, which also served as their rehearsal space. Their producer on those early records, Doug Williams, is still one of my best friends. Doug set up his microphones around the band and recorded the instrumental tracks live. The band felt very comfortable there, and it showed in the recordings.

I still look back on photographing the *Mignonette* sessions as one of the best things I have ever worked on. Their mother, Susan Avett (I still call her "Mrs. Avett," to this day) made us all sandwiches, and the band recorded an amazing number of songs in just one afternoon. At the end of the session, the band decided to tackle a new song entitled "Salvation Song." "Let's see what happens," said one of them. I sat in the circle with them as they recorded the song. From the moment they started it,

I knew that this was *the* take, and they nailed it from start to finish. What you hear on that record is the first take of that song, with the vocals added later. That capped the day, and what a day. The band later recorded overdubs at Doug's studio in Winston-Salem, Electromagnetic Recorders.

Electromagnetic Recorders (Winston-Salem)

One of my proudest experiences at Electromagnetic, or any studio, involved a musician who is not well known to many, although I wish he were. Sammy Walker emerged in the early 1970s as a folk troubadour, immersed in the sounds of Woody Guthrie, Hank Williams and early Bob Dylan. The legendary writer and singer Phil Ochs was so impressed that he produced Walker's first album for Smithsonian Folkways, which was where I first heard Walker's

Sammy Walker, Electromagnetic Recorders, Winston-Salem, January 2006.

name. By 2006, Walker had not been in a studio for several years, until Dolph Ramseur gave Walker the chance to record again for Ramseur Records. Dolph asked if I'd be willing to drive to Electromagnetic Recorders to photograph the session.

An unexpected treat to the sessions was finally getting to meet Tony Williamson, who is a fantastic mandolin player and has the resume to prove it. He had been friends with Walker for years and wanted to see this new album come together as well. Tony played on several songs and gave Walker another musician to work with in the studio.

Tony Williamson, Electromagnetic Recorders, Winston-Salem, January 2006.

Tony's presence also inspired Sammy to bring in several new songs and play with the arrangements.

Knowing that Walker didn't come to posing for photos naturally, I purposefully said silly things to keep Sammy in a good mood. At one point, I was taking a photo of Walker and Williamson together, and I said, "Let me get a shot of you two shaking hands. It'll be my version of the Lincoln and Douglas debates photo." I honestly have no idea where that idea came from, and no, Lincoln and Douglas never did pose for photos together. But Sammy laughed, and it made for a good photo. "You did well," Ramseur said afterward. "The last photographer that was here, for the local paper, Sammy kicked him out."

As mentioned, Doug Williams has also worked with artists away from his studio. After *Mignonette*, Doug and I followed the Avett Brothers to Robbinsville, North Carolina, where much of their following album was recorded in a rented

Caleb Caudle pauses for a photograph outside the Electromagnetic Recorders Studio in Winston-Salem in 2006. Caleb had stopped to visit Doug Williams, the studio's director.

house. The house overlooked the state line to Tennessee and was in a very quiet and remote part of the state. The songs seemed to flow from the band. One night, they recorded a song that told the truth about an earlier song that the band had recorded. Someone that night remarked that the song sounded a lot like a Jim Stafford song, with its freewheeling chord changes, and a vocal that was more spoken than sung. Scott Avett, who had written the song, seemed perturbed by this. We all soon went to sleep.

The next morning, Scott came down with a new song. "I've been working on the song all night," he said. It was a song about thieves, which referenced our conversation from the night before. The song's melody sounded a bit like "Three Blind Mice," but that was intentional. The song did not need much instrumentation, and we all felt that it should stay largely the way Scott had originally played it for us. The song was quickly recorded, and the band then moved on to record more songs. That quiet song later became the title track of the album, "Four Thieves Gone."

Interview with Doug Williams

COSTON: *How did you start playing music?*

DOUG WILLIAMS: After years of bedroom air guitar, I was roped in to play bass at a high school talent show. I'd not really done anything with a band before, and no one else wanted to play bass, so I got the gig. I had the right hair at the time too.

What were some of your first gigs as an engineer and producer?

Mostly Winston-Salem stuff. Squatweiler, Jet Crown Dixie, Codeseven, Running from Anna would be some of the larger projects near the beginning. I worked with the Charlotte bands Me and Emma, and Lou Ford early on.

What is the difference between producing and engineering?

That has fluid meaning. Strict engineering would be simply setting up equipment and getting sound from source to destination correctly. Producing can be anything else beyond that: comments on and changes to songwriting, directing aspects of performance, picking/advising the recording location, picking the type of equipment used to get the desired sounds, being therapist to the artist, et cetera.

What led you to form Electromagnetic?

Electromagnetic Radiation Recorders grew organically out of a need to have consistent working space. I found it hard to get time in existing studios that met the needs of multiple schedules, and most acts weren't prepared to block book a studio for weeks on end.

What are the advantages of running your own studio?

I can make the schedule myself, or have it run amok. Consistency, for better or worse. If it's broken, it's my fault, and no one else's.

What have been some of your favorite artists and records to produce?

The ones that feel creatively productive, and if there was pain involved, it paid off. I think, like most musicians, I'm always looking to the future for bigger and better, and over time records that wear well and continue to reflect well on all involved grow dearer. In contrast, there's tons of really great music I've worked on that's never been heard by much of anyone, best songs that were left off records by the artists, even great records that were done and never released. Those are painful, since music doesn't exist in a vacuum.

At the end of the day, what do you hope listeners get from CDs that you've produced or engineered?

Musical enjoyment, on whatever level the listener takes. Hopefully they hear something unique and special.

Echo Mountain Studios (Asheville)

By the time the Avett Brothers began work on their next album, *Emotionalism*, the band had moved to Echo Mountain Studios, in Asheville. Echo Mountain is a converted church, with a natural echo that's perfect for recording. Built as a Methodist Church during the 1920s, the building now houses several studios for both audio and video recording. The church's original sanctuary, with its original stained-glass windows still intact, is still the studio's main calling card.

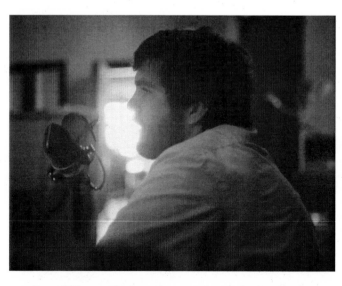

One thing I can tell you about the Avett Brothers, wherever the inspiration takes them is where they'll go. They may have planned on working on something else, but if a new idea appears, then they will see that idea through. When I photographed the sessions for *Emotionalism*, they had planned to record a song called "Sing It to Me" that evening. However, just before that was to be recorded, Scott and Seth started writing a new song.

Dave Wilson, Chatham County Line, Echo Mountain Studios, Asheville, June 2008.

It was a song about saying good-bye to your loved ones, your friends, in search of something else. I felt like they were, in an unspoken way, saying good-bye to me and many of us that had known them. They wrote the song, and recorded it, before deciding that it was now time to record "Sing It to Me." Yes, I'm happy to say that I was there for that song's creation, as well. But as I drove home that night, I knew that my relationship with the band was changing fast.

Another great band that I've gotten to work with at Echo Mountain Studios is Chatham County Line, who are based out of Chapel Hill. The band's sound is rooted in traditional bluegrass, but the songwriting and showmanship is all theirs. The cover shot for that album, titled simply *IV*, was what I call a found photo. The band had leaned their microphone-stand cover, embossed with the band's name, against the wall. I noticed it, thought it looked like a good shot, and took a few photos of it. An album cover photo, taken just like that.

One quirk with photographing the Chatham County sessions is that Dave Wilson doesn't like having anyone else but the band in the room when they're recording. That included me. Once I figured this out, it got to be something of a game. Can I get the photographs I want and still be on my way out the door, or can I not even be in the room before Dave waves me off? Yes, it sounds silly, but if it helps to lighten the mood of long recording sessions, so be it.

Chandler Holt, banjo player and vocalist with Chatham County Line, prefers to have songs written before he goes into the studio. "Occasionally some things will happen on the spot, but that seems to be the exception." Holt also prefers to record elsewhere and not have a home studio. "I don't want one personally. I think it would be so much work to keep up with and would become a money pit. I'm way more interested in playing music in a studio than keeping one current."

As for recording studios in North Carolina, "Echo Mountain, in Asheville, is pretty awesome. I really like the Fidelitorium, in Kernersville, North Carolina, too."

Echo Mountain is not the only recording studio in Asheville. CollapseAble Studios has been recording great albums since 1999. Also situated in the Asheville area are Landslide Recording, Whitewater Recording, Asheville Recording Studios, Hollow Reed Arts, and Hillcreek Studio.

When I start photographing a recording session, I prefer to take a look around first, walk around the room, and get a sense of the space, what it feels like, what spaces are best for lighting. While I often do not know how a recording session will go, its good to know what the room looks like. This allows you to come up with visual ideas or angles that will work better than others. It's also good to take notice of any small spaces where I might be able to stand and shoot from without getting in the musicians' way.

Every once in a while, taking photos in the studio has to be done very quickly. This can take me out of my comfort zone, but it forces me to really think what the

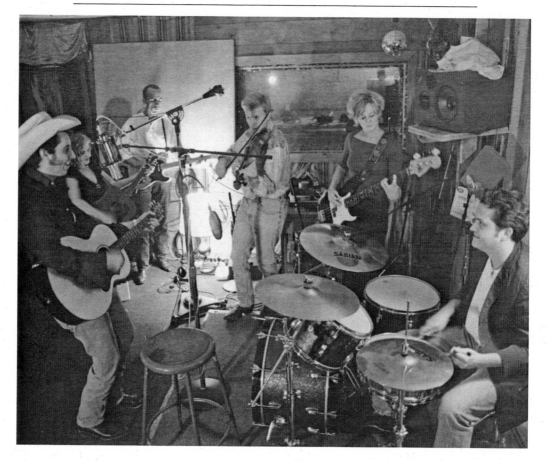

Two Dollar Pistols with Tift Merritt (left to right: John Howie, Tift Merritt, Michael Krause, Jon Kemppainen, Ellen Gray and David Newton), Raleigh, September 1999.

best shot is at that moment. The first time that I photographed Tift Merritt in the studio, I had been hired by Yep Roc Records to photograph her recording session in Raleigh with the Two Dollar Pistols. At the time, Yep Roc was a fledgling Chapel Hill–based record label, with just a few bands on the roster. Yep Roc celebrated their 15th anniversary in 2012, and the label now has a healthy roster of international as well as local artists.

Shortly before the studio shoot, Yep Roc hired me to photograph another one of their artists, the Countdown Quartet, that same evening, at a club in Durham. The Quartet had just added Jimbo Mathus of the Squirrel Nut Zippers, so I said yes, even though I knew that I might be setting myself up for disaster. I ended up pulling

Opposite: Countdown Quartet (left to right: Dave Wright, Bellino Evans, Ted Zarras, Jimbo Mathus, Tim Smith and Steve Grothmann), Durham, September 1999.

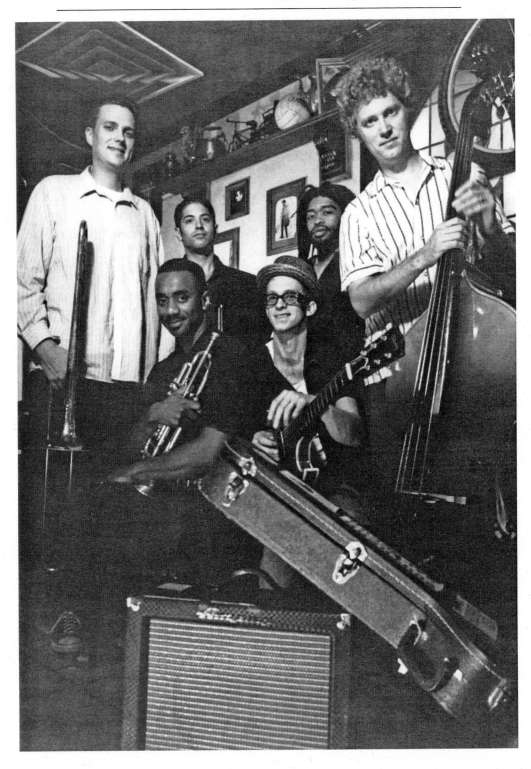

the whole evening off, but just barely. I had received bad directions to both venues, so I was late for both gigs from the start. By the time I got to the recording studio in Raleigh, it was late, and some of the Pistols were about to leave. I asked them to "run through a song," which the band obliged. To get a good group shot of everyone, I wedged my head into the corner of the studio and used all of the available light in the room. Afterward, I could barely remember what I'd photographed. But it worked. The room's lighting looked good in black and white, and one of the group photos was used in the resulting album.

"I seem to make a record about every two years, where I get to be in the studio for a block of time with the people I make music with," says Tift Merritt. "There's nothing better. But I like to get in the studio by myself for a day now and then as I go, say when I have a batch of new songs that I want to test out. I think the more you can be in the studio, the better you know yourself there.

"I surely tweak things in the studio — things have a way of coming to life in the studio — but I do not write in the studio. Writing is a very private act. And the further considered ideas are before getting in the studio, the more the writing is thought through — the more freedom there is to go in any direction. I like working quickly. I think the heart of things is performing together." As for her favorite studios in North Carolina, "I love Overdub Lane."

Overdub Lane (Durham)

Overdub Lane is one of the top studios in North Carolina. I first visited Overdub in 2009, as the dB's finished work on a new album. I had such a good time working with John Plymale, it really made me wish that I'd gotten there sooner. Plymale does not own Overdub, but he does work out of the studio as a freelancing home base. During the session, the dB's also needed photos done for the upcoming CD. John graciously gave me the key to a nearby office, I taped backdrops to the walls, and the photos were done all in one fell swoop.

Interview with John Plymale

COSTON: *How did you start playing music?*

JOHN PLYMALE: I took lessons on a lot of things as a little kid — drums, piano, guitar, even the recorder — but never really stuck with any of them very long or got particularly far with any of them. I wanted a drum kit but only had this little practice pad thing that sure wasn't very inspiring to play! And later I had this cheapo nylon-string acoustic guitar but wasn't smart enough yet to figure out why the KISS and Aerosmith songs I was trying to play didn't sound right on it. Oh duh, I need an

electric guitar! Then later I played trumpet and trombone in junior high and high school.

The Pressure Boys started when I was 17 and a senior in high school. Basically I became the singer in that band because nobody else in the band really wanted to sing. Not that I was really qualified though. During the Pressure Boys era (1981–1988), I also learned to play guitar, which I used to write songs with. Then between 1988 and 1994 I played guitar and sang in the band Sex Police.

What got you into engineering and producing?

The Pressure Boys were fortunate to have been steered toward Mitch Easter to make our first recordings in 1982, and working with him and Don Dixon on the next two Pressure Boys albums gave me a view into the world of producing/engineering. I loved the idea of the magic you could create in the studio, and Mitch and Don were both hugely influential on my desire to continue in a similar path as theirs. They were fun and inspiring people to work with, and they seemed to know a lot of really cool and mystical things about sound and recording.

Having spent a decent amount of time actually in studios working on my own band's projects, for some reason other people started to think I could be a help to them with their projects when they went into the studio. So I started to get asked to come in and give my unbiased thoughts on things and help negotiate between everybody and all their different opinions as they navigated their way through the process. Basically, I just fell into the role of producing.

Eventually I got to where I really needed to learn how to engineer sessions all by myself. You get to a point where you really know exactly what it is sonically that you are going for, and the only way to achieve it is to just put your hands on all the controls yourself and make it happen. So over several years I threw myself into the fire and learned the basics as I went. At times it wasn't pretty, but there's nothing like a real-world education in the hot seat to help you hone your skills.

What is the difference between producing and engineering?

An engineer is the guy who literally puts his hands on the controls of the mixing board as well as sets up the microphones and other pieces of equipment. He's in charge of the technical aspects of making the recording in a hands-on way.

The producer is the person who is sort of guiding the session through from day to day. They can do as little as sometimes just sit on the sofa in the back of the room and sort of act like a cheerleader, to as much as helping to rewrite the lyrics of the song — and everything in between. A big part of it is to be the person who can manage all the different personalities present during the session and be the person people are willing to defer to when nobody can see eye to eye on a problem.

Different artists and situations require different needs from the producer. Sometimes the producer *is* the same person as the engineer on the record, or sometimes

it's one of the band members. Not every project has a person who is really deemed to be the producer up front. In those cases, everyone involved who gives input is a partial producer on the project.

Talk about the North Carolina music scene, its diversity, any specific musicians you like working with, as well as being a part of the North Carolina scene.

I like the fact that everybody kind of knows everybody around here, and there is a great sense of community between artists. It's so common to see everybody chipping in and helping each other out when the need arises. I see much more collaboration than competition between most area bands, artists and studios.

At the end of the day, what do you hope that listeners get from CDs that you've produced or engineered?

I just loved the magic and emotion that I felt when listening to my favorite songs as I grew up and fell in love with music, the kind of out-of-body experience that a really amazing song and its production can give you. So, for me, trying to be a part of what makes those experiences come to life for any listener of one of my projects is what completely motivates me. Every day my job is all about attempting to catch a magic, timeless, spiritual moment on tape. It doesn't happen every day. But when it does, it's incredibly satisfying.

When I started taking photos of musicians, recording studios were still somewhat of a rare commodity. While studios are not always giant rooms, the technology and recording equipment needed were still cumbersome, and expensive. Now, most people have the capability to record music on their own computer. Smaller, independent studios have now begun to flourish. More musicians can now also record themselves, giving all musicians the chance to document their music more often and sell it directly to the public.

Every musician has their own process, and their own timelines. Some have their own recording studios, and others prefer to record elsewhere. But the end result is the same. Create the music and make that music available to listeners.

Studio M (Durham)

"We usually do a record every year or so," says Django Haskins, of the Chapel Hill–based band Old Ceremony. "Then there's also plenty of other side projects, and playing on friends' records. I generally come to the studio with the songs written if not road tested by the band. We like to track pretty quickly, then take more time to mull over the tracks to see what's missing or what's not needed. I love recording in our studio. Actually it's our vibes/organ player, Mark Simonsen's studio, Studio M, in Durham. It's

comfortable for us, there's tons of fun toys and vintage gear, and we have been working with engineer Thom Canova so long that he's basically a member of our band."

"I always have the songs written before, because I don't mind arranging in the studio but I really don't like writing there," says Justin Robinson, a founding member of the Carolina Chocolate Drops, who now leads the Mary Annettes. "I like to get to a point where I don't have any doubts about the content and structure before I lay it down. Some songs can be done rather quickly and others require a lot more time, but you have to start out with a lot of time and use it as needed. I really liked where *Bones for Tinder* was cut, Studio M, in Durham. It has been one of the best recording experiences I've had."

Studio M has been a popular stop for local musicians for some time and is one of a host of popular recording studios in the Durham and Raleigh areas. This includes Spacelab, Sound Pure Studios, Playground Studios, North State Sound, Basement Studios, Evenform, Osceola, Trailblazer, and PostPro.

"When we've been in the studio, we've pretty much straddled the line between minimal recording to more technical recording," says Dom Flemons, multi-instrumentalist with the Grammy-winning Carolina Chocolate Drops. "Most times, we've tried to have everything at least partially arranged before going in, for speed, but also so we can lay out what parts might need overdubbing if any at all and how to mic everything. Based on the song, we'll have a vocal booth and another area for instruments where the vocalist can be seen by the instrumentalists. Some of the old-time numbers, definitely instrumental ones, are done in one room. It's always important to have a live sound with the breakdowns and such, but for more arranged or ballad-like material, it just works better to have separation. This is not only for bleed through but also for redos on vocal if the right feeling isn't reached. It just gives flexibility. Overdubs are usually done last unless it seems to be a very easy overdub or it is particularly inspired.

"Our group has written much material wholesale, but there have been arrangements that have been made in the studio. Two original songs, 'Country Girl,' and 'Kissin' and Cussin'" were written beforehand and made their final tweaks in the studio. If the time is there, there will always usually be a few pieces that are inspired while in session in some form or another, whether a piece is fully realized coming into it or if it pops up when you're in the thick of it.

"I've always preferred a quicker session. I can't imagine doing months in the studio. Two weeks is good for me. The shortest I've ever worked with is just two days. One day recording, one day mixing for *Dona Got a Ramblin' Mind*. It is all about the size and direction of the project. If you are capturing a group that has all of the material together, then it shouldn't take but a few days with some discussion before and after. If the material is in no way together with a group of musicians who have not worked together, that's a different story. I'm always a fan of doing a ton of pre-production work so that the studio time is shorter. I am a fan of studio recording,

but it can become very daunting very fast, and the worst thing to me is getting sick of the song before you've recorded a 'good' take, because there is a lot of work that needs to go into it. It's terrible if either you dislike the take and have to build on my overdubs to make it passable, or if your ears just get plain tired, it can lead to disaster.

"The advantage of having your own recording studio is being able to do tons of work without the clock ticking. This means also if you decided to record you snapping rubber bands between your fingers and putting a bunch of effects on it, that's your business and no one else's. When you are working in a professional atmosphere outside your own home, sometimes you are in other people's homes; that is not a luxury you just have to work with. Also, sometimes it's nice to let ideas flow and become nothing. Sometimes they inspire other things."

"I usually do a big project every other year, and I record cuts for friends' projects a few times a year," says Joe Newberry, musician, and music historian. "I try to have the songs written and well rehearsed before I head to the studio. I do like to work quickly in the studio. A producer friend of mine says that all of his money is in the rewind button. I don't have my own studio, but I do have a program on my computer that allows me to do rough tracks and demos. It allows me to send folks what my vision sounds like if they are playing on a number. My favorite recording studio is the Rubber Room in Chapel Hill. I have also enjoyed working at Charles Eller Studios in Charlotte. Favorite radio stations are many. WPAQ in Mount Airy, WUNC in Chapel Hill, WXYC in Chapel Hill, to mention a few."

"We usually don't spend too much time in the studio until we're ready to start recording an album," say Andrew Marlin and Emily Frantz, who together form the Chapel Hill–based duo Mandolin Orange. "The songs are usually arranged and ready to go before we go into the studio, but different parts are definitely added and written while we're in there. We like to work quickly in the studio using live takes; that way we get more natural sounds than when we pick everything apart."

As for the advantages of having your own recording studio, the duo says, "It's a lot cheaper, and you can experiment more when you're not paying by the hour. But you can definitely pick something to death when you have unlimited time and resources. We're really comfortable recording at the Rubber Room in Chapel Hill. It's where we recorded *Quiet Little Room* and *Hard Hearted Stranger*. We're really familiar with the gear and room there, so it takes a lot of the guesswork out of the engineering side of things."

The Rubber Room (Chapel Hill)

The Rubber Room has established itself as a musician-friendly recording studio for both established musicians and newcomers. It should come as no surprise then

that the Rubber was founded by, and is still operated by, a fellow musician. Jerry Brown is a member of the long-running bluegrass group, the Shady Grove Band. In 1996, he opened the Rubber Room to record the Shady Grove Band's albums, and opened himself up to working with some of the best in the country. Among those that have recorded at the Rubber Room are the Steep Canyon Rangers, Doc Watson, Ben Folds, Don Dixon, and a host of nationally recognized artists.

Much like the rest of the Triangle area, the Chapel Hill and Carrboro area have a remarkable number of recording studios. This includes Modern Recording, which is run by Chris Stamey; Kitchen Mastering, run by Brent Lambert; Arbor Ridge Studios; Gismo Studios; Warrior Sound; and Double Decker Bus. Also near Carrboro is Duck Dee Studio, run by Jerry Kee in Mebane, North Carolina. Southern Culture on the Skids leader Rick Miller also runs his Kudzu Ranch Studio out of Mebane.

There are other great studios throughout the state. Double Time Studio, run by Jens Kruger of the Kruger Brothers, operates near Wilkesboro, North Carolina. Figure Media Studios is up and running in the Taylorsville area and already has had everyone from MTV to Carolina blues legend Pops Ferguson. In the Outer Banks area, there's the Ranch Recording Studio. Founded in 2000, the studio has hosted the likes of legendary bluesman (and Outer Banks resident) Mojo Collins, as well as many local and regional acts. There are many more studios across the state that I haven't visited yet, but I hope to do so soon.

Like many of the musicians I work with, I stay busy. The road beckons, and it's on to the next gig. But it's the documents we leave behind that remind us of those moments. For many musicians, it's the recordings. For me, it's the photographs.

CHAPTER 2

On the Road

I love to travel. It's one of the few things that have not changed while I've been taking photographs over the past 16 years. If there's money for the trip, and the promise of some new, potentially cool photos, I'm there. Heck, I still do this even without the promise of gas money. Just put me in the car, give me a sandwich and soda for the road, and let's go.

There is a thrill of discovery in traveling, a feeling of possibilities that isn't there if you're sitting at home. Many of my favorite photographers, such as Walker Evans, Alfred Eisenstaedt, Jim Marshall, and others went out and found their subjects. Their travels were their canvas. Like most musicians, they made their greatest work while traveling across the world. There is still a sense of romanticism in working that way, at least for me. I may see that dream a little more realistically at this point, but I still believe in it.

My first out-of-town shoots with bands were relatively modest ones. A trip to a small recording studio in Morganton, North Carolina, with a Charlotte band, and to Salisbury for my first photo shoot with a band, for a great group called Mercury Dime. I will always have a soft spot in my heart for those first bands that I worked

Dom Flemons of the Carolina Chocolate Drops preparing to hit the road again, Mebane, May 2008.

with, no matter where they resided. Lou Ford, It Could Be Nothing, the Johnsons (from Winston-Salem), the Pinetops (also from Winston-Salem), and others became my training ground for working with musicians. I learned a lot from working with Mercury Dime, and I believe that they're still one of the best bands I ever worked with.

As I got into the car to drive to Salisbury for that first shoot, the radio started playing Johnny Cash's then-new single, "Rusty Cage." Wow, I thought, what a great version of that song. I took it as a good omen

Left: Jeffrey Dean Foster ponders his next song. Pinetops antique store, Charlotte, June 1999.

Mercury Dime (left to right: Jim Martin, Alan Wyrick, Darryl Jones, Cliff Retallick and Eric Webster), Salisbury, June 1997.

for the shoot, which it turned out to be. To this day, I still look for those good signs when starting a shoot, or traveling to it — a song I haven't heard before, a call or e-mail from someone I haven't heard from in a while, a good piece of news. It all can put you in the right frame of mind and make the trip go a little easier.

Within a year of starting to take photographs, I began to get restless. Living in Charlotte, some people wanted to get stuck on being the best this and that, or the best-known this or that. I quickly lost interest in being the best-known music photographer in town, although I never stopped working in Charlotte. Around this time, the rest of North Carolina had an amazing music scene. Chapel Hill, Raleigh, Asheville, and Winston-Salem all had their own sets of good musicians. The Chapel Hill scene was especially prominent at the time, with Squirrel Nut Zippers, Ben Folds Five, and Southern Culture on the Skids getting national airplay. Raleigh also had a remarkable scene, with Whiskeytown and the Backsliders garnering their own share of attention.

I soon picked up on one advantage of traveling out of town to photograph musicians. It seemed to level my playing field. In Charlotte, I had never liked the feeling of being "a local guy," that person that people got used to seeing around town. Too often, if people are used to seeing you, they don't take your work as seriously as you might wish. It doesn't matter what you're creating, because some people just take for granted that you'll be there. However, when out-of-town bands found out that I had driven a certain number of miles to see them, I was simply a photographer. I had never thought that musicians might be impressed that I had done a six-hour round-trip drive to see them. I did it to take their photo and enjoy the show. But it did level the playing field, and the musicians took more notice of what I was doing. And that's all I wanted. Give me the chance to show you what I can do, and let's go.

The Triangle Area (Raleigh, Durham, Chapel Hill)

The majority of the photography trips I first took were along Interstate 85, from Charlotte to Chapel Hill and the Triangle area. For a few years, several patrons in the Triangle area thought I lived up there due to the frequent shows I attended. The first place I ever went to in Chapel Hill was The Cave, then followed up by trips to Local 506. The Cave is exactly what it sounds like, a small hole-in-the-wall venue that requires you to walk downstairs from Franklin Street. Both The Cave and Local 506 have been important places for many musicians in the area to get their start and build up a following.

Walking just a few blocks from Local 506 puts you in Carrboro, which is home to the legendary Cat's Cradle and the Carrboro ArtsCenter. Both sit in a nondescript shopping center. I have taken a lot of photos at the Cat's Cradle over the years. Many

national acts, as well as popular local acts, have filled the 900-plus-capacity venue. Despite all the times that I've been there, it wasn't but a few years ago that I got to finally photograph and talk at length to the Cradle's owner, Frank Heath. Frank still has that love of music that he started with and has helped a lot of bands get up the ladder of success. Due to my workload these days, I don't get back to the Cradle as often as I should, but I always look forward to being there. The same goes for the ArtsCenter, which only holds about 300 people but is one of the best smaller-sized venues in the state.

In recent years, an amazing series of venues have popped up in the Triangle area. This includes the Nightlight in Chapel Hill. Durham has the Carolina Theatre, the Durham Performing Arts Center, Motorco Music Hall, the Casbah, and others. Durham also has the Back Porch concert series, a concert series at the American Tobacco Campus that runs throughout the summer. Raleigh has a number of different venues. This includes the Lincoln Theater, which began as a movie theater during the 1950s. The Longbranch Saloon was open for many years as a country music venue but now presents everything from hip-hip to techno music. Smaller venues such as Slim's, the Pour House, Tir Na Nog, and many bars and restaurants are always popular. Disco Rodeo and Meymandi Concert Hall are both large venues that cater to national touring acts. King's Barcade is back after several years away, and Sadlack's Heroes has remained a popular hangout. RBC Center, Walnut Creek Amphitheater, and Red Hat Amphitheater also bring many national acts to Raleigh. There's also the Koka Booth Amphitheater in Cary, North Carolina.

One recent addition near the Triangle area is the Haw River Ballroom, located near Saxapahaw. Situated in a renovated textile mill, the Ballroom is a remarkable building that has also reestablished Saxapahaw's town center. I first visited the venue in the summer of 2012 to attend the memorial concert of friend and Chapel Hill musician Matt Brown. It reinforces the idea that a concert hall can be more than just a concert venue; it can be an important part of the community.

Some musicians know where they'd like to get their photos taken. I have been a huge fan of Caitlin Cary for years, starting with her days with Whiskeytown. When she called me one day about taking some new photos of her, I asked her if she recommended any places. Caitlin lives in Raleigh, and I knew that she would have a better idea of locations on that side of the state than I would. She was heading to Durham on the day of the shoot, so she suggested the grounds of the Doris Duke hospital in Durham. It ended up being a fantastic shoot, with the open grounds and the great weather providing an ideal backdrop. We walked around, coming up with ideas as we went.

"I usually travel by car or in a van," says Caitlin. "I don't care much for flying in general, and I find fly dates difficult and stressful and prefer to avoid them. I've done tours on a bus before, but I actually sort of prefer the van. On a bus you've got very little

autonomy. You can't stop where you want, and because you're in a gigantic, unwieldy vehicle, you are often stuck in suburban parking lots during downtime. I dig the 15-passenger van as long as the band is small enough so that everyone has their own bench!

"When we play as a duo, it's fun traveling in a little car. Then it doesn't even feel like touring. It feels like you're on vacation! I've actually never done a tour all by myself. I don't think I'd like it. Camaraderie is actually one of my favorite things about making music, and I think I'd be terribly lonely on the road by myself.

"I guess most of [a day on tour] tends to be spent in the van getting there. So it's napping, reading, knitting, Scrabble on the iPhone, laughing, chatting, playing car games, rest stops, jerky gazing, listening to music, and then you're there. And it's load gear, sound check, find food, play; load gear, drive someplace, unwind, sleep. It's a pretty simple existence, usually. I usually don't find there's ever all that much time to spend backstage. And also green rooms tend to be pretty inhospitable places, usually even in swanky venues. I usually don't like spending a whole lot of time there. I like to walk around, see stuff around the club, sit in a bar or a restaurant. It's nice to be on familiar ground, to feel like you're near to your people and your roots."

Caitlin Cary on grounds of Doris Duke Hospital, Durham, October 2002.

One of my favorite "on the road" shoots I ever did was with Chatham County Line, who are also from Raleigh. For their album *Speed of the Whippoorwill,*" which was based around the themes of trains and traveling, the band asked me to meet them at the North Carolina Transportation Museum, in Spencer. The museum is remarkable, based around the old train station in Spencer. The museum is full of vintage trains, train equipment, and all modes of transportation.

When I got to the museum, I figured that the band had set things up beforehand with the museum. The band proceeded to walk into the museum, introduce themselves to the various museum employees, and talked them into letting us get photos throughout the museum. It was a photogra-

pher's dream. We did all sorts of photos in vintage train cars and came away with some great photos. Afterward, we all went to Lexington and ate barbecue. Now, that was a good day.

Dave Wilson and Chatham County Line are also good at pushing me to do better work and to think on my feet. For the photo session for their 2010 album, *Wildwood*, we met in a small forest in Raleigh. There was a slight mist of rain falling that day, which gave everything an interesting shade of gray. After some posed pics, the band said, "We're going back inside for a minute. Take a few minutes and shoot what you see." They knew exactly what they were doing. This forced me to think about what was around me and how I could translate that into an interesting visual. I also had just purchased a new camera, which I was still not used to. The first few shots of the treetops I accidentally overexposed. But I realized that I liked the way the photos looked and kept the settings as they were. The cover photo of *Wildwood*, as well as some of the shots on the inside sleeve of the CD, come from those wet, yet productive minutes.

I prefer doing posed photos of musicians before the show, rather than after it. If you perform a 90-minute set in front of anyone, much less hundreds of people, your brain is going to be a little distracted. Every once in a while, however, the after-show pics do work. I was (and still am) a huge fan of a band called the Kingsbury

Kingsbury Manx (left to right: Kenneth Stephenson, Scott Myers, Ryan Richardson and Bill Taylor), Kings Barcade, Raleigh, June 2000.

Manx. The band was originally made up of four friends from Wilson, North Carolina, and put together a debut album in 1999 that is still a fantastic record. Suddenly, they went from playing in basements to playing in theaters across the country.

Another band I was working with at the time lined up a show with the Manx in Raleigh, and since I already had their album, I was ready to go see them. We all began talking before the show. They still didn't have any posed photos, they admitted to me. I asked about doing photos before the show, but the band was also hanging out with a lot of friends, and they didn't leave the party. "How about afterwards?" they asked. Why not? I thought.

During the show, I realized that the shoot was going to have to be a strategic strike. The band wasn't going to stand very long for photos. It also didn't help that the venue was fairly dirty and would not look good. There was a hallway behind the stage, lit only with one florescent strip. In a corner, someone had left a large wooden box, for reasons that I never figured out. In my mind, I started tying all of these objects together.

As the band came offstage, I said, "Everybody! Stand up here on this box!" This put the band's heads near the florescent light, and gave me just enough light to use for a roll of black-and-white photos. Because of the lighting at hand, the photos had somewhat of a washed-out look to them. But that was what I wanted and was an honest reflection of what the feeling in the room was like. "We really don't remember much about that shoot," one of the band members admitted to me later, but I pulled off the shoot, and those photos got used for a number of years afterward.

I don't look for big things inside venues as possible photo backdrops, just little places that will give me enough to work with. It can sometimes be a daunting task, but there is an indescribable joy for me when a great shot emerges from underneath a light, near an open doorway, or anyplace that you come up with a good idea that had frankly not been in your head when you first walked into the room.

When a musician arrives at a venue, the soundcheck is often the first order of business. Load in whatever equipment the musician has and work on getting the sound right and getting a sense of the venue. Afterward, the musicians might find their dressing room, or anyplace that feels comfortable to them. If it's a big tour, the tour bus is always there. If the musician is more economy minded, it may be the car or van that they pulled up in. When I photographed the Squirrel Nut Zippers in 2007, the band members made use of any and all places. Jimbo Mathus was writing songs in the band's dressing room and Katherine Whalen was writing songs in the band's van while drummer Chris Phillips and the rest of the band took naps and checked out the restaurants around the theater.

I first saw the Zippers in 1995. I happened to wander into a free local festival, with various bands playing throughout the day. I can still see written on a dry-erase board, sitting on the ground next to the main stage, "9 P.M., Squirrel Nut Zippers."

Top: Chris Phillips of the Squirrel Nut Zippers taking a nap before a show in the green room of the Double Door Inn, Charlotte, June 1999. *Bottom*: William Dawson and Katherine Whalen outside the Neighborhood Theatre, Charlotte, October 2007.

I knew nothing about them, but I was impressed with their sound. In that day's trend of noisy grunge bands, a group dressed in 1930s-era clothes, playing a mixture of swing and jazz music, was almost breathtaking to see. Two years later, the Zippers packed Tremont Music Hall to the rafters. It was one of the most crowded shows I've ever seen. As soon as someone left, ten more people walked in the building.

The frontlady of the Zippers, Katherine Whalen, is still making her own kind of music today. The venues may be different now than they were in the Zippers days, but I still look forward to seeing Katherine every time she steps on stage.

When asked whether she prefers touring solo or with a band, Whalen says, "Traveling with a band, there's less getting lost, but more cursing." As for her pre-show routine, she prefers to "Read old *National Geographics* and warm up. I love performing live. It's the cherry on top of hours of preparation and travel."

On the Way to the Outer Banks

On your way down I-74 toward the beach, you'll find many towns that sponsor music in bars and restaurants. As you get near Rockingham, head toward Aberdeen for the Rooster's Wife. Usually held on Sunday evenings, this down-home venue has been converted from its origins as a garage and is lined with numerous couches for seating. It is also a venue that is supported by the whole town and is a great place to visit.

In Wilmington, you'll find the Soapbox Lounge, which features local and national touring acts. There's the Greenfield Lake Amphitheater in Wilmington for large shows, as well as the Riverfront Park. Also in Wilmington, Thalian Hall opened in 1858 as an opera house. Notables such as John Philip Sousa, Buffalo Bill Cody and others appeared there during its first eight decades of existence. After the city of Wilmington saved the theater from the wrecking ball in 1963, the Thalian was restored and is now part of a larger city hall complex that opened in 1990. Most towns heading toward the North Carolina coast have at least one music venue. Oriental, North Carolina, has the Old Theater, which was built in 1945. Morehead City has the Morehead City Center, while Jacksonville has Gus' Warehouse and Hooligan's Music Hall.

The more I traveled the state, the more I would store away ideas for locations. If you're going to be in this region, why don't you go here? It can be something of a game for me as a photographer. Where in this town would be great for photos? It keeps you thinking about visuals and what might work — old buildings, rustic architecture, vines, anything slightly Gothic looking. I would be interested in those kinds of visuals anyway. But put a bunch of musicians in front of it? Now you've got something.

Back in 2002, I was hired to do photos of Hobex by their record label. The band was led by Greg Humphreys, whose previous band, Dillon Fence, had been a driving influence in the North Carolina rock scene during the 1990s. I met the band out in

Hobex (left to right: Steve Norfleet, Bob Miller, Greg Humphreys, April Howell, Andy Ware and Dustin Clifford), in front of a coffee shop in Wilmington, August 2002.

Wilmington before a show. It had been a whirlwind month for me. I had just come back from Memphis, Tennessee, where I'd photographed Graceland and numerous music icons. I was exhausted but extremely confident, and thrilled to be doing a shoot with Hobex.

To decide on locations for the shoot, the band and I met at a local coffee shop. As we sat talking, I realized that the lighting by the window looked great. "How about right here?" I said. "You all stand here, and let's see what happens." And we started shooting. I think I did ask the store manager about what we were doing, but we were already taking photos, and I was too headstrong at that moment to take no for an answer. I knew what that photo was going to look like. The looks on the faces of people coming in for coffee that morning was something to see.

Sure enough, that setup was the label's favorite pics, and one of the photos became their promo shot. I try now to be more respectful of public spaces and how their owners might feel about having a photo shoot suddenly take over their business. I'm not sure I'd operate the same way now that I did back then, but that wide-eyed photographer still lurks inside me.

The Mountains and the Piedmont Triad

Interstate 40 runs from the mountains of North Carolina all the way to Wilmington. Starting in Asheville, you have a number of music venues. The Orange

Peel, which has hosted everyone from local bands to Bob Dylan, has brought a number of people to Asheville. The city also has the Grey Eagle, the Thomas Wolfe Auditorium, the Emerald Lounge, Jack of the Wood, the Diana Wortham Theater, the Rocket Club, and many more. Also near Asheville is the Fletcher Feed and Seed, a converted general store in Fletcher, North Carolina. The venue offers up bluegrass and Americana music on Friday and Saturday nights, and offers gospel during their Sunday services.

Also in the mountain area, you can find the Smokey Mountain Music Center in Franklin. Also nearby is the town of Maggie Valley, which prides itself on being the international home for the dance style of clogging. Stop in at the Stompin' Grounds, and you'll see cloggers from all over the world keeping that traditional style of dance going for future generations.

Traveling down I-40 for a few minutes takes you past Black Mountain, which is home to the White Horse Tavern. Also nearby is Swannanoa College, which hosts the Swannanoa Gathering every summer. Going further, up Highway 221 brings you to Boone, which has a number of places for music. CeCe Conway and Appalachian State University are also involved with the music scene in Boone. Another venue nearby is the James Broyhill Center in Lenoir, North Carolina.

Heading toward Winston-Salem and Greensboro, there are a number of places to check out. Ziggy's is now back in Winston-Salem with a new location and building. In the downtown area, the Garage supports a number of local shows, as well as national acts. Winston-Salem has a thriving arts scene downtown and a number of bars and restaurants that support live music. The Millennium Center also houses large shows in Winston-Salem, while Greensboro Auditorium does the same. Also in Greensboro is the Carolina Theatre (separate from the one in Durham), Blind Tiger, the Greene Street Club, and others. Not too far from this stretch are a number of auditoriums and community centers that present live music. This includes venues in Newton, Maiden, Cherryville, Statesville and Lincolnton.

I should make special note of the Carolina Theatre in both Greensboro and Durham. I love old theaters. I love the architectural feel that often reflects the times during which those theaters were made. I love the acoustics in these theaters, many of which were designed before the days of electrical amplification. Like many other historic theaters, the theaters in both Greensboro and Durham were their communities' after the theaters' original owners had closed down. Theaters like these can become a linchpin of a town's history and charm, as well as supporting the local music scene.

There are six theaters in North Carolina that have been given Historic Theater status. The Carolina Theatres in Greensboro and Durham were both originally opened during the late 1920s. The Gallery Theater in Ahoskie was originally built in 1906, during the days of the nascent "nickelodeon" movie days. The Hayti Heritage Center in Durham was originally built in 1891 as part of St. Joseph's AME Church. Among

Musicians jamming outside the Downtown Cinema Theater, home of WPAQ's Merry Go Round. Mount Airy, June 2006.

the programs that the center has been involved with is the Bull Durham Blues Festival, as well as a separate concert series. The Temple Theater was built in Sanford in 1925 and hosted movies, theater and vaudeville shows. The theater now hosts eight plays a year, as well as concerts by artists such as the Red Clay Ramblers.

I've already covered many of the towns that run along Interstate 77, but I do want to mention the Cook Shack in Union Grove. The Cook Shack is an old southern restaurant that transforms itself on the weekends and for select shows on weekday nights. Their shows are always a big deal in Union Grove, and they are always packed to the back of the room. Old record albums hang from the ceiling. Moon pies and RC Cola are available at the corner. Any night you can make it to venues like the Cook Shack is a good night.

Many people in North Carolina don't know that the third-longest-running radio show in America is based in Mount Airy. The Merry Go Round began as a Saturday radio show on local station WPAQ in 1948 and over the years has hosted the greatest bluegrass, country and gospel groups to come through the region. After years at various venues, the show now runs every Saturday at the old movie theater in downtown Mount Airy. The show starts at 11 A.M., but musicians start turning up at 9, and start jamming outside the venue, as well as in the theater's lobby. And the music continues even after the live broadcast is done. It is really something to see, and I hope to get back there again soon.

The Charlotte Region

Another highway that runs the length of the state is Highway 74. This highway is known by many names throughout the state. In Charlotte, it's generally referred to as Independence Boulevard. On the way to Charlotte, you'll find the Don Gibson Theater in Shelby. The theater was originally built in 1939, and the city renovated and reopened it in 2010.

In Gastonia, Rodi's has supported live music for a number of years. Like many venues, Rodi's makes their money as a popular restaurant. However, their live shows bring many patrons out on Friday nights and give many musicians a place to play between Asheville and Charlotte. Like many towns, Gastonia also sponsors concerts downtown on summer weekends. The nearby towns of Belmont and Mount Holly have also hosted concert series during the summer.

Charlotte has a growing number of music venues, both large and small. Both the Visulite Theater and the Neighborhood Theatre began their lives as movie theaters. During the late 1990s, both were brought back to life as music venues and have helped to bolster their respective neighborhoods. Across the street from the Neighborhood Theatre sits the Evening Muse. Seating just over 100 people, owner and record pro-

ducer Joe Kuhlmann has put together a great place to see and hear music up close.

Across town, the Tremont Music Hall has brought many popular rock and punk acts to Charlotte for more than 15 years. The city now has a wide array of medium-size venues, ranging from the Chop Shop and Amos' Southend to larger venues such as the Fillmore, the Uptown Amphitheater, Coyote Joe's, and the Verizon Wireless Amphitheater.

Port Huron Statement, Chip Taylor (left) and Todd Henderson, Tremont Music Hall, Charlotte, February 2001.

Jimbo Mathus writing songs, Neighborhood Theatre, Charlotte, October 2007.

One other venue in Charlotte means a lot to me. The Double Door Inn has been in operation since 1973 and is now one of the oldest blues venues in the United States. Built as a home in 1914, the venue is what you want a venue that features blues music to be: old, intimate, with a bit of grit on the floor. I have seen some of the greatest musicians in the world come through that place. When a friend approached me in 2008 about putting together a book on the venue, I jumped at the chance. Never mind that I had never edited a book before, or that this person had never written a book. I wanted to see the Double Door, and its owner, Nick Karres, get the attention that they have deserved for a very long time. Much like the Double Door, there is probably a great music venue near you, wherever in North Carolina you live. The sooner you discover it, the sooner you'll find the great music and culture that is in your own backyard.

Christian Tamburr playing the vibraphone at a restaurant gig in Charlotte in 2005. I think Christian knew the kind of shot I was going for and hit some good poses while playing.

Several towns have made use of old movie theaters or other older spaces for music venues. In Concord, the town's old courthouse has been renovated into an art gallery and performance venue. Places like this offer the enjoyment of music mixed with the charm of older architecture that you cannot find in every venue.

One of my favorite things to photograph isn't a music venue at all. The North Carolina Music Hall of Fame is nestled in a small building in Kannapolis. Director Eddie Ray was one of the first African American record executives in the music business, and he put the museum together in 2008 as a way of celebrating the music of North Carolina. The museum may not be big as of yet, but it does have big plans.

For the museum's first few years, induction ceremonies were held in a nearby hotel. Having

missed the first year, I found my way into the 2010 ceremonies through Maurice Williams, who was being inducted into the Hall of Fame. When Williams went to the museum the day of the ceremony, I tagged along and talked my way into photographing the ceremonies.

The whole night was a remarkable assembly of talent, all from the state of North Carolina. Everyone from Williams to Doc Watson, George Hamilton IV, Don Schlitz

Doc Watson playing for small group backstage at the North Carolina Music Hall of Fame ceremony, Kannapolis, October 2010.

Curly Seckler (left) and Tommy Scott at the North Carolina Music Hall of Fame induction ceremony in Kannapolis in October 2010. Seckler and Scott did their first recordings together in 1941.

(author of "The Gambler" and numerous hit country songs), and Curly Seckler, who was a pioneering mandolin player and a mainstay in the Flatt & Scruggs band for years. After the ceremonies, I wandered backstage to find Curly Seckler. I found my way into a bare room and discovered Doc Watson sitting there, playing George Hamilton IV's guitar to an audience of two people. After listening and quietly getting a few photos, I found Seckler and took photos of him with Ramblin' Tommy Scott. Seckler and Scott made their first records together in 1941. "And we're going into the studio next week," they told me. After that, how could I not come back to these ceremonies?

Possibly the nicest sight of the 2011 ceremony was Ben Folds bringing along his eighth grade music teacher for the evening. The two talked about music and days back in school. Folds was thrilled to have him there and to acknowledge the influence that his teacher had been to him.

Another legendary honoree was Maceo Parker. I first met Parker in 2006, when he came to Charlotte for a fantastic show with fellow James Brown band alum Fred

Ben Folds discusses music with his middle school music teacher, John "Chick" Shelton, at the North Carolina Music Hall of Fame induction ceremony in Kannapolis in 2011. Folds was inducted into the Hall of Fame and brought along the teacher who inspired him.

Wesley. Parker changed the way saxophone players approached a solo, all the while keeping to Brown's edict to "make it funky." And here was Parker again, posing for photos with his sons.

Where else are you going to see Maceo Parker, Ben Folds, John D. Loudermilk and Billy Edd Wheeler (two of the greatest songwriters that this state has ever produced) and others, all laughing and cutting up around a giant cake that's emblazoned with their faces? I love the unknown quality of the event from year to year and wondering what kind of photos I'll get. And it's fun for me. Money is always nice, but gigs like this are supposed to be fun. And they still are.

One of the museum's best-known honorees, James Taylor, came from a very strong musical family. All five of his brothers and sisters have played music at one point or another, but it is James, who started playing in bands in Chapel Hill in the early 1960s, that continues to attract the most attention.

One night, I had just gotten back into Charlotte, and I decided to go see a show at the Neighborhood Theatre. James Taylor was playing a show in town at the Verizon

(Left to right) Anthony Dean Griffey, Billy Edd Wheeler, John D. Loudermilk, Maceo Parker, Billy "Crash" Craddock, North Carolina Music Hall of Fame ceremony, Kannapolis, September 2011.

Amphitheater the following day, and his band decided to put on a show of their own. I figured that James was out of town or busy with other things that night. As I walked in, the doorman said, "Watch it down front, James Taylor is sitting down there." Yeah, right, I thought. This wasn't the first boast I had heard from the doorman, so I just started shooting down front. At some point, I looked to my left, and there was James Taylor, sitting on the front row and enjoying his own band. It wasn't a boast! It would have been bad form to take photos of him during the show, so I didn't, but James hung around after the show to sign autographs. I thankfully had an unused roll of black-and-white film in my bag and used that to get a few candids of James.

James Taylor talks to fans. Neighborhood Theatre, Charlotte, May 2001.

When I phoned the *Observer* the next day to tell them what I had gotten, their response was, "How soon can you get the film up here?" They wanted to run a photo immediately. I got the film processed that afternoon. After turning in the film to be processed, I realized that I had forgotten to have them push the film speed. This meant that the processor would leave the film in longer, so that a 400 speed roll would have

Livingston Taylor, lost in thought during a conversation. Evening Muse, Charlotte, March 2002.

more light, as if it had been a 800 to 1,600 speed roll. I nervously got the roll back and discovered that the lighting was perfect. I had accidentally set my flash for more light than I had meant, instead of turning it down for higher speeds. If I had processed it at a higher speed, it would have cooked the negatives. I turned my negatives in and smiled as I walked away. You have to work hard sometimes to make yourself lucky in this business, but sometimes you're also just plain lucky.

As for James' brother, Livingston Taylor, I photographed him in somewhat different circumstances. After a show at the Evening Muse in the summer of 2003, Livingston hosted a workshop at the Muse the following day. For some musicians, this is an additional way to supplement their income and provide fans with a one-on-one opportunity with the musicians. The Muse has a huge window at the front of the venue that let in a lot of natural light, allowing me to work without a flash and be less obtrusive. Livingston was busy teaching his class and didn't seem bothered at all by my camera. My favorite photo was a close-up of Livingston as he listened and then answered someone's question. These are sometimes my favorite moments as a photographer. Don't worry about me. I'll follow what you're doing and create from there.

Looking around the room, I also tend to find little things that make for great visuals — scraps of paper with songs written on them, guitar cases stacked together. I first met Dwight Moody in 2002 as he and the Briarhoppers were honored with the North Carolina Heritage Award. Over the years, I learned more about Dwight's story, how he formed his first band in 1945 and began to build a reputation as a great fiddler; how he formed his own record label, Lamon Records, in 1961, which is still going strong today; how he toured the world with the George Hamilton IV and with his kids, the Moody Brothers, and has enough stories to fill a few books.

One day, while backstage at a Briarhoppers show, I walked past his open violin case. I stopped to look at it. There inside that case were pieces of Dwight's entire life, and his life on the road. You don't plan on a violin case or a guitar case like that. It's forged over a lifetime of music, traveling and playing as you go.

For musicians, the road is a different place. Many musicians must stay on the road to make a living, playing a constantly varying schedule of concerts. Many of them have traveled all of their lives and become quite used to it. Others, after a number of years, try to travel as little as possible. The love of performing itself stays with many musicians, but it's the getting there, and the next gig, and the next gig, that sometimes leads them down different paths.

A lot of artists often get new promotional photos done while on the road. "I've got a show in Charlotte on the 24th. Can you come out before the show?" Or they may call when they're coming to North Carolina or the Southeast. Some will also call or e-mail when they are actually in the town the day of the show. When a musician friend calls or e-mails and starts with, "I meant to contact you about this sooner," I

Dwight Moody's fiddle case, Hickory United Methodist Church, Charlotte, September 2010.

know what's coming. I can't always drop my plans immediately, but if there's any way I can do the photo shoot, I will. I hate saying no to people, and I'm always excited by the possibility of new photos and what results can come out of it.

There are many different ways for musicians to travel, and in many configurations. Travel is often the best way to find what your bandmates are really like, for better or worse. I've always had an appreciation for playing in a band or traveling with someone in your family. Imagine doing a long drive with your family. Now imagine getting to your destination, playing a full show, and then going somewhere to do it again, and again, night after night.

One of my favorite father-son combinations is David Childers and his son Robert. David is an amazing songwriter, entertainer, and all-around raconteur. From an early age, his son Robert took an interest in music. When David put together a band, he knew who his drummer would be. I've seen David play with just his son on stage with him and command an audience. Music and family can both run very deep.

Another time, I photographed the debut album for a group called the Sammies. The Sammies are based in Charlotte, but the band members were all originally from Wadesboro. The band suggested that we do photos out at their grandfather's farm.

This wasn't just any farm. The main house on the property was used in the movie *The Color Purple*, while a portion of the woods behind the house was used in the legendary horror film *Evil Dead II*. Everywhere you turned, it looked like a great visual.

We set the band up in the middle of the field, with guitars and amplifiers in tow, and set them up to play as the sun set behind them. My goal was simple. I wanted the cover to look like one of those album covers you picked up as a kid and thought, "Wow, what a cool cover. That band looks cool. I'll buy this." The smaller CD artwork sometimes diminishes the power that the cover shot can have, while vinyl's larger covers worked great for album artwork. To this day, if one of the CDs that I've photographed comes out on vinyl, I always buy a copy of it. The kids that used to buy cool album covers sometimes grow up to be photographers, as well as musicians.

If the musician does not want to do photos around the venue that they're playing at, quick thinking can be a big help. When I was thinking about photos for my friend Mike Orlando, who at the time was branching out after playing with local favorites Cast Iron Filter, I was stuck for a different location. Finally, almost in desperation, I finally said, "Why don't you come over to my house?" We did a good number of photos in my living room, using the white walls as a backdrop. Mike felt comfortable there, and the photos looked good. That being said, I didn't want the world to know

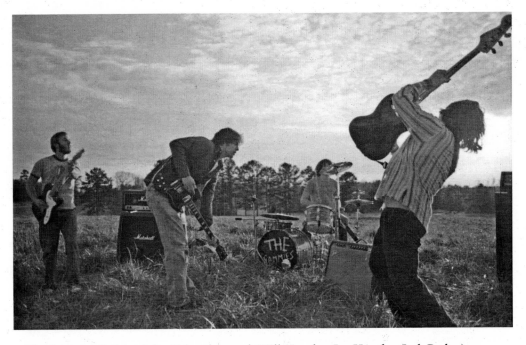

The Sammies (left to right: Tyler Sheppard, Will Huntley, Joe Huntley, Josh Parker) performing on the farmland of the grandfather of two of the bandmembers, Wadesboro, January 2006.

that the photos were done at my house. But I knew what I could do there and what spaces would be good for the photos we had talked about.

Sometimes, musicians want "posed shots," but they don't want to pose for them. One of my first-ever photo shoots was with a great Charlotte band named Lou Ford. They needed photos, but they didn't want to stand in front of the camera and smile. After some discussion, someone mentioned that they were hungry, and talk turned to the Waffle House nearby. The idea then emerged. What about the Waffle House? The band sat at one table, while I sat at another. No flash photography, just as candid as possible. The best photo we got was as the waitress brought them their food, and the viewer could see the entire goings-on of the Waffle House surrounding the band.

Doing photos at venues before, or sometimes after, the show can be tricky. Every venue is different, and so is the decor. Older venues can be more fun, especially if they've kept some of their original features. When I did photos with the Carolina Chocolate Drops at the Neighborhood Theatre in late 2010, I wandered around the lobby and found their original curtains. Gathering the band there for a few minutes while they rehearsed and discussed songs, I jumped on a chair while taking photos. This helped to give me a different perspective on the photos and also helped me to crop the "Restrooms" sign that was just over their heads.

I have photographed Dom Flemons of the Drops several times over the years, both with the band and playing as a solo act. "Our group travels in a 15-passenger van, with a trailer on the back when we are driving," says Flemons. "We either do that or fly and then rent a van. I like both. Vans are easier to carry stuff around in, but a plane will get you there faster.

Mike Orlando looks over his mandolin while standing in my living room in Charlotte in 2004. Orlando was on his way to a show and stopped by to have some promotional photos taken.

"Traveling solo can be so much easier. You just have to deal with yourself. I prefer traveling solo just so I don't have to deal with anyone else. The upside to traveling in a band is that you have others to get your back, and also you get a sense of community through traveling with others. When you're alone, the one downside is that you are in control of everything, and if something goes wrong,

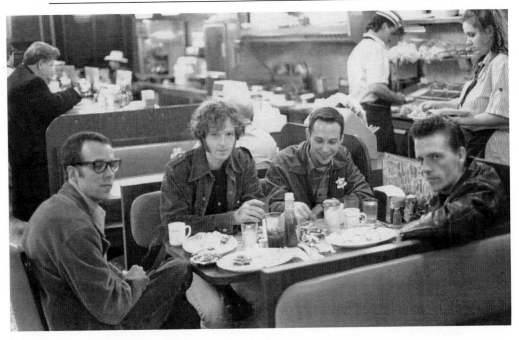

Lou Ford (left to right: Alan Edwards, Shawn Lynch, Chad Edwards, Mark Lynch) at a Waffle House, Charlotte, January 1997.

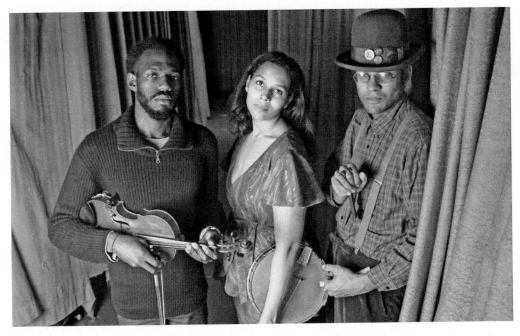

Carolina Chocolate Drops (left to right: Justin Robinson, Rhiannon Giddens Laffan and Dom Flemons), Neighborhood Theatre, Charlotte, December 2010.

then you are responsible for it. Car breaks down, that's all you, buddy. In a group setting, you have others to help."

Dom and the Drops have toured the world many times over and know the routine very well. "Get up, have breakfast (sometimes), go to soundcheck. If you're coming from another city usually drive to the next city and then soundcheck or check into a hotel based on the timeline. After soundcheck, hang around till the performance. Here is where the main fluxuation can happen. This area is set aside for dinner. You can also do interviews for radio, TV, or journalistic. This is also an area to meet up with friends that are local or ones who have traveled to see you It can also be a time to practice (solo or group) or work material if you either have a new piece or a guest that might join you on stage. Also, at some point the set list gets written out. Finally, do the show. After the show, talk to the audience, sign autographs if necessary (sometimes folks don't wait for you to come out and just leave after buying) before packing up the stage. After packing the stage, pack the van. For us, we can pack instruments first and then merchandise second after the tour manager settles up. After that, it's off to the hotel before doing it all over again.

"The main advantage to playing in the home state is that you have the hometown crowd on your side. Unlike when you remain local, the hometown folks will come out to support when their 'prodigal' children come home. They also know the nuances of the music best so that it can be a great experience on both sides of the stage. For our group, playing the South in general its nice to play a breakdown and see people cuttin' the backstep to it. You just don't find it everywhere. That's something I love about it."

"Honestly, I'd prefer not to travel at all," counters Si Kahn. "I have a wonderful long-term marriage and a great home life. I'd rather be with my spouse than anywhere else. Plus for the past almost 50 years I've had a full-time day job as a civil rights, union and community organizer. So I actually perform and travel relatively little, maybe on average a dozen concerts and three or four festivals in a year.

When asked what a normal day on the road is like for him, Kahn says, "'Normal' isn't exactly the word I'd use here. Generally, if the show is away, the schedule is

Early wakeup, often very early
Travel to airport/search for something
　edible for breakfast
Fly to airport nearest to concert
Pick up rental car
Drive to venue
Check into hotel
Drive to radio stations for interviews
Eat lunch

Drive to more radio stations for
　interviews
Nap
Tune guitar
Practice
Make up set list
Drive to venue
Check sound
Set up sales table

Eat dinner backstage
Talk with friends and fans
Do the concert
Talk with more friends and fans
Sell and sign CDs and books
Pack everything up

Go over finances with concert
 promoter
Get paid
Drive to hotel
Pack for early-morning departure
Sleep

"If I'm playing within 100 miles of Charlotte, I can do the concert and still get home I time to sleep in your own bed. That's not called 'having an advantage.' It's called 'having a life.'"

With many musicians, the routine of traveling and performing is very familiar, with slight differences and points of view. "There is no normal," suggests the duo of Mandolin Orange. "It just depends on where we are. Generally, we search for good coffee, good food, and a music store." As for their pre-show routine, "We make a set list, play whatever we feel like, if we have that kind of privacy. A lot more people know about us in North Carolina, so that makes for energizing shows. When you get farther out on the road, you never know what you're going to get."

When asked about playing and touring, Sara Bell speaks of "waking up in a

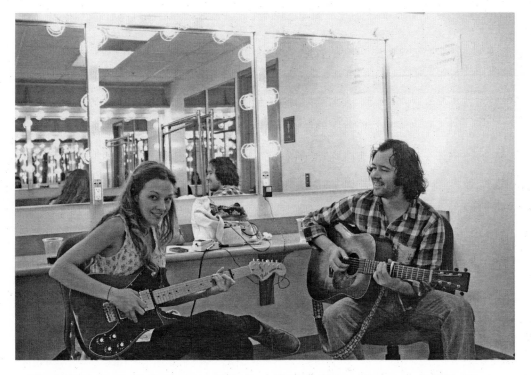

Mandolin Orange, Emily Frantz and Andrew Marlin, Halton Theater at CPCC, Charlotte, October 2011.

strange place, waiting around for everyone else to wake up. Trying to figure out where to eat, eating, driving and driving and driving, doing crossword puzzles, trying to figure out where to eat, eating, driving and driving, stopping for gas and eating some gas station snacks, listening to music, driving, taking an exit ramp and suddenly being in a city, finding the club, loading your equipment, hanging around trying to figure out where to eat, eating, taking a really long walk around the neighborhood, hopefully finding some great shopping nearby, playing a show, watching and meeting a bunch of other bands, making friends with bartenders, loading your van, trying to figure out where you are staying, finding some more food, hanging around listening to music with your friends, and going to sleep in a strange place.

"I have to take a really long walk before playing, and if there isn't any time it can be a big bummer. This is really helpful for the ADD moments, and you can learn a lot about where you are. I have also discovered that I don't get so nervous if I was able to do some kind of strenuous exercise, like swimming or running or walking, before a show."

"I'll warm up, make or tweak a set list," suggests Joe Newberry. "I don't usually write backstage, although if I have a good idea for a song, I'll for sure put it in my little notebook that I always carry. Actually, come to think of it, I have written a couple of good songs [while] waiting to do a show."

"It is usually busy," says Tift Merritt about her moments before a show, "but I like to handwrite a set list and have some quiet if I can. No writing, no phone calls, just allowing a space for performing down deep to open up. Our band likes to be together, and we have that nice thing where we can be really laid back one minute and pretty intense the next. It is nice to have that on hand for performing.

"Hands down, North Carolina is the best place to play. That kind of love in the room, between band and audience, for so many years, had kept us going. It's our home."

Another exception I made to the "no photos after show" idea was when I photographed the reunion of a band called Hummingbird. In the early 1970s, this band was just amazing, playing largely entirely improvised sets—no set lists, no charts, just four guys thinking and feeding off of each other. In the intervening years, all of the musicians had gone on to great things. Guitarist Zan McLeod teamed up with another North Carolina musician, Mike Cross, and had toured the world. Later, he became one of the foremost Celtic musicians in the world, playing on the *Titanic* movie soundtrack and numerous other records. The drummer, Rob Thorne, helped to found the Spongetones in 1978, and that group is still going.

When they got together in late 2011 for a reunion at Rob Thorne's house, it wasn't for money or fame. It was to again feel that spark of inspiration, and to again enjoy that connection between that group of friends. After they played together for the first time since 1974, I asked to get a photo of them together, and they immediately

Mike Cross on stage at the McGlohon Theater, Charlotte, March 2012.

Hummingbird band reunion (left to right: Zan McLeod, Michael Floyd, Munk Fellows and Rob Thorne), Charlotte, December 2011.

fell into a group hug, laughing and looking at each other like the group of friends they had always been.

All musicians deal with downtime a little differently. Many call home, check their e-mail, their phone messages. When I started taking photos in 1996, a musician might ask the club, "Do you have a pay phone?" Now, many musicians ask if the venue has Wi-Fi. This downtime also gives the musicians time to come up with a set list for the show, write new material and just take their minds off of the upcoming show.

Legendary North Carolina blues musician John Dee Holeman posing behind the Gaston County Museum in Gastonia in 2009. Holeman had just arrived to perform at the Museum's "Blues Out Back" summer concert series.

I don't expect the musicians to make a big fuss about me when I visit them backstage. I really want anything but. The best photos are often the ones where the subjects don't worry about you, and you don't bother them. These are often my favorite photos, where you see something in the musician, and that person themselves, that you wouldn't see onstage. Many of the best bands I've ever worked with (including the Avett Brothers and Chatham County Line) never gave any direction to me backstage, and I never directed them. I let them be themselves, because that was the photo I wanted to get.

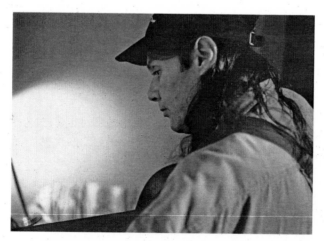

Malcolm Holcombe tunes his guitar backstage at the Neighborhood Theatre in Charlotte in 2003. Malcolm didn't like posing for photographs, so I took this picture while peering over his shoulder.

Because of the limitations backstage, before or after the show, I'm often the most proud of these sets of photos. Getting the great bluesman John Dee Holeman to look at me for just four frames, as the sun set on a brick wall behind him. Peering over Malcolm Holcombe's

shoulder, as he tuned his guitar. Peering through an open door, and finding Mark Lynch styling his newly cut pompadour.

"There is no normal day on the road," responds Chandler Holt, banjo player with Chatham County Line, when asked about what normally happens while traveling. "Wake up. Eat. Drive. Sound check. Eat. Play. Party. Eat. Sleep. Repeat. There's not an agenda. It all depends on where you are that day. Sometimes it's catching a nap, sometimes it's having a beer with some friends who have come out to see you."

Mark Lynch fixing his hair backstage after having his long locks cut off on stage to benefit Locks of Love and preparing to play bass with David Childers. **Neighborhood Theatre, Charlotte, September 2004.**

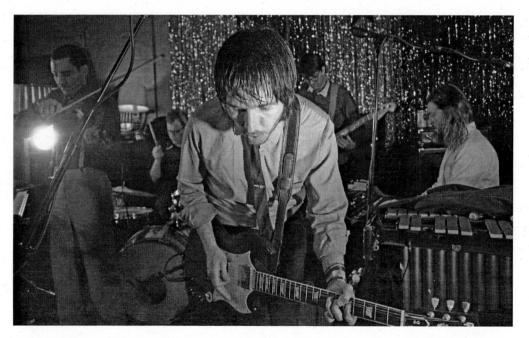

Django Haskins of the Old Ceremony puts his face in my camera. In the background, left to right, are Gabriel Pelli, Daniel Hall, Matt Brandau, and Mark Simonsen. Snug Harbor, Charlotte, June 2011.

"Typically, tuning all the instruments, fixing hair, shining shoes, writing the set list," adds Justin Robinson. "Phone calls are not a good idea right before a show. They can totally throw you off."

"I usually write set lists immediately before the show," says Django Haskins, "because I like to feel what the vibe is like in the club, with the crowd, before shaping the show."

"I rarely hang out backstage," adds Si Kahn. "Usually I'm out in the audience or in the lobby, visiting with old friends, thanking people for coming to the concert, answering questions, taking requests to do songs. People come to a concert for the artist as well as for the music, and I try to meet that responsibility."

Some of my favorite photos of musicians on the road don't involve shows at all. Even when they're not traveling from show to show, a musician can travel a lot, to see friends, visit family, or work on songs with other musicians. I love shooting weddings of musicians. It's a chance to see a group of friends dress up, something that not all musicians do on a regular basis. I couldn't have gotten Benji Hughes to clean up for a photo in a million years, but the photo of him at my friend Randolph Lewis' wedding is just priceless to me. One advantage to being a photographer is that when

Benji Hughes looks on during the wedding of fellow musician Randolph Lewis in Cornelius in 2001. Hughes has a following across the country for his sometimes quirky love songs. He's also known as someone who usually doesn't dress up, so the shot of him backlit in a field in a tuxedo was too good to pass up.

my friends get married, their first question to me is usually, "Can you bring your camera?" And I'm always happy to do so.

What are some of my favorite places to travel to? It varies, for me. When I was starting to take photos, it was exciting to work in big venues. Whether it was traveling to the North Carolina mountains to photograph Earl Scruggs playing at a large rodeo, or working at various large theaters in Raleigh, Durham or elsewhere, there was always an excitement of a "big show"—big stage, lots of people. However, over time, I came to appreciate the smaller venues a lot more. There's a more intimate feel, and often less rules for photographers like myself. Sometimes it depends on the venue and the musicians playing it.

Music Everywhere You Go

There are so many great venues to mention, all across the state: the Orange Peel in Asheville, which hosts both national and local acts; the Fletcher Feed and Seed, in Fletcher, North Carolina, a former merchant store that also doubles as a church on Sundays; and the Carolina Theatre, in both Greensboro and Durham — both theaters have been brought back to the splendor that they displayed when they were opened in the early 1920s. In Charlotte, John Tosco began by holding house concerts in his house. Now his Tosco Music Party sells out large venues across the city, and his annual Beatles tribute night puts local musicians in front of thousands of people. He's also good at getting people involved. Heck, he even got *me* to sing at the first couple of Beatles tribute shows.

When I asked Mandolin Orange about their favorite places to play, they cited "Cat's Cradle, Evening Muse, a quirky little listening room called R.A. Fountain outside of Greenville, and a little outdoor pub on the Ocracoke Marina called Jolly Roger." As for their favorite

Jim Lauderdale backstage at the Neighborhood Theatre in Charlotte in 2003. Lauderdale wasn't in the mood for photographs, so I started saying goofy things to get him to crack up. For one shot, it worked.

Ruth Kee Wherry of the Flat Possum Hoppers, playing stand-up bass, Great Aunt Stella Center, Charlotte, September 2011.

shows, "It's hard to top CD release shows and hometown shows. So I'd say our Cat's Cradle CD release show and a holiday show we did there a couple of months back with a lineup full of our friends.

"[Playing live is] one of our favorite parts of this lifestyle. It gives you energy and a feeling of purpose. When you're writing, arranging, recording it's easy to get lost in what you're doing, but then making it a shared experience with others makes it real."

"Cat's Cradle is always great," says Django Haskins. "The Orange Peel in Asheville is similarly classy and open feeling. Motorco in Durham has a great vibe, and since that's my hometown now, I love playing there. Performing live gives us the energy to do all the other things we do as musicians. It's the fuel."

Justin Robinson lists among his favorite venues "the Visulite Theater, Triad Stage, North Carolina Museum of Art." As for what musicians need to do onstage, Robinson says, "Make them feel important, make them glad that they came to your show instead of staying at home watching *Downton Abbey*."

Katherine Whalen mentions "Motorco in Durham and the Kraken in Chapel Hill" among her favorite venues. Laura Boosinger lists "anywhere with the Lightning Bolts" as her favorite place to play but also mentions "Todd, North Carolina, in a park—beautiful and a nice audience. The Mountain Dance and Folk Festival in Thomas Wolfe Auditorium. *Love* those *big* crowds!"

Joe Newberry knows the venues of North Carolina very well. "Rooster's Wife in Aberdeen; Meymandi Concert Hall and Marsh Woodwinds Upstairs, both in Raleigh; Festival for the Eno in Durham; Triad Stage in Greensboro; White Horse Black Mountain in Black Mountain; Mountain Home Music series in Blowing Rock; Charlotte Folk Society's series at the Great Aunt Stella Center," he lists among his favorites. As for his all-time favorite shows, he says, "The Gathering with Laurelyn Dossett, Rhiannon Giddens, Mike Compton, and Jason Sypher. Homemade holiday music and great players. We played a wonderful show last December at Triad Stage that stands out in my mind. There is a great music series at the North Carolina Museum of History that is sponsored by PineCone, the Piedmont Council of Traditional Music. I love playing for the Charlotte Folk Society folks. Janet Kenworthy is the Rooster's Wife, and she is tops."

While I love working with musicians that have a lifetime of experience, I have been very lucky to work with some great musicians on the way up. At the same time I met the Avett Brothers, I also met Nicole Atkins. At the time, Nicole was a singer from New Jersey who had moved to Charlotte, having just graduated from UNC–Charlotte. Nicole was also hanging out with the Memphis Quick 50, which at the time included the Avett's future bass player, Bob Crawford. She would ask about music that I liked, wanting to find new music and new ideas. One day, she asked me about taking some photos of her. "I've never done a photo shoot before," she said.

Nicole Atkins posing at her first-ever photo shoot at the Diamond Restaurant in Charlotte in 2001. The Diamond opened in 1945 and had been virtually unchanged when this photograph was taken.

"It doesn't have to feel like one," I replied. Instead of backdrops, I had her meet me at a local diner. She sat across from me, and we talked about music and life. Here and there, I took some photos. We got some really good ones that day, and I went to photograph Nicole's first few releases. Nicole has since gone on to national acclaim, and I'm proud that I helped Nicole along the path to where she is now.

When people ask about artists like Nicole or the Avett's, they sometimes say, "They're all working with other people now. Doesn't that bother you?" One of the ghost stories of photographing musicians is that once you discover that band or artist that will make it big, they will take you with them into the stratosphere of success. When any person starts to gain notoriety, they come into contact with other people — managers, record producers, fellow musicians, other photographers. Their interests change, just as their home base sometimes changes. Do you hang out with the same people you did in high school? Probably not. The circles changed. People change.

Has it bothered me occasionally that I got left behind when an artist got big? Sure. I am human, after all. I'm susceptible to all the emotions that come with the oddities of that situation. But that feeling does subside. I would rather see my friends

succeed than not succeed, regardless of my current relationship with them. There are some people I've photographed (some of whom are in this book) that I may never see or talk to again, but I hope they are doing well. I may not have answered that question the same way in the past, but much like the musicians featured here, life and music are often an emotional journey, as well as a physical one.

On Stage

It's a Friday night in Charlotte. It's just past Christmas, and the temperature outside is just below freezing. On this night, the Comet Grill is full of patrons, all of whom shuffle out of the cold and immediately walk past the musician they came to see. Lenny Federal has been playing throughout Charlotte, and North Carolina, for close to 40 years. His various outfits over the years — Federal Bureau of Rock and

Crowds gather for the Lenny Federal Band at the Comet Grill, Charlotte, December 2011.

Roll, Wire Mules, Federal Brothers, among others — are known to nearly everyone in tonight's audience.

The stage in the Comet Grill sits next to the front door. People stop to say hello to Lenny and his band as they walk in. Some then go to the bar, and others try to find a seat or anyplace to stand and watch the show. They are all here for the music, the fun, and Lenny. By 11 P.M., the two floors of the venue are packed. It's going to be a good night.

On stage is where the connection between the performer and the listener often begins. A great recording can grab your attention and put you in the world that the song inhabits. However, on stage is where the listener sees the performer and experiences the songs in the same space as the person who's singing them. We often remember when we first heard our favorite albums, but we also never forget when and where we saw that musician in person.

As a photographer, this is also where everything usually begins, photographing musicians on stage as they performed. Like many others, I started in this business by photographing live shows: Rock-and-roll bands in local bars, acoustic performers in small venues, and music of all kinds in theaters and arenas. Every experience early on was a little different for me and only made me want to photograph more.

I also discovered in those early days that photographing one artist or group would often lead me to photographing several others. I soon heard the names of the trailblazers of North Carolina's musical heritage — Doc Watson, Earl Scruggs, the Briarhoppers, the Red Clay Ramblers. But learning more about the Ramblers would lead me to Mike Cross, Sammy Walker, Etta Baker, and many others. I was also lucky enough to start documenting music during one of the best times in North Carolina's musical history.

North Carolina Music Scene in the 1990s

The 1980s had seen a good number of artists emerge in North Carolina. Corrison of Conformity emerged from Raleigh in 1982 and continues to influence the hard rock scene to this day. Also emerging from the Triangle area were Southern Culture on the Skids, Snatches of Pink, the Pressure Boys, the Flat Duo Jets, and the Connells. Mitch Easter, while also producing bands such as R.E.M. and Game Theory, released three albums with his band, Let's Active. Fetchin' Bones, from Charlotte, released three albums on Capitol Records. Also from the Charlotte area, Antiseen gathered interest in Europe for their mix of punk and rock, all from the perspective of southerners who had grown up on wrestling and horror films.

By the early 1990s, there was a sea change in music that was happening everywhere. A louder, more aggressive sound was spreading. In the Triangle area of North

Carolina, there was suddenly a multitude of bands that were getting interest from across the country. Superchunk, Polvo, Archers of Loaf, Dillon Fence, Zen Frisbee, the Veldt, Metal Flake Mother, Pipe, and the Sex Police all gathered acclaim from beyond North Carolina's borders.

One of the biggest bands of that early 1990s Chapel Hill scene was the Archers of Loaf, who had a noisy but rhythmic sound. By 1998, the band was exhausted from touring and decided to hold two final shows in Chapel Hill. I drove up for the last night. When I arrived, the manager said, "Great! You're here. Our photographer can't make it tonight." For my photos, and just showing up, I was given a T-shirt. Yes, I still have that T-shirt.

There was also a new wave of record labels to release this music. Merge Records, Mammoth Records, and later Yep Roc Records stepped up to release the music that seemed to be coming out of every corner of the state.

By the mid 1990s, the first wave of alternative rock had waned. Tired of the trappings of that scene, many musicians reacted by inspiring a second wave, all very

Archers of Loaf (left to right: Eric Johnson, Eric Bachmann, Mark Price, Matt Gentling) performing at the Cat's Cradle, Carrboro, 1998. This was the last show until their 2011 reunion.

different from the music of a few years before. Ben Folds Five emerged from Chapel Hill with a piano-based pop sound. Other bands came out of the ashes of other groups. Jimbo Mathus, once a member of Metal Flake Mother, helped to found the Squirrel Nut Zippers. The Zippers took their cues from the hot jazz, blues and swing of the 1920s and 1930s. At the same time, Dillon Fence leader Greg Humphreys changed his focus from pop to soul music for his new outfit, Hobex.

In Raleigh, the move away from grunge manifested itself in a new appreciation for the merging of country and rock. Whiskeytown, the Backsliders, Six String Drag, and others all emerged in a very short time. This was also echoed in Chapel Hill, where John Howie founded the long-running Two Dollar Pistols, a band that I had the good fortune to work with on a couple of albums.

Oh, the stories I could tell you about Whiskeytown, which was led by Ryan Adams and Caitlin Cary. Some musicians can be on point every time you see them, and others can sometimes wobble on the tracks. Whiskeytown was sometimes in the latter, but

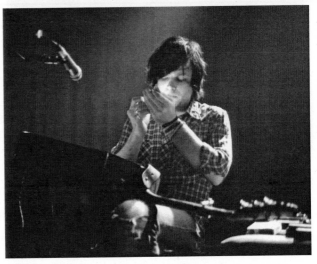

Top: John Howie of the Two Dollar Pistols. Cat's Cradle, Carrboro, December 1999. *Bottom*: Ryan Adams has a smoke break between songs. The Brewery, Raleigh, September 2000.

that was part of the thrill of their shows. Every show was different and open to the elements.

After Whiskeytown broke up, Ryan began playing solo shows around the region. His solo career had not taken off yet, although he still drew crowds around the state. My photos of those shows are among my favorites of Ryan. No pretense, just me in the crowd, taking photos and enjoying the music. Ryan is a big star now, and he deserves to be. I don't know if I'll get the chance again to photograph him the way I used to. But I am okay with that. I did a good job, and my photos got to be part of Ryan's visual story. I don't know if Ryan still has my photos in a special shoebox, as he once told me he did, but I'd like to think that he still might.

Many of these bands were quickly signed by major record labels. Ben Folds Five, Squirrel Nut Zippers and Southern Culture on the Skids all had hit singles between 1996 and 1998. Suddenly, the bands that were living in the same state, or the same city, as you were on the radio and on TV. It was a remarkable window that opened for many bands in North Carolina, if only for a short time. The Triangle area also enjoyed a healthy hip-hop scene during this period, with Lords of the Underground and Little Brother both encouraging a stable of MCs, and record producers.

In Charlotte, a remarkable scene popped up as well. Lou Ford, a band that fused more sensibility with its country-rock songs, produced two amazing records. From nearby Faith, North Carolina, Mercury Dime were one of the first bands I ever photographed, and their second album, *Darkling*, is an amazing album that has recently started to find a new audience in Europe, 15 years after its release.

When I started taking photos of musicians in 1996, I was lucky to find a diverse collection of musicians who were willing to be good subjects. Lou Ford, Mercury Dime, punk rock veterans Kudzu Ganja, experimental rockers It Could Be Nothing, Major Nelson, and others. These bands were also my friends. I learned to have them trust me and know that I could get a good photo of them.

Several acts in Charlotte were also snapped up by national record labels. Spite, Animal Bag, and Buzzov-en were among those that emerged during that time. Jolene, led by John Crooke, signed with A&M and toured internationally for years. Sugarsmack, led by former Fetchin' Bones members Hope Nicholls and Aaron Pitkin, released one album nationally, as did Muscadine. The two key members of Muscadine, Jonathan Wilson and Benji Hughes, have each gone on to success on their own. Rock and roll wasn't the only genre that labels were picking up from Charlotte. Jodeci, featuring singers K-Ci and JoJo, spent several years on MCA Records.

One of my favorite bands during this time, the Blue Rags, emerged from Asheville. The Blue Rags were like the Band, a traveling medicine show and a rhythm-and-blues combo all wrapped into one. They mixed original songs with rollicking takes on traditional blues and bluegrass songs.

The Blue Rags proved to be an influential group for many, and this included

Fetchin' Bones reunion concert, Aaron Pitkin and Hope Nicholls, Amos' Southend, Charlotte, May 2007.

the Avett Brothers. At one point in the late 1990s, the Blue Rags made a T-shirt that featured my photos of them. Some years later, I went to see the Avetts play at a record store. I decided to wear my Blue Rags shirt, as I hadn't worn it in a while. Before the show, Scott Avett and I were talking when Scott suddenly stopped in mid-conversation and said, "Where did you get *that* T-shirt?" "The band made it," I said, "and these are my photos." Scott made Seth Avett walk over to see the T-shirt as well. Score one for the photographer.

In Winston-Salem, there were the Pinetops, led by Jeffrey Dean Foster. Foster had led the Carneys during the early part of the decade, after leading another group that should have been bigger, the Right Profile. Foster is one of the best pure songwriters I have ever met, and he still writes great songs to this day. I saw the Pinetops play at Ziggy's and other Winston-Salem venues many times, along with another excellent group of that period, the Johnsons.

Much like the times that the music was created in, many of these bands came and went too quickly. In the intervening years, many of these groups found new audiences. Many of these new fans never saw the artists perform live. They found the

The Blue Rags (left to right: Jake Hollifield, Scott Sharpe, Woody Wood, Mike Rhodes and Bill Reynolds) have fun with me during a show. Verizon Amphitheater, Charlotte, June 2006.

records online or found old video clips of the band on YouTube. Recently, several of the groups I mentioned have reunited for new albums and new shows. I wholeheartedly welcome it. Whether I saw the band once or several times, I'm always ready for one more show, and another round of photos.

Southern Culture on the Skids

Whether you revel in their splendor or just walk away in a confused daze, Chapel Hill's Southern Culture on the Skids has always stood out from the crowd, a mixture of rockabilly and other early country and surf rock influences mixed with a sloppy embrace of southern kitsch and culture. Are they celebrating retro white trash culture? Are they making fun of it? Yes, and yes. The keyword is *fun*.

What really makes a Southern Culture show unique is the interaction with the fans. When the band plays the song "Eight Piece Box," pieces of Bojangles chicken go flying. There are limbo lines and onstage singalongs with the audience. In a tribute

song to 1950s Mexican wrestler and B-movie star El Santo, an audience member dons the El Santo mask onstage and leads the band through the song.

Formed in Chapel Hill in 1983, the core of the band has remained unchanged since its early days. Guitarist and singer Rick Miller leads the way, while bassist and singer Mary Huff and drummer Dave Hartman are as recognizable to their fans as Miller. They have toured all over the world, but the band is a purely North Carolina creation. A Southern Culture on the Skids show is an event that has to be seen and heard to be understood, and is still capable of providing surprises.

I conducted the following interview with Rick Miller in 1998 as the band was preparing to release the follow-up album to *Dirt Track Date* entitled *Plastic Seat Sweat*. The years may have gone by, but the music and ideals are still the same for the band. Go to their show, let loose and have fun. Long live El Santo, eight piece box, and limbo. Long live fun, and long live Southern Culture on the Skids.

COSTON: *Touring has always been a big thing with you and the band.*

MILLER: I think that's the way to get fans. If you don't have a big name or a big hit or a top-40 album, there's really no other way for people to enjoy your music and really get to know you. I prefer it that way because records can be so misleading.

Rick Miller, of Southern Culture on the Skids, prepares to play. Visulite Theater, Charlotte, December 1999.

Some bands sound one way on the record, and then you see them live, and they sound nothing like that. But that's okay, as long as it's a good live show.

You guys also do so much during a live show, with the chicken and the limbo lines. Where did all that start?

Basically, just out of desperation. Just trying to make sure that everybody was having a good time. Involving the audience is also a great way of making sure that everybody is having a good time, because hopefully the show is entertaining to you too. The band is entertaining, but the minute that the audience starts to get involved, it just takes everybody up another notch. We play the same songs night in, night out while we're on tour trying to promote a record, and it can get a little bit old. Whenever you bring in another element like that, it throws another spin on everything, and I enjoy that. It keeps me on my toes.

Were you surprised by the success of "Camel Walk"?

That was the last song that any of us thought was going to get on the radio. It's an old song. We've been doing it for a while. I'd say that for the last ten weeks that we toured when "Camel Walk" was on the radio, 80 percent of the crowd that came to see us had only heard that song. But I think we won them over. The people who buy *Dirt Track Date* say, "I heard that 'Camel Walk' song, and I bought the record, but I really like 'Voodoo Cadillac,'" and they like a whole lot of other songs.

Is it a challenge to come up with new things that'll bring some of those people back? Obviously you don't want to write "Camel Walk II."

No, we don't. [laughs] Once you have success with something, it's hard to get it out of your craw. But you don't want to keep repeating stuff, so I think that it's important that you set up new things. We're always thinking, "What's the next 'Camel Walk'"? But I don't know if I want another "Camel Walk."

What were some of your early inspirations when the band first started?

We started out doing this punk rockabilly stuff, and then we started trying straight country with a rockin' beat, and nobody wanted to come see it. Our shows dropped off like crazy. Our original bass player and drummer quit, and that's when I got Mary Huff and Dave [Hartman], and we just decided to woodshed for a while and go back somewhere between the two, and came up with this sort of swampy rock and roll.

I've noticed that there's been a polarization among people about your band. People either just love you, or they don't know what to make of it.

I'd rather have some of the people just scratch their heads and literally outright hate us than just sit there and be like, "Oh, they're okay." The people who like it, really like it. If we wanted to appeal to everybody, we'd be like Michael Bolton.

I don't really care for bands that are just straight retro, either, because how many times can you hear "Be-Bop-A-Lula"? I enjoy that music, but for a career, trying to be an original artist, it's kind of a dead end.

Why do you think a lot of bands fall into that?

I think that a lot of people think it's good enough to try and emulate somebody else. It's easier. You don't have to work as hard. You don't have to put as much of yourself out on the line with it, really. Another thing is that you can't be too irreverent. That's the only way you can make it yours. And that's why I like bands that have sort of an irreverent attitude toward their music, and have a sense of humor and maybe a sense of irony, something you can fool with. And I think that there's a big audience out there for that.

If Southern Culture on the Skids were a B movie, what kind of B movie would it be?

It would have to be sort of a *Macon County Line* and *Walking Tall*, but with a zombie theme. A zombie moonshine sort of thing.

The Avett Brothers

For all of my twists and turns with the Avett Brothers, my sense of timing with them is unlike most of the bands I've worked with. Watching them grow into the worldwide stars they have become has been remarkable. Within the first year of photographing them, I realized that I was consistently better at getting the best photo, knowing where to be, at the right place at the right time. As a photographer, you can struggle for years with some musicians, figuring out what to shoot and when. With the Brothers, it was there from the beginning, and it's still there.

Over the last few years, the Avett Brothers have become North Carolina's best-known ambassadors, performing on the Grammys with Bob Dylan, two sellout nights at the fabled Red Rocks Amphitheater, and sellout shows across the country and in Europe. What started in a workshop near Concord, North Carolina, has become a worldwide phenomenon.

I first saw Scott and Seth Avett in 1999. Tremont Music Hall in Charlotte was having a huge benefit concert for breast cancer awareness. I was there to see some friends play, but I arrived in time to see the first act on the bill, a band called Nemo, which I'd never heard of. Nemo was formed by Scott while he was attending East Carolina University. Nemo was loud, raucous and noisy. I thought that they were all right, but it was not what I had expected to listen to that night. I did not get any photos of the band at that show (much to my regret, looking back), but I did grab one of their business cards. I still have that card somewhere, and I hope to find it again someday.

After Nemo's breakup in 2000, Scott and Seth Avett began playing some shows

as an acoustic duo, or with former Nemo guitarist John Twomey. On the surface, it might have seemed an about-face from Nemo's abrasive volume. But the brothers always had a love of acoustic music. Their father, Jim Avett, was also a songwriter and performer and kept an impressive collection of country and bluegrass records in his workshop. Jim knew what music he liked and tried to pass it on to his children.

After Twomey left the burgeoning Avett Brothers, Scott and Seth began looking for a stand-up bass player. They found one in Bob Crawford, whom I knew through another band, the Memphis Quick 50. Soon after Crawford left the Quick 50 to join the Avett Brothers, he urged me to come see the band play.

I first saw the Avett Brothers at Fat City, a restaurant and bar that was housed in an old building with yellow bricks. From the start, the Brothers were something different. They were playing songs that were rooted in Americana, yet with a raw spirit that showed their rock-and-roll roots. I took some photos and sent them along to Scott Avett.

Scott liked my photos, and we traded e-mails for several months. At one point, I offered to come out and take some posed pics of the band, which Scott eventually agreed to. We met in their father's woodshop, where the trio rehearsed. One of the first things that Scott said that night was, "I don't want to play banjo anymore." That

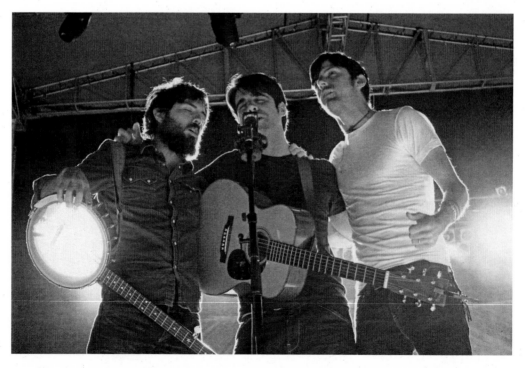

The Avett Brothers (left to right: Scott Avett, Bob Crawford and Seth Avett) open a show with a performance of "Hard Times." Greensboro, October 2011.

night, he was in the mood to play guitar. Looking back, this was a hallmark of the Avett Brothers, restless in their search for ideas, constantly changing their original notions. Soon after, the band gave me a copy of their new album, *A Carolina Jubilee*. I was floored by how good it was and how determined the band was in pushing their sound further.

I continued to work with the Avetts over the next several years. Sometimes they paid me for my photos. Other times, I just came to see them and to have fun. I remember doing a photo shoot with the band soon after I photographed Johnny Cash's last public appearances at the request of the Carter Family. The brothers had a lot of questions about Mr. Cash, as I called him — what he was like, what he said, what he sang. In the last few years, Johnny Cash's longtime producer, Rick Rubin, has produced two Avett Brothers records and has had the Brothers overdub themselves onto two unreleased Cash songs. Looking back on that long-ago conversation, I'm amazed by how far it all has come.

I had a lot of good times with the Brothers. Photographing the *Mignonette* album and watching that great album come together, piece by piece; photographing the *Live Vol. 2* album and working frantically to get the photos together; taking photos of their Black Sabbath-like side project, Oh What a Nightmare; watching the mayor of Concord proclaim it as Avett Brothers Day as the room was packed beyond capacity; sleeping on the living-room floor during the recording sessions for the *Four Thieves Gone* sessions; their first shows at Merlefest; and watching their New Year's shows build with each passing year.

I dare say that I've put more of my heart into my work with the Avett Brothers than almost any other artist I've ever worked with. Only my photos of Cash and a couple of other acts may mean as much to me. Working that way with any artist has its advantages and its drawbacks. When your subjects move on, as is bound to happen with any subject, you're not always willing to let them go.

I didn't look at my photos of the Avett Brothers for a couple of years. They felt unfinished, like I had not succeeded in my original goal. One day, I was looking at a portrait of Franklin Delano Roosevelt that was being painted on the day he died. The artist had only completed Roosevelt's face and had left the rest of the painting unfinished. What one might have seen as incomplete, I saw as an uncluttered view into the subject, and the painter. It helped me to come to terms with the work I'd done with the Avett Brothers and other artists. Sooner or later, it's the work I create, regardless of what else I had hoped to accomplish, that stands alone.

Yes, I do still photograph the Avett Brothers. As always, I wish I saw them more often. But I do have a strong sense of pride for what they have accomplished. Watching them tour and conquer the world is like looking at a distant star in the sky, for me. I may often wish that I could be closer to it, but I will always be happy in knowing that their light still shines.

This conversation took place via e-mail while Scott was on the road. Given the band's constant touring schedule, it seemed appropriate.

COSTON: *How often do you record in a studio?*

SCOTT AVETT: When we make records, which is sporadic over a period of months in 6- to 10-day stretches, it can be anywhere from 10 to 40 days a year.

The Avett Brothers (left to right: Bob Crawford, Seth Avett and Scott Avett) put on their stage clothes before a show. Sylvia Theater, York, South Carolina, June 2004.

Do you usually have the songs written, and how often do you write in the studio?

We try to have all songs completely written by the time we are documenting them in the studio. The alternative has proven to be a problem.

Do you prefer working quickly in the studio, or do you like having a lot of time to work on songs?

Both. The song calls for the amount of time spent in the studio, and sometimes they work out faster than others. We do take our time more now than we used to though. I think that is because we listen much more than we used to.

What have been your favorite recording studios, radio stations, or TV stations to record or play in?

I love Echo Mountain and Electromagnetic Radiation recorders.

What were some of the first festivals in North Carolina that you went to before you began playing?

Merlefest, and a couple of other fiddlers conventions.

What are some of your favorite festivals in North Carolina to play?

Merlefest and Shakori Hills.

How different is a show day at a festival as opposed to a club or theater show?

Much more relaxed. The festival community makes me feel more like I'm picnicking than performing, and that is terrific.

What are some of the advantages of playing festivals?

Variety in variables that always make the show challenging and exciting.

How do you travel to shows? Do you prefer car, bus, or plane?

We travel in all ways. I love long tours on the bus and living on the road. Cars are great because you can see every mile you travel. Planes are good because they are fast.

What's a normal day for you like the day of a show?

A lot of thinking and practicing. I look inward a lot and explore less than I used to as the shows are so physically demanding. I do try to take time to move physically though.

What do you usually do backstage before a show? Do you catch up on phone calls, write songs, go over a set list?

Set lists are the main topic of discussion. I do not catch up on phone calls, and I do not write songs.

What are the advantages of playing in your home state as opposed to playing elsewhere?

Being close to "home" is always great. I don't get enough time in North Carolina,

so I have to admit, because of the ones I know and love so well, I always prefer being there. I guess it puts me in a good mood, and that could be an advantage.

What are some of your favorite places to play in North Carolina?

Orange Peel in Asheville, Cat's Cradle in Carrboro, Neighborhood Theatre in Charlotte, Fat City in Charlotte, the Lincoln Theatre in Raleigh, Bojangles [Arena] in Charlotte, the list would go on and on.

What are some of the important things that a performer needs to do with an audience?

It's their party, not yours, but always try to relax and let the game come to you. Remember, no audience is ever more important than another, and there is always another chance even though all you have is this very moment.

Do you enjoy performing live?

I love performing live. I love being on stage.

What makes it different from every other part of being a musician?

It is the reason I do everything else involved in the business. To me, it all revolves around interacting with people from the stage.

What have been some of your favorite shows in North Carolina venues?

One at the Soapbox in Wilmington sticks out in my memory as the hottest and most mind-bending show, in regards to exhaustion. There are truly too many to try to list them all.

How often are you at home, as opposed to being on the road?

It feels like our time is split about half and half at home and on the road.

How much writing do you do at home?

Same as on the road; when it hits I write.

Do you prefer writing at home or on the road?

Both the same; it makes no difference. Writing is about feeling for me, and I don't really schedule that.

What makes you proudest to be a musician?

It makes my mom and dad smile.

Talk about the North Carolina music scene or North Carolina musicians, what it's like to work in the same circles, and some of the musicians in North Carolina that you admire or that have influenced you.

I think there is an undeniable depth to the history of musicians from North Carolina, and we are very proud to be part of that, though I realize we are still on the shallow end of it. Names like Doc Watson, Charlie Poole, Ola Belle Reed, John

Coltrane, Roberta Flack, Ryan Adams, Ben Folds, Don Reno, Earl Scruggs, Arthur Smith, Thelonious Monk, Blind Boy Fuller, and others I don't even know about are all reasons to be proud of North Carolina's rich musical history.

Following the Musicians

There are several artists that I've been lucky enough to photograph over a period of years and document their evolution as musicians. Jay Garrigan, who is based in Charlotte, is one that immediately comes to mind. Along with making some great records, some of my all-time favorite photos of musicians in mid-air are of Jay. These are the shots where the musicians are in mid-jump, lost in the process of making music — the classic rock and roll poses, as some might call it.

Getting a good shot of musicians in mid-flight is not easy. One's good timing is especially necessary. But I seem to have that timing with Jay. If you asked me before the show, "When is he going to jump?" I'd have no idea. But when the song starts

Skip Matheny of Roman Candle takes a leap off of his amplifier during a show at the Local 506 in Chapel Hill in 2005. The group also features Skip's wife, Timshel Matheny (on keyboards). Nick Jaeger has his back to the camera and Danny Kurtz is at right. Logan Matheny, on drums, is out of the shot.

Jay Garrigan jumps on stage at the Evening Muse in Charlotte in 2011. Jay has played in numerous groups I've photographed over the years, either as a frontman (he was leading his own group, Garrigan, the night of this picture) or as a sideman.

and Jay really gets into the song, I know that a good shot is coming. Don't over-think the moment; just let it happen. Take the photo and enjoy the moment.

Another one of my best photos of musicians in mid-air is of Skip Matheny and Roman Candle. I learned early on that when club owners recommended a band, I should listen. Joe Kuhlmann, who runs the Evening Muse in Charlotte, took me aside years ago and said, "Don't miss this band." He was right. Roman Candle, led by brothers Skip and Logan Matheny, and Skip's wife, Timshel, are the kind of rock-and-roll band that you root for in any situation — good people making great music.

One night, I went to see them at Local 506, a famous bar and music venue in Chapel Hill. The place was full of the band's fans, friends and family members. It was the middle of August, but no one seemed to mind the heat that much. Near the end of their set, I decided to stand behind the stage, looking out toward the crowd. Why? I don't know. It felt like a good idea. Near the end of a song, Skip ran toward his amplifier, which was in front of me, stepped on his amp, and jumped into the air. His back was to the crowd, but he was facing me. He didn't know I was there;

Justin Fedor of the New Familiars jumps at the end of a song. Neighborhood Theatre, Charlotte, September 2011.

he was in the middle of playing the song. I instinctively took a photo as he jumped. When I got the negatives back, I couldn't believe it. There was Skip, in mid-air, with the full view of the band and the club behind him. Yep, classic rock photo, as I like to say. Again, let your instinct lead, and your head and eyes will follow.

A lot of photography in music really is catching the action as it happens. I rarely go in with a game plan. The closest I get to that is thinking about what kind of photos I did or did not get the last time I photographed that person, and using that as a barometer. Sometimes even that plan goes out the window, and you just respond to the music.

Peter Holsapple

I may have first seen Peter Holsapple in 1991, when he appeared on stage with R.E.M. during their *MTV Unplugged* special. I didn't know back then that he was from North Carolina or that he had already been an important figure in music scenes ranging from Winston-Salem to New York City. I just saw him playing with a lot of other cool musicians, and I thought, "Wow, how do you get that gig?"

After playing with numerous bands, as well as leading the dB's and the Continental Drifters, Holsapple came back home to North Carolina. And the music scene in North Carolina is better because of that. I've had the great opportunity to photograph Peter with the dB's, with other artists, and on his own, and I always look forward to his next e-mail and the next chance to work with him.

COSTON: *What got you started in music?*

PETER HOLSAPPLE: My mother and dad were not musical in the least, apart from enjoying some of it. My older brother Curt was a classically trained pianist, organist and chorister; he eventually was a church organist and choir director in New York and Connecticut. I heard him play all the time and was mesmerized at the sound. He practiced piano at home, but my mother and I would go to Christ Church in Greenwich to hear him practice the pipe organ. Shortly after we moved to North Carolina where the family would live in Winston-Salem and he would start at Chapel Hill, he leaned in to me and said, "Peter, there's this band playing on *Ed Sullivan* this Sunday that I think you should see. They're called The Beatles." The die was cast. From there I took my mother's Silvertone guitar and sat at the piano with it and learned how to play them both at once, mostly by ear.

My brother discouraged my parents from getting me piano lessons because he felt then that I understood something already. He had a small student accordion, and my dad had a bowlback mandolin that he'd had in the Mandolin Club at Harvard in the 1930s. I played them too, along with the pump organ my uncle Ray had hooked

up to an Electrolux vacuum cleaner that resided in the basement. I sang in my church choir and was a boy soprano soloist (the untrained one). I took string bass in fourth grade, then switched to snare drum in fifth through eighth grade. My choir director, Helen Cornwall, and my band director, John "Chick" Shelton, were huge influences on me wanting to do music. They just seemed so innately connected to music and sound that I wanted to feel as attuned and moved by it as they were.

You had a pretty remarkable group of friends, growing up around Winston-Salem— Mitch Easter, Chris Stamey, Will Rigby, and others. Talk about having a group like that around you as you started to form bands.

It was an incredible time to be a kid playing music, and in Winston-Salem, it was particularly remarkable. The number of good musicians on all different instruments that were as young as 14, like Mitch Easter, who was in Sacred Irony, all drawing from the wealth of underground rock music that affected us is still a little daunting, since so many of those people are still playing music today, more than 40 years later. It really helped that we all seemed to like mostly the same music, starting with the Beatles and sprawling from there

Later, of course, I realized the bands that seemed like they were together for ages actually were only together a year or two, at the most. My entrée to that scene, which came to be known informally as Combo Corner after a gathering of band members before school and during lunch at R.J. Reynolds Senior High School, was through Chris Stamey. He was best friends with Mitch, as were their mothers. I knew of Mitch but was daunted by his guitar prowess even then. He played in a lounge band at the age of 13, on a Gibson ES330 through a Fender Super Reverb, and he was the stage band guitarist in junior high school, handpicked by Mr. Shelton, who knew a thing or two about musicians. I was far too shy to introduce myself to Mitch, but Chris would let me tag along to shows where he would record Sacred Irony. The Irony were writing their own songs and played them in their sets at local church coffeehouses and recreation centers, alongside favorites like "Better by You, Better Than Me." This made a huge impression on me. Even more amazing was watching from the orchestra pit of Reynolds Auditorium the debut performance of the second incarnation of Rittenhouse Square, in which Mitch played one of two lead guitars. They played a note-for-note rendition of "Yours Is No Disgrace," including vocals, and I finally made the connection between what I'd seen on *Ed Sullivan* a few years before and what I might be able to do myself.

I know that you have lived different places at different times. What are the advantages of coming back to live and play in North Carolina?

I came back with my young family after Hurricane Katrina destroyed our home in New Orleans. I needed to come back to North Carolina, partially because my mother and father (now deceased) were elderly and living in Winston and par-

tially because I felt the need to return to where I felt most comfortable after the hurricane.

Talk about the North Carolina music scene or North Carolina musicians, what it's like to work in the same circles, and some of the musicians in North Carolina that you admire or that have influenced you.

Since I've moved back to North Carolina, I have done a few musical projects, such as the Holsapple & Stamey album and the new dB's album. I have participated with bands like Hobex, Luego, and Baron von Rumblebuss as a multi-instrumentalist. I've gotten to know and play beside great musicians down here like Jeff Crawford, Mike Nicholson, Rob DiMauro, Tim Smith and Dave McCracken live and in the studio. It's a very vital time to be down in this area, but really, when hasn't it been? The first session I got to do when I moved here was for Mac [McCaughan] and Portastatic, which was a lovely first shot fired.

Do you usually have the songs written, and how often do you write in the studio?

Never written in the studio. I always have the song written and arranged and hopefully completely rehearsed by the time I pay for studio time.

Do you prefer working quickly in the studio, or do you like having a lot of time to work on songs?

I'd rather work the songs out off the clock. I think the time best spent in the studio is time determining if the rhythm section locks in.

What are some of your favorite festivals in North Carolina to play?

Merlefest, Festival for the Eno River, LEAF, Shakori Hills, Summer on Trade.

How different is a show day at a festival as opposed to a club or theater show?

If you come in on a bus, you feel a little trapped there unless you can get off-site. There's only so many funnel cakes and corn dogs one musician can eat.

How do you travel to shows? Do you prefer car, bus, or plane?

I do like riding on tour buses when the driver is a cool person.

What are the differences in traveling with a band as opposed to playing and traveling solo?

Really just coordinating departures and pickups around everyone's schedules. The groups I've toured with are usually not the hotel wreckers.

What's a normal day for you like the day of a show?

With Hootie & the Blowfish.

6:00 A.M.: Bus arrives.

6–7:00 A.M.: If there's a day room, go sleep more.

12 noon: Wake, find restroom then catering at gig or restaurant at hotel.

1–4:00 P.M.: Wander, read, write,

record, bike, tourist stuff, visit with local friends.

4:30 P.M.: Arrive for soundcheck, get gear ready and warm up a little.

5:00 P.M.: Ready for soundcheck.

5:20 P.M.: Band starts arriving for soundcheck.

5:40 P.M.: Soundcheck ends, light dinner.

6:30 P.M.: Shower, get dressed.

7:00 P.M.: Wander, pick a little.

8:00 P.M.: Shots, and go on stage.

10:00 P.M.: Last notes ring, back to bus.

10:20 P.M.: Band returns to bus, begins to party. Retire to bunk in sleeping area with novel.

12:00 midnight: Trying to sleep. Much hall transit and chatter.

2:30 A.M.: Party starts to wind down, driver arrives.

3:30 A.M.: Last off-campus partiers return, motor started and pop-outs brought in.

3:45 A.M.: Bus rolls.

What do you usually do backstage before a show? Do you catch up on phone calls, write songs, go over a set list?

Before a dB's show, it's a combination of most of the above, although writing is usually not a part of it. Too much already written to have to try to remember.

What are some of your favorite places to play in North Carolina?

R.J. Reynolds Auditorium (Winston-Salem), Carolina Theatre (now Stephens Center (Winston-Salem), DPAC (Durham), Merlefest, Cat's Cradle, Summer on Trade, ArtsCenter (Carrboro), Rooster's Wife (Aberdeen), Old Opera House (Winston-Salem), Showmobile (Winston-Salem).

What are some of the important things that a performer needs to do with an audience?

Always give them your best performance.

Do you enjoy performing live? What makes it different from every other part of being a musician?

I like it all right. I prefer recording because I'm more confident when I don't have an audience in front of me, but applause is certainly gratifying and exhilarating. In no other form of music do I feel such butterflies.

How much writing do you do at home?

All of it. When the spirit moves me.

Do you prefer writing at home or on the road?

I'll take it wherever I can get it. On the road with my ProTools rig, it was nice to have a recording studio at my disposal that could be set up in 10 minutes. But it really just depends on when the song appears in my consciousness.

What makes you proudest to be a musician?

I'm proud of the songs I've written, and that people more often than not like

them; that I've gotten to play music professionally with great musicians and record wonderful songs in superb studios; that I still love to listen to great music and can cry like a baby at a moving melody; that I have passed that love of music along to my children, much like my brother did for me.

Nappy Brown and Bob Margolin

Years ago, I went to the Double Door to see Pinetop Perkins, who had spent years playing piano for Muddy Waters. The place was packed, and the band was fantastic. Fellow Muddy Waters band alums Bob Margolin (whom I'll say more about shortly) and Willie Smith put on an excellent show. But the big surprise lay in the middle of the show.

About 40 minutes into the show, Margolin announced, "We'd like to have Nappy Brown come up and do a song." I had heard about Nappy Brown but had yet to see him. Nappy was one of the first North Carolina musicians to break through when

Nappy Brown takes his show into the audience at the Double Door Inn in Charlotte in 2004. The Double Door is one of the oldest venues for blues music in the country, and a Nappy Brown show there was always something special.

rock and roll and rhythm and blues began to merge. Songs like "Don't Be Angry" (which Brown also wrote) made the national charts, and another song that Brown adapted, "Night Time (Is the Right Time)," would soon become a worldwide smash for Ray Charles. After spending years devoted to gospel music, Margolin convinced Brown to return to the blues music scene.

Watching Nappy Brown on stage was like watching a ball of fire flash by you. Brown was all of six foot five, rail thin, and strutting as he came on stage. Brown, as he often did, took over the show. Soon, he was rolling on the floor, both on stage and in the audience, sitting on ladies' laps and undoing his shirt, all while singing and shouting and urging the band on. It was unbelievable. I took so many photos that night of Brown, documenting as his one song turned into a 25-minute set. (I've heard that this often happened with Brown.)

In the last years of his life, Brown finally got the due that he deserved — appearances on *Prairie Home Companion*, a new album, and the respect of his peers. I saw Brown several more times after that first show, but I wished that I had seen him more. After Brown passed away in 2009, I helped to raise money for a headstone for him.

As I mentioned, Bob Margolin's influence on music goes far beyond his excellent guitar playing. If you watch the film *The Last Waltz*, one of the best-ever music concert films, you'll see a young Bob Margolin playing guitar behind the legendary Muddy Waters. Margolin toured with Waters for several years and then took to the road with his own band. When Margolin settled in North Carolina in 1989, he immediately began to have an impact on the music scene in North Carolina.

Bob Margolin looks out over the audience during a show at the Double Door Inn in Charlotte in 2004. Margolin was part of Muddy Waters' band throughout the 1970s and can be seen standing behind Waters in the legendary concert movie *The Last Waltz*.

Along with lending a hand to Nappy Brown, Margolin has also helped many musicians find a new audience. This includes Carey Bell, a longtime harmonica player for Muddy Waters. Margolin and fellow North Carolina bluesman Mookie Brill helped to bring Bell, as well as other musicians, to this great state, and we, the fans were the better for it.

Even though I've photographed Margolin for years, I've never had the chance to talk to him at length. I really don't know why. Photography is sometimes a misleading profession. Just because you spend time photographing someone doesn't mean that you always get to know them personally. But I've always known that Bob's heart is in the music, and he puts that forth by constantly playing across the state.

Playing Live Across the State

When I asked Si Kahn about his favorite places to play in North Carolina, he was more than happy to give me his list.

The Evening Muse in Charlotte
The Great Aunt Stella Center in Charlotte
The ArtsCenter in Carrboro
The Fiddle & Bow in Winston-Salem
The Cook Shack in Union Grove
The Todd General Store
The Wilkes County Folk Society
 monthly jam

The Charlotte Folk Society monthly
 jam
The Kruger Brothers' Studio
Carolina in the Fall
MerleFest
 Festival for the Eno

"You need to make every member of the audience feel that they're the center of your attention," says Kahn, "that you're playing, singing and talking for them, individually as well as collectively. You have to open up a space within which they can experience a wide range of emotions over the course of your performance. You should make them laugh and help them cry. You want to get them thinking, to challenge their assumptions, to reinforce their ideals. You need to leave them with a sense of hope. In some ways, a live performance is the ultimate test of musicianship. Unlike in a recording studio, if something isn't quite right, you can't go back and 'fix it in the mix.' It's just you and the audience, face to face."

"I've enjoyed playing the universities," says Dom Flemons, "especially UNC–Chapel Hill. It's a good vibe out there. I've always loved the Cat's Cradle as well. It's probably because I lived in Chapel Hill that I'm partial to it. Another place we've played for several years has been at the Music in Sugar Grove festival in Sugar Grove, North Carolina. That's where I first met Doc Watson and the Kruger Brothers.

"One of the favorite shows in the past few years have been at the Orange Peel in Asheville. That's been a great one because we've able to have a variety of guests out there. We usually get the Green Grass Cloggers to come out and usually one other. That's a great thing to be able to do where folks know you're coming and you can give them a unique show as well as an experience.

"To me, the most important thing I think a performer can do with an audience is to let them know that the performance that they are getting is a unique performance to that night and make a point of it. This can be very simple, whether you make a different joke or play a unique song for that crowd, or whatever it is just so that if people ever come back and see you at the same venue next time, they will see something different.

"I love performing live. It's great to have a real conversation and a moment with an audience. It's like meeting people. There is something unique about each encounter that is molded for that exact moment that cannot be repeated again. Performing live is like that."

There are great venues all over North Carolina, big towns and small. Even in

Si Kahn congratulates a young fan during a show at the Evening Muse, Charlotte, May 2012.

rural towns like Marshall, North Carolina, you'll find a thriving bluegrass scene at the local train depot every Friday night, or legendary fiddle player Bobby Hicks playing at a coffeehouse every Thursday night. Trying to pick out your favorites is sometimes like trying to pick out your favorite flowers. Or photos, in my case. It's also different for each musician you talk to.

"I love playing Marsh Woodwinds in Raleigh," says Caitlin Cary, "the Casbah in Durham, the Garage in Winston, the Evening Muse in Charlotte; love doing WNCW in Spindale, and WKNC has been great to us over the years in Raleigh. And of course Merlefest is great!

"I think it's important to connect in a way that's really honest. I *do* value the fourth wall, and I *do* believe that the audience wants and needs to see the performer as 'other' than themselves. But there also needs to be established a level of intimacy that I think can only come through honesty. I tend to be pretty confessional. I like to tell my audience something about how I'm feeling in the moment. I do *not* like watching performers who over-share, or who seem to use their time on stage like a therapy session, but I also don't want to feel as though I'm watching a show robot going through the motions of a performance. So there's a careful balance to be struck. I hit it sometimes and I miss it a lot, but I know what I'm going for, and I love when I feel like I've achieved it. Of course what a performer *most* needs to do is to connect to the audience through the music. That's about being present, engaged, and, of course, you know, *good*.

"I do love performing live! There's really nothing like the 'high' of it. It's hard to describe the feeling, sort of an out-of-body thing, but of course there's also a heightened 'presence.' I find that I often don't have much of a concept of how I *am* on stage. When I watch a video of myself, it invariably surprises me. I guess what it boils down to, where the pleasure really lies, is in the immediacy of it. Here is me, here is my art; do you like it?"

When I asked Caitlin about memorable shows, she says, "Memorable was opening, fairly early on in my solo career, for Rodney Crowell at the Carolina Theatre. Whiskeytown's early shows at The Brewery are unforgettable for me,

Rhiannon Giddens Laffan of the Carolina Chocolate Drops sings it out. Charlotte, June 2012.

primarily because I was so excited and so nervous. Tres Chicas had a really great night when we opened for Geraint Watkins at the Pour House. Meeting him and his producer/friend/engineer Neil Brockbank led to our getting to make a record in London, and the after-show hang was really fun!

"Performing live is the hardest part about being a musician," says Justin Robinson. "So much can go wrong, and you are mostly relying on muscle memory and the knowledge that you actually know what you're doing. It is also the most immediate response to your music, so you know right away if people get what you are doing."

The Briarhoppers

As I mentioned earlier, I saw the Briarhoppers at my elementary school, and I never forgot them. Here was a band that once had the ear of listeners across the eastern half of the United States, when WBT could be heard from Chicago to the Southeast. All these years later, the Briarhoppers are still out there, playing for schoolkids, and kids of all ages.

In 2002, the Briarhoppers were given the North Carolina Folk Heritage Award. I can't remember how I heard about this event, but I knew I had to be there. In

Briarhoppers Orval Hogan (left) and Roy "Whitey" Grant, Charlotte, March 2002.

putting this book together, I'm amazed at how many places I just showed up at and found a way to get photos of what I wanted. Such was the case with the Folk Heritage ceremony, where I simply walked into the Levine Museum and started photographing the award ceremony. Call it what you will, but I'm glad that I did.

The Briarhoppers followed up the awards with a performance at a local church across the street from the museum. The band had changed since I last saw them. Shannon Grayson and "Fiddlin' Hank" Warren had passed away. Dwight Moody and Bill Monroe band alum David Deese had stepped up to take their place. But still on bass was Don White, the band's founding bass player, and leading the band were Roy "Whitey" Grant and Orval Hogan.

At first, the sight of the Briarhoppers playing in a church was not what I had expected. But then I began to think about the history of these musicians and this band. For Whitey and Hogan, they had started their careers in Gastonia out in places just like this in the 1930s — churches and other gathering places, away from the mills where many of them worked. Gospel music was also part of their upbringing, and those influences never left them. Indeed, they had come home, and the Briarhoppers indeed come home again to Charlotte.

George Hamilton IV

Another musician that deserves recognition for his longevity is George Hamilton IV. In 1956, while studying at UNC–Chapel Hill, Hamilton recorded a song at the local campus radio station. "A Rose and a Baby Ruth," written by another soon-to-be North Carolina legend, John D. Loudermilk, was released by Colonial Records, a label based in Chapel Hill. After getting some airplay, the single was picked up by ABC-Paramount Records, who helped the song become a top-ten national smash.

Hamilton still performs "A Rose and a Baby Ruth" at every show, and he always gives out a rose and a Baby Ruth to a fan. One time, I was going to photograph a show with Hamilton and Dwight Moody when Dwight called. "George forgot to pick up a Baby Ruth," Dwight said. "Could you pick up one? And pick up a small one, as well. I want to pull a prank on George."

It took a trip to more than one store, but I finally found both. When I got to the venue, the parking attendant said that the parking lot was full. "But I have George's Baby Ruths," I replied. They let me park in the lot. At the show, Dwight slipped George the mini–Baby Ruth, before giving him the Baby Ruth that he was expecting.

Hamilton is one of North Carolina's best-known exports. To this day, Hamilton tours the world constantly: a concert hall in Amsterdam; outside of a church in Matthews, North Carolina; any and all places throughout Canada — George has been there. He has also been a member of the Grand Ole Opry since 1960, a feat of respect

and endurance that is beyond commendable.

I've photographed Hamilton in a number of places over the years: saying hello to fellow North Carolinian Donna Fargo at a Western Film Fair convention in Winston-Salem, churches all across North Carolina, playing with Doc Watson at the North Carolina Music Hall of Fame, and visiting friends and fellow musicians like Dwight Moody. It's always fun to watch Hamilton with John D. Loudermilk, who have known each other since they collaborated on that first hit song. Loudermilk is a free spirit, and brings out Hamilton's playful side. Watching both of them together is like watching two kids having fun, and not caring about what age they happen to be at that moment.

Many great musicians were born and raised in North Carolina before finding their

George Hamilton IV, with a church tower in the background, plays at an event in Matthews in 2007. Religion is a staple of Hamilton's music, and this shot seemed to suggest itself as a good idea.

calling elsewhere — John Coltrane, Thelonius Monk, Nina Simone, Ben E. King, George Clinton. One of the greatest on the list is Link Wray, whose revolutionary electric guitar sound influenced many generations of guitar players. In the movie *It Might Get Loud*, Jimmy Page of Led Zeppelin is asked what record made him want to be a guitar player. He immediately plays "Rumble" by Link Wray.

I photographed Link Wray twice in 1998 as he visited various venues throughout the state. When Wray returned to Charlotte for his second show, I brought him photos that I'd taken at the previous show. Wray was really enthusiastic about my photos and told me how great a photographer I was. It was the first time that someone I admired on that level spoke highly of my work, and it gave me another reason to keep shooting.

Old friends George Hamilton IV and Donna Fargo say hello during the Western Film Fair in Winston-Salem in 2007.

Link Wray performing at the Double Door Inn in Charlotte in 1998. Link's distinctive guitar sound, which he originally achieved by distorting the speaker cones of his amplifier, has influenced everyone from Pete Townshend to Jimmy Page.

Sara and Dex Romweber tear it up on stage. Snug Harbor, Charlotte, May 2011.

In the same scene in *It Might Get Loud*, the same question is asked of Jack White. He in turn cites a record by another North Carolina musician, Dex Romweber. On his own, with his sister Sara, or with the Flat Duo Jets, Romweber has always taken his own path with music — raw, honest, rooted in the early roots of rhythm and blues and rock and roll. For a photographer, Romweber is great, because you know that he will give it everything he has every time. The game that I play with the photos is, "What haven't I tried yet?" Try to shoot something different with the artist and challenge yourself. It happens if you've been taking photos for a year or 20 years. It's never too late to come up with a good idea.

George Clinton of the Parliament/Funkadelic All-Stars gestures to the crowd at a festival in Columbia, South Carolina, in May 2002.

Andy Griffith

If you walk through the streets of Mount Airy, North Carolina, the presence of Andy Griffith, and Sheriff Andy Taylor, are everywhere. The mythology of Sheriff Taylor, which Griffith portrayed on *The Andy Griffith Show*, is still a powerful force. Even in Griffith's hometown of Mount Airy, the image and idea of Sheriff Taylor are intertwined with Andy Griffith.

Yet Griffith was a very different figure from his most famous creation. He was an actor, musician, and stand-up comedian. His love of music and song appeared in many of his best-known performances, and he continued to return to his love of music. In public and in private, Griffith was a different man than what people saw on *The Andy Griffith Show*. Griffith was a more complex and diverse man than Sheriff Taylor. All of that helped to shape Griffith as one of North Carolina's best-known actors and musicians.

Griffith was born in Mount Airy in 1926. By the time he attended Mount Airy

High School, he had developed a love of acting, music, and theater. Griffith spent several years acting in *The Lost Colony*, a play about the first English settlement in North Carolina. *The Lost Colony* is still performed in Manteo, North Carolina, to this day, and is currently the second-longest-running outdoor drama in the United States. Griffith spent several years with the play, working his way up to the lead role of Sir Walter Raleigh. Griffith helped to rebuild their theater when it burned down in 1947 and eventually moved to Manteo permanently.

After graduating from UNC–Chapel Hill, Griffith taught at Goldsboro High School for a couple of years. Along with singing, Griffith began to write and perform comedic monologues. In 1953, his piece "What It Was, Was Football" was released as a single by the Chapel Hill–based Colonial Records. The single eventually reached number nine on the national charts, and Griffith never looked back.

Despite his success around the world, Griffith never left North Carolina, and he never left his love of music. He exposed millions of people to bluegrass music via *The Andy Griffith Show*, and released an album of country and gospel songs during the show's run. Griffith released several albums of gospel songs in his later years, winning a Grammy, and was inducted into the Christian Music Hall of Fame. Griffith was known around the world, but he always carried pieces of North Carolina and its music with him.

I was lucky enough to photograph Andy Griffith on three occasions. The first was the dedication of the Andy Griffith highway, near his hometown of Mount Airy, North Carolina. Much of the town turned out for the event. It had rained throughout the day. At one point, it was going to take place under a tent that didn't allow anyone outside the tent to see what was going on. The crowd and the media grumbled. After a long wait, the skies cleared, and the event began. I talked my way into the media section, far from the stage, and eventually snuck down front with a couple of other photographers.

Andy Griffith sat with the then-governor of North Carolina, Mike Easley, and Easley's wife. The speakers

Andy Griffith holding the guitar he used on *The Andy Griffith Show* after donating it to the University of North Carolina's Southern Folklife Collection. Wilson Library, UNC–Chapel Hill, September 2005.

that spoke before Griffith went on forever. There was a local politician who gave the appearance that he had never spoken in public before. He blathered on for what seemed like forever, speaking so quietly that the crowd kept shouting, "Speak up!" Ten minutes into his torture (and ours), he said, "I'd now like to introduce Governor Hunt." Jim Hunt had been the previous governor. The speaker turned bright red, and Griffith, Easley and everyone else just cracked up. We all got great photos of Griffith's beaming laugh.

Griffith finally got up to speak and wiped the floor with everyone who had approached the podium. Not everyone on this earth is a natural public speaker, but Griffith had it in spades. He was funny, he was direct, and he was suitably grandiose, using his hands in sweeping motions. He was the only speaker that day who didn't need a speaker system. It was an impressive thing to witness. I got some good photos of Griffith with his highway sign, and then he was gone.

Two years later, Griffith came back to Mount Airy for the dedication of a statue honoring *The Andy Griffith Show*. It was held in the middle of Mayberry Days, an annual celebration of the TV show. Many former actors of the show were there, as well as the classic lineup of the Dillards, who were featured on several episodes of the show. I went to the event with another photographer, who somehow got into the photo pit ahead of me, leaving me to shoot from a distance. I was still able to get some decent photos, including Griffith watching the Dillards perform. The Dillards even wore their Darlings outfits for the show. Looking back, it was an amazing day to witness.

The following year, Griffith made an appearance at UNC–Chapel Hill. He had graduated from UNC in the 1940s and was returning to donate his archives to the Southern Folklife Collection. This was a fun event, with Griffith playing the guitar that he played on *The Andy Griffith Show*. The guitar had been given to Griffith for promotional tours for the movie, *A Face in the Crowd*. Griffith kept the guitar after the tour was done and was proud to show it off to the audience.

I met Griffith briefly later that day. Griffith may have been a public performer, but he was not a public person. He didn't have much to say, and I think he believed that I might be someone from the media, which Griffith tended to shy away from. I told him that it was great to meet him and left it at that.

Another thing I remember from that day was that there was an older gentleman taking photos of the event. A few times he tried to give directions to Griffith, and have him pose for photos with different people. Griffith seemed annoyed, but he did seem to know the guy and he put up with it. "Who is that guy?" I asked someone. "Hugh Morton," was the answer. Since then, I had always been a bit mad at myself for not getting better photos of Morton. When Griffith passed away in 2012, I dug out my photos of the 2002 Mount Airy event. After Griffith had left, I finished that roll of film with various photos of people posing with the highway sign. There at the

end of the roll, with a camera around his neck, was Hugh Morton. I had gotten the shot I wanted all along, and I hadn't even been aware of it. And that's all that I can ask for with these photos, and these experiences — pieces of the moments, as they happened, that remind me that I'm glad I was there.

Tift Merritt

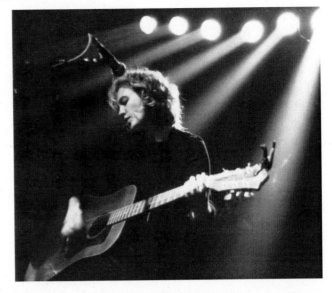

Tift Merritt performing at the Local 506 in Chapel Hill in 1999. This is one of Tift's early solo shows, and she was opening for another North Carolinan, Ryan Adams. The venue had just added that row of lights in the background, and I made full use of them in my photographs that night.

Someone that I've seen grow into one of the best musicians in this region is Tift Merritt. I first saw her in 1998 as she opened for the Two Dollar Pistols. She played five songs that night, two of which were Gram Parsons covers. It was just her on stage with her guitar as she stomped out the rhythm with her shoes, which made a huge sound on the Local 506 stage. Even then, Tift was something special, and she's continued to be that to this day.

"I do enjoy performing live," says Tift. "On one hand, I love practicing when you connect with an instrument. I love recording and performing, because you connect with other musicians. An audience is an even wider, broader kind of connecting, an invitation into something that is at once a loud celebration and something very private." As for things that a performer needs to do with an audience, "Give wholeheartedly. Listen wholeheartedly."

As for her favorite shows in North Carolina, "Headlining shows at the Art Museum and the Carolina Theatre have certainly gone down as days I'll always remember. Singing 'Supposed to Make You Happy' with Emmylou Harris at Meymandi Hall [in Raleigh] and having her introduce me to my hometown crowd was a really special night. I remember after the show my mom told me, 'Well, you just got everything you ever wanted for Christmas tonight.' What is especially nice about North Carolina performances is that they have really marked our growth. We can pin all the places we've traveled, both literally and more figuratively, with North Carolina performances. I guess that is what home is." Merritt also singles out "Cat's Cradle,

North Carolina Museum of Art, Carolina Theatre, Playmaker's Theater, Meymandi, and the Bynum General Store" as some of her favorite venues.

Chatham County Line

Chatham County Line is a rare band that knows the traditions of the music they play yet can push the music into the future. Formed in 2001, the quartet immediately stood out from the crowd, performing in suits, utilizing just one microphone for the entire show, and displaying the North Carolina state flag behind them, as well as the Chatham County Line signpost that drapes their microphone stand. Yet you won't hear any traditional bluegrass songs performed by the group. Led by singer and main songwriter Dave Wilson, the group has released five albums of all-original material. Chatham County Line knows those who have helped to shape their music, but the voices that come out are clearly their own.

It is that aesthetic that has helped to make them popular not only in the United States but around the world. In 2009, their collaborative album with Norway's Jonas

North Carolina flag, Chatham County Line show, Neighborhood Theatre, Charlotte, August 2011.

Fjeld was nominated for the Norwegian equivalent of the Grammy for album of the year. All the while, the band proudly displays their North Carolina flag at every show. They're also one of my favorite musicians to work with. It's great music made by fun people to be with, and I always look forward to my next adventure with them.

I talked to John Teer, the band's mandolin player, fiddle player, and harmony vocalist, about the roots of the band and the music that they play.

COSTON: *How did Chatham County Line get their start?*

JOHN TEER: We were in college, and Chandler [Holt, banjo player] had gone to a party at the Blue House on Boylan Avenue, which was where Dave [Wilson] and Greg [Readling, bass] and some other folks were living at the time. And it was in the early days of Stillhouse, and Chandler told me the day after the party, "I saw this amazing band. They like the same kind of music that we do."

We got in touch with them and started hanging out. Chandler and I were in another band at the time, and Stillhouse opened up for us once or twice. We loved bluegrass, and we started playing, and playing Dave's tunes in the acoustic format.

Was not having a drummer an advantage in putting the band's sound together?

Yes. Dave had seen the Del McCoury band at the Carolina Theatre and was blown away by how they worked around the one mic and wore suits. I had a deep appreciation for traditional bluegrass, and we said, "If we're going to do this, let's do it this way." We started practicing that at the Blue House. We just thought it was cool to us.

How soon did the Chatham County sign in front of the mic stand come about?

That was pretty early in the game. Greg was the original bass player, but he couldn't play with us full time because he was with Tift Merritt's band. So we had another bass player for our first album. Once Greg was in the band full time, we really started using the sign more, and we were able to become a little more serious. At the time, I was playing with Thad Cockerell; Dave and Greg were in Tift's band. Chandler had a day job. We were just waiting for that chance, and when the days opened, it was, "All right, we can do this."

You guys always took the band and the music pretty seriously from the start.

It's always been that way. We had that attitude that we wanted to do our own thing. It was sort of a punk mentality toward it, and we decided that even though we were going to wear suits, play around one mic, and do it this way. We put the North Carolina flag behind us, and we said, "We're going to do Dave's tunes." We're doing this traditional setup with the instruments, but we're not going to play traditional bluegrass tunes. We're going to do our songs, and if nobody else likes it, tough. The flag as a backdrop started early on, as well. We were proud of our state, and proud to be from there.

How many flags have you gone through?

Two, I believe. We originally had one of those cheaper nylon flags, and then a fan donated a legitimate old-school cloth flag. That and the signpost have been through a lot of wear and tear.

What has been people's response to seeing the flag on stage? Do they have a lot of questions about North Carolina?

We always take the flag everywhere. We jokingly say that we feel like ambassadors of the state, but on stage, we always invite people to come see the beautiful state of North Carolina. We're proud of our home. After the show, people come and ask us about the dates on the flag, and they ask about certain areas of the state, and they know about all this great music that has come from North Carolina. So they're intrigued by it, too.

Away from North Carolina, where have been your favorite places to play, and why?

Europe, of course, we've loved going to since we started going there about six or seven years ago. The fan base we've built, and they're respectable about the music. They're very knowledgeable about the music. In the UK and Ireland, you go over there, and they're singing the songs. You can barely hear yourself sing because they're singing over top of you, and that's very cool.

What have been your favorite places to play in the state of North Carolina?

Cat's Cradle definitely stands out. Neighborhood Theatre in Charlotte is a cool spot. Playing at Fletcher Auditorium, where we recorded our live record, that's an epic spot for us. The Saxapahaw room [Haw River Ballroom] is a really cool space. The Art Museum in Raleigh is great. There's a lot of good places around the state.

What comes to mind when you think about the music scene in North Carolina?

It's great. There's a lot of diversity, a lot of great musicians that are outstanding. It's awesome to have such a good music scene in Raleigh, Chapel Hill, Durham, Asheville, and there's spots popping up elsewhere. You've also got the Hopscotch Festival that's really putting Raleigh on the map. You've got all these great venues, like the Cat's Cradle. There's just a slew of great musicians because of all the different music styles. You've got bluegrass throughout the state, and around the mountains are just filled with old-time music and festivals. There's just a wealth of all kinds of music, anything from bluegrass to jazz, and blues to indie rock. Great student-run stations like WKNC, and things that really help to get the music out. So yeah, a lot of people know about it. Wherever we travel, they want to know about Raleigh, and Asheville, and they know about the music scene, for sure."

Earl Scruggs

In 2009, a plaque was erected outside the Ryman Auditorium in Nashville, Tennessee. The Ryman was the physical home of the Grand Ole Opry for decades and still serves today as the spiritual home for so much great music. The plaque honored the night that Earl Scruggs first stepped on the Ryman's stage with Bill Monroe and the Blue Grass Boys. Monroe and his band had played the Ryman before, but on that night in December 1945, the combination of Scruggs and his style of banjo playing helped to give a voice to a new kind of music, soon to be known the world over as "bluegrass."

Earl Scruggs was born near Shelby, North Carolina, in 1924. He grew up in a musical family, with all four of his brothers and sisters playing guitar or banjo. At a young age, Earl began experimenting with the way he played the banjo. Many played banjo with a pick or in a two-finger style, which was either known as "clawhammer" or "frailing." Scruggs began experimenting with a three-finger style, utilizing his thumb, index and middle finger.

Scruggs was not the first to play in a three-finger style. The legendary Charlie Poole, from Eden, North Carolina, had played in a variation of the three-finger style. Scruggs himself cited the banjo playing of fellow North Carolinian Snuffy Jenkins and onetime North Carolina resident Don Reno as an influence on his playing style. But it was what Scruggs played in that style that broke the mold: a fast sense of melody that transformed the banjo into a lead instrument, and the use of phrases, or "licks," that would have been played on the guitar, now played on the banjo. Scruggs may not have been the first to invent the style, which would soon be known as "Scruggs style," but he was the right man in the right place at the right time. And the music would never be the same.

After three years with Monroe, Scruggs and fellow bandmate Lester Flatt left the Blue Grass Boys to form their own band. In 1948, their recording of "Foggy Mountain Breakdown" sold three million copies and redefined Flatt & Scruggs as bluegrass superstars. The band continued touring throughout the 1950s and reached a new audience in the early 1960s through television. Their recording of the *Beverly Hillbillies* theme song and subsequent appearances on the show gave a whole new audience the chance to see Scruggs play.

By 1969, Scruggs had started to become restless. Always wanting to push his music to new places, he broke away from Lester Flatt to form the Earl Scruggs Revue. Joining forces with his two sons, Earl began to do things that many of his contemporaries refused to do: playing with electric instruments and a rhythm section, and speaking out against the Vietnam War. Scruggs also embraced many younger groups that the old establishment would not touch. In 1968, the Byrds released Sweetheart of the Rodeo, a country and bluegrass drenched album that was miles away from the

band's rock-and-roll roots. When the band performed on the Grand Ole Opry, the band was booed. Where his contemporaries saw the Byrds' long hair and ideas as an affront, Earl Scruggs heard the music and the possibilities for the future. Scruggs invited the Byrds to play with him on a TV special, bridging the gap between the roots of country and bluegrass and the younger crowd that was making that music their own. The sense of sharing the music with the next generations continued through *Will the Circle Be Unbroken*. When the Nitty Gritty Dirt Band got resistance from some older musicians about playing on the album, due to the band's age and long hair, Scruggs jumped right in. As with another North Carolinian, Doc Watson, the triple album brought a whole audience to Scruggs and acknowledgment of his influence.

I first saw Scruggs at the North Carolina Mountain State Fair in Fletcher, North Carolina. The show was held at the McGough Arena, which was also designed to hold rodeos. The stage was in the center-ring portion of the arena. A young local band, the Steep Canyon Rangers, won a contest to open the show. This band now tours the country on their own and backing up Steve Martin, a writer, comedian and banjo player who has acknowledged a huge influence by Earl Scruggs.

The show was great, with Earl and his sons going through songs that spanned Earl's entire career. I waited at the end of the line and got Earl to sign my ticket. I know that I talked to him, but I cannot remember a thing that we said. All I remember thinking is, "It's Earl Scruggs!" A few years later, I was fortunate enough to see and photograph him at Merlefest over a few different shows, which I will always cherish.

There are only a few people who genuinely change how a mass audience views the musical instrument they play — Jimi Hendrix, Les Paul, Doc Watson. Far and away, the person who changed the way we see and listen to the banjo was Earl Scruggs. The city of Shelby is currently working on opening a museum that honors Scruggs' legacy. Whatever comes of that museum, Earl's influence will far exceed the doors and walls of that building. It is still living, still breathing, in the hands and minds of those who play the banjo, and the ears of those who listen to the music.

George Shuffler

In 2006, I drove up to one of the most rural parts of Virginia for one of the state's best-known festivals. Ralph Stanley's Hills of Home festival is now nearly 40 years old and continues to spread the music that Stanley began with his brother Carter in the late 1940s. That year's festival was a special event, as it commemorated 40 years since the passing of Carter Stanley.

A litany of musicians, all of whom had played with Ralph Stanley over the previous 60 years, made their way on stage to perform. One, however, meant more than

Ralph Stanley (left) and George Shuffler reuniting on stage at Stanley's Hills of Home festival, in Coeburn, Virginia, in 2006. The two had played together for 17 years in the Stanley Brothers.

others. For 17 years, George Shuffler was the third Stanley brother. Along with supplying his harmony vocals, Shuffler developed what is now known as the crosspicking style of guitar playing to fill out the Stanley's sparse arrangements. Shuffler was born and raised in Valdese, North Carolina, and still lives in North Carolina, but his influence is known to bluegrass lovers the world over.

During the show, Shuffler and Stanley sang together on the same microphone, much as they had done with Carter Stanley so many years ago. Seeing and hearing them together, I found a new appreciation for what these gentlemen had created, and for the knowledge that only comes from playing with someone for that length of time. I may have been in Virginia, but the influence of a musician from North Carolina was all around me, again.

Jimmy Brown of Matrimony

One of the great joys of working with musicians is watching younger bands emerge and grow. One day they are your friends, playing at a local bar. Soon they're

selling out venues across the state and garnering interest from around the country. Some then sign contracts with major record labels and push their fan base even further. Yet for many of these musicians, the goal remains the same: create the music and find a way to reach an audience, big or small.

Jimmy Brown is not originally from North Carolina. He was born and raised in Belfast, and he traveled the world in search of whatever was to come. It wasn't until he arrived in Charlotte that he found his voice, through music. After playing on his own for several years, he is now part of the band Matrimony, which he shares with his wife, Ashlee Hardee Brown. In 2012, Matrimony was signed to Columbia Records, one of the oldest and most prestigious record labels in the country.

Despite this, what remains important to him is the music. He talks intently about what he is writing, as well as other music that he enjoys. Much like myself, coming in to North Carolina has given Brown a different perspective on the music of this state. No matter what may come, I look forward to the music that Brown and Matrimony will create and to having them as another part of the bright future that the music of this state continues to hold.

Matrimony (left to right: Ashlee Hardee, Jimmy Brown, Jordan Hardee and CJ Hardee), UNC–Charlotte, February 2012.

COSTON: *How did you first get involved in music?*

JIMMY BROWN: I first got involved with boys' choir in school. I was eight or nine years old, and my teacher thought that I was awesome. She would try to pitch me for different parts. I really loved singing. One day, the cathedral came along, and they held auditions. I was one of 30 or 40 kids. We were all in one long line, and the priest came along, and we all had to sing the same thing so that he could hear what our voices sounded like. And he got to me, and he just kept walking.

He didn't pick me, so I was absolutely distraught. I went to my teacher, crying, and my teacher took me back to the priest, and she said, "Listen, you've got to listen to him sing again." And he still said no. After that, my dad was a roadie for a band. He drove the bus and would take care of merchandise. He would also play a lot of David Bowie, the Beatles and Led Zeppelin, a lot of UK bands during the 1980s, as well.

Later, I got into Bryan Houston, who is like the Belfast version of Bob Dylan. I went to all his shows and bought his records. Years later, I was playing a show down in Austin, Texas, at the South By Southwest festival. I was walking down the street, and he was sitting there with his wife. He was telling me that he was about to quit playing music, and he was my main inspiration. So I sat with him and quoted back to him all of his lyrics and how much they had meant to me. I wrote him a song called "Three Feet from Gold," and he named his next album *Three Feet from Gold*.

What brought you to the United States?

I had gone to South Africa, and Indonesia, and Europe. I had a friend who said, "I'm going to buy land in China. Do you want to go?" So I went to China, and then he said, "I'm going to buy land in Charlotte, in North Carolina. I'll pay your way if you want to come?" Soon after I got here, I met another guy from Belfast who was an amazing guitarist and singer. He later asked me to join his band. Actually, he didn't ask me to join. It took about three or four months, and eventually I told him that I should be in his band. I didn't even really know how to play guitar. I could play the chords and had written and recorded some songs, but I wasn't very good. But I joined the band and went to work, learning all the time and flying by the seat of my pants. Through that, and meeting some really good friends, I ended up staying.

What struck you about the music scene in North Carolina when you first moved here?

Growing up in Belfast, people have this perception that you grew up listening to traditional Irish music. Or just being Irish, people think that you're versed in all this music. The music in Northern Ireland is a very small, close-knit scene. I don't want to say anything bad about it, but there wasn't anything free about it, to me. But when I came here, there were kids playing music all the time. They grew up playing in churches, and they all play their instruments way better than my friends were

at home. They were just a whole lot more free about music. That may not mean that they were better songwriters, but they had a different upbringing than what I did. So I really latched on to that side of it. There was no fear in them, like getting up and playing something that they hadn't played before. I think that the people I've met here have been very open-minded and free, and they're just willing to go for it. I think the music around here suggests that. There's a lot of different bands, writing about different things. But the idea of people reaching out and doing it is what I like about it.

What happened after you decided to strike out on your own?

I made a decision that I wasn't going to turn down any show that anybody offered me. That first year, I played 150 shows by myself, and I traveled all across America. I would busk in the streets because I had no money, and I would play for five, six hours at a time and make enough money to get to where I wanted to go next. I'm really glad I did all that stuff, and I wouldn't be opposed to doing it now, if I wasn't married.

How has being married, and married to a fellow musician, changed your perspective on life?

The reason me and Ashlee started playing music was because we wanted to be married more than we wanted to be musicians. We did have dreams of writing these really great songs, but we realized that we wanted to be married, and we realized we couldn't be married and play separate musical careers. It is very hard to make that work, and we didn't think that we could do that. Since then, the most important part of our music is remembering that, that there's nothing more important to me than her, and if the music ever gets in the way of that, then we stop the music and we focus on the marriage. And that's where the power is, with the music.

Doing that also takes the pressure off, and that's usually when the good songs come. When you're not pressured by something that means so much to you, you let go a little bit. Our marriage has made music a little less important, even though it's still the second most important thing that we have.

Tell me about some of your favorite places to play in North Carolina.

The Evening Muse in Charlotte is one of my favorite places. I think it was the first place in town that I played in Charlotte. Joe Kuhlmann has a real big heart for music, and I think it shows in that place. In Chapel Hill, we played a place called the Station Bar a lot. That was a ton of fun. We've played at Local 506 a bunch of times. I played at The Cave a lot on my own. I really enjoyed the Berkeley Cafe in Raleigh — really nice bunch of people. I played at the Soapbox in Wilmington about five or six times. That was awesome. North Carolina's got a lot of great places to play.

What does it mean now to be part of the fabric of this state's music scene?

It's a privilege for me. I feel very, very honored to have any part in that. I never

thought that I would be part of it. I guess I am, now. That's the first I had thought of that. Just seeing the music that has come out of here. There's a lot of bands from Charlotte in the last six months that have gotten some attention and signed some record deals. Obviously the Avett Brothers have gotten to be a big influence, in terms of their attitude, and their work ethic, and their music. Even just knowing the history of the Double Door and seeing who has played there. The more that you hang around here, you also meet some characters who won't tell you what they've done. But once you get to know them, you find out that they've done some really cool things in music. There's nothing spectacular about how they present themselves. That's just what they do, and that's what I'd like to be. I'd say the majority of people that I've met in music are pretty levelheaded.

Anywhere You Turn, a Good Show

Every artist in North Carolina puts their own stamp on their music, and I've tried to let the photographs reflect that. On one side, you have the literary wit and thoughtfulness that is the Mountain Goats, led by John Darnielle. On another, there is the Americana-infused sound that is Megafaun. Both bands have seen their sound evolve and change. When I first saw Megafaun, they were immersed in the "old weird America" sound of Carolina folk songs and moody harmonies. When I saw Mega-

faun again, just a couple of years later, they had grown into a full-blown rock-and-roll band. This didn't disappoint me. Instead, it made me happy. New ideas, new sounds; isn't that what exploration is all about?

In Charlotte, the new artists make me want to keep going out to shows and taking new photos. Bands like Paint Fumes appeal to my love of 1960s garage rock, and just playing loud and having a good time. There are also bands such as Yardwork, who are

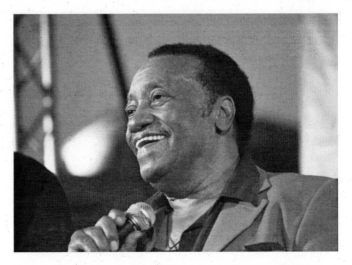

Maurice Williams looks out over a crowd at an outdoor amphitheater in Greenville, South Carolina. To this day, the way Williams connects with his audience is something to see. Some of the people that attend his shows have been following Williams since the late 1950s.

part of a collection that release albums through the locally based Kinnikinnik Records. Why stop taking photos now? I might miss something.

Above all else, it's the music of North Carolina that hits you, no matter what the size of the venue. The first time I saw Joe Thompson play, it was in the basement of the Main Library of Charlotte. Joe was the last of the traditional old-time string band musicians, from a time when musicians made what money they could from playing dances. Joe made the venue his own. For an encore, he put his bow aside, clutched his fiddle, and sang "I Shall Not Be Moved" like I hadn't heard anyone sing it before or since.

"I truly love The Cave, and Sadlacks; they feel like home," says Sara Bell. "The Garage in Winston Salem is a great club. I am looking forward to playing on the Tiki Bar Pier at Carolina Beach this summer! I think really dynamic performers that involve the audience are the best. I love how in African American tradition there is really no barrier between performers and audience; it's just understood that the one nourishes the other. I think I've always been too shy to perform music that way, and I wish I weren't. The times when I feel comfortable and talkative and able to engage with the audience between songs are always the best. I've gotten more comfortable with [playing live] over the years. The most fun bands to play with are the ones who love performing and everyone understands the dynamic of

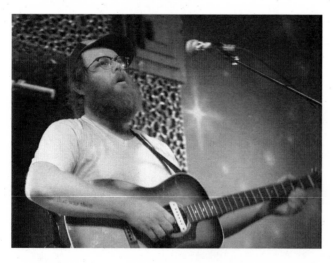

John Darnielle of the Mountain Goats, Visulite Theater, Charlotte, April 2012.

Brad Cook, multi-instrumentalist for Megafaun, Visulite Theater, Charlotte, June 2010.

Above: Paint Fumes (left to right: Brett Whittlesey, Elijah Von Cramon and Josh Johnson), Milestone Club, Charlotte, August 2011. *Right*: Joe Thompson singing "I Shall Not Be Moved" at the Main Library of Charlotte, September 2005.

performing and putting on a show and dressing up and having fun. I tend to be kind of nervous about it, so I like being in bands with people who aren't because it draws me out!"

Many performers can reach out to the audience with just their songs. Others, like the Chapel Hill–based band, Lost in the Trees, can take it a step further taking the show out to the audience. Lost in the Trees is a remarkable band to listen to, an emotional mix of symphonic pop and personal lyrics. After a full show on stage, the band usu-

Hip-hop musician, Charlotte, June 2006.

Lost in the Trees, led by Ari Picker (with guitar), performing in the audience, Visulite Theater, Charlotte, June 2012. Other band members, left to right, are Mark Daumen, Emma Nadeau (back to camera), Yan Westerland, and Jenavieve Varga.

ally finishes by performing in the audience. Along with the stark intimacy of playing while standing in the crowd, unplugging the instruments forces the entire crowd to pay attention and listen. As a photographer, it's great to get photos where the audience is literally standing alongside the musicians.

Sometimes, a musician generates a lot of energy with their onstage actions, working the crowd while jumping about the stage. However, it can be even harder for a musician to get a crowd to calm down and focus on their show. Through an extraordinary set of circumstances, I was asked to photograph Johnny Cash in June 2003. He played unannounced at the Carter family's venue in Virginia, the Carter Fold, to celebrate what would have been the birthday show for his late wife, June Carter Cash, who had passed away the month before. The show was beyond purely emotional; it was one of the most amazing shows I have ever witnessed, and photographed.

The announced band for that day's show was the original members of the Red Clay Ramblers. I am quite sure that Johnny Cash knew the significance of having these musicians on the show with him. The Ramblers were personal friends of the Carter and Cash families, having played at the Fold for years. They had also performed

Original members of the Red Clay Ramblers (left to right: Joe Newberry, Mike Watson, Bill Hicks, Mike Craver) performing at the Carter Fold in Hiltons, Virginia, June 2003, before Johnny Cash takes the stage. John Carter Cash looks on from the far left of the stage, and Jeanette Carter is sitting behind them.

at the funerals for both Sara Carter and Maybelle Carter, at the request of the Carter family. Nearly three years after this show, these same musicians would perform at the funeral of Janette Carter, founder of the Carter Fold. With them, and Cash's performance, the circle would remain unbroken.

I remember looking at the quartet on stage as they prepared to play. Joe Newberry, the newest member of

Bland Simpson, Red Clay Ramblers, Durham, September 2012.

Branford Marsalis performing at a free street festival in Charlotte in 2011. For this show, Marsalis's entire band was made up of musicians from North Carolina, which Branford has called home for a number of years.

the group, was playing his first show with the band. We were all trying to recover from the emotional experience we had just witnessed, and members of both the Cash and Carter families were still standing around the stage. It was like a thrilling and exhausting marathon that we had all just been a part of as the musicians tried to steady themselves for the next sprint. It took a little while, but soon the musicians had the dancers back out on the floor, and the crowd was singing along. Play good music, and music that you love, and the rest will follow. It was a wonderful, wonderful day.

While we're on the subject of the Red Clay Ramblers, I should also acknowledge the current version of the band, who have been led by Bland Simpson since 1986. Simpson and the Ramblers have continued to find new audiences through their work with musicals and various projects throughout the region. The lineup of the Ramblers may have changed over the years, but the music continues on.

When asked what a musician should do with an audience, Joe Newberry responds, "Tell the truth. Make sure that they have a good time. Make whatever happens on stage part of the show. And don't overstay the welcome. Grandpa Jones used

Bryon Sutton (right) with Bela Fleck and Victor Wooten, Ryman Auditorium, Nashville, Tennessee, July 2003.

to say, 'Son, don't make an audience happy twice. Once when you start, and once when you stop.' Performing for people is a pretty amazing thing to be able to do. No two audiences are alike, and that is what makes it so fun, figuring out, sometimes on the fly, what is going to make it work for that night. The trick is to not try and apply what worked with an audience the night before directly on the audience tonight. That usually never works."

The venues always change, but the audiences are always there. Branford Marsalis has seen this all over the world. I had the good fortune to photograph Marsalis at a festival in downtown Charlotte. The organizers set up the stage before the show and then carted it away when the show was done. But it is the people who filled the streets to hear the music that made it the place to be in Charlotte that day.

Marsalis had just flown back from a show in Russia and would soon be on the road again. Yet he told the crowd how good it was to be playing for the people of North Carolina, a state that Marsalis has now called home for several years. The band for this show was also special, made up almost entirely of music professors from various North Carolina colleges. It really was a welcome show, and the crowd loved it.

I have traveled far beyond this state and found musicians from North Carolina on stage. Walk into the famed Continental Club in Austin, Texas, and there's the Mayflies USA, one of the best pop rock bands this state has ever produced. I drove seven hours in a rainstorm to see Les Paul perform at the Ryman Auditorium in Nashville, Tennessee. Who was the first performer I saw on stage? Bryan Sutton, performing with Bela Fleck and Victor Wooten.

CHAPTER 4

Festivals

While many performers do like the intimacy of smaller venues, there is always the lure of music festivals, particularly the festivals that take place all across the state throughout the summer. As a musician, you go to the festivals because that's where the large crowds are. That's where your fellow musicians are. As a photographer, you go because that's where the music is, as well as the musicians.

Bluegrass and Traditional Music

Union Grove

It's 7:30 P.M. on a Friday evening. The sun is starting to set behind the tops of the trees that stand tall throughout the fields around me. I am in Harmony, North Carolina, which sits alongside its sister town of Union Grove. In the 1960s and 1970s, thousands flocked to the Union Grove Fiddler's Convention, held here on the VanHoy farmland. They walked, drove or carpooled to the event in search of old-time music. Some of the greatest musicians to ever grace this state came through that festival, and John Cohen, whose photography work in the Southern United States is still an influence on my work, came to document this festival in 1962.

Fiddler's Grove

In the late 1970s, the Fiddler's Convention moved away from the VanHoy farms, and other versions of the festival continued elsewhere. The Fiddler's Grove Convention, held every May just down the road from the VanHoy farms, continues to attract new visitors and music fans every year. But on this night in April 2012, the music came back to the farm where it all began. Visitors came in their RVs, campers and Airstreams, setting up throughout the farmland. As you walked through the parked vehicles, the sound of banjos, guitars and stand-up basses came from every corner.

135

Local musicians picking at the Union Grove Fiddler's Convention in Harmony in April 2012.

This continues as the full moon rises over the festival and everyone looks forward to the competitions and showcases the following day.

The original Fiddler's Convention may have left the farms for a number of years, but the music never did — that feeling of being part of something bigger than just you and your music, a mass congregation of bluegrass fans, full-time musicians and part-time pickers having a good time together. That feeling never left the grounds, and because of that, the people are back here again. The music returns, and an old festival begins anew.

"I used to sleep in my car and stay up all night listening," remembers Si Kahn about his younger days at the Fiddler's Convention. "I was there the year the Hell's Angels motorcycle club arrived in full force. I'll tell you one thing, a motorcycle is one hell of a lot louder than a fiddle."

This feeling is what brings many back to festivals throughout North Carolina, year in and year out. The faces may change and the music continues to evolve and grow, but it's that shared experience that remains, the chance to return to a favorite venue or favorite town, to listen again to your favorite musicians, and hopefully discover some new ones. North Carolina has hundreds of music festivals throughout the year, each with its own story and makeup of musical styles. But it's the love of music, and the people of this state, that ties them all together.

Musicians jamming in the signup cabin at the Fiddler's Grove Festival, Union Grove, June 2006.

Merlefest

The one festival that I get asked about the most is Merlefest. What began in 1988 as a way to raise money for a memorial garden for Merle Watson has become a Mecca for lovers of traditional music, as well as other genres. Yes, Merlefest has changed a lot over the years, as has the size of the crowds. With the passing of Doc Watson, the festival will change and evolve again. Yet the music will continue on, and the crowds will follow.

I knew about Doc Watson years before I ever got to see him in person. His name was on the lips of every music fan I knew in North Carolina in my formative years — the seamless interweaving of musical genres, and the seemingly effortless way he played the guitar. And oh, by the way, Doc had been blind since the age of one.

Arthel Watson was in born in Stoney Fork, North Carolina, in 1923. He was raised and lived the rest of his life in Deep Gap, North Carolina, in Watauga County. An eye infection caused him to lose his sight before his first birthday. As a child, Doc heard harmony and shape note singing at the local Mt. Paron Church. By the age of six, Doc was learning to play the harmonica. He received his first stringed instrument at the age of 11, a fretless banjo that was built by his father.

At the age of 10, Watson entered the Governor Morehead School for the Blind,

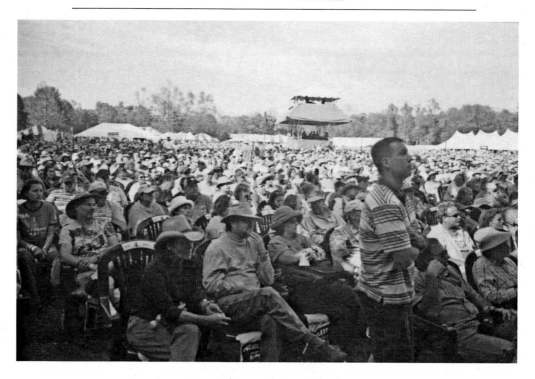

Crowd at Merlefest, Wilkesboro, April 2005.

located in Raleigh. While there, he began to hear jazz music and the playing of guitarist Django Reinhardt. Watson also learned a few guitar chords from a fellow student. Later Doc's father bought him his first guitar, a $12 Stella model. A few years later, Watson bought his first Martin from a guitar store in Boone and played on the streets of that town for tips, which helped to pay for the guitar within a few months.

Around this time, Doc began playing local dances. At a radio broadcast from a furniture store in Lenoir, the announcer decided that Arthel was too long a name to announce. Someone in the crowd shouted, "Call him Doc!"

Watson had first learned to play the guitar with a thumb pick, but then he realized that he could play some songs easier by using a flat pick. That ability showed itself again when Watson joined a dance band in the early 1950s. Hired to play lead electric guitar, Doc learned to play fiddle tunes on guitar, since the band did not have a fiddle player.

Out of those circumstances, Doc became a guitar player like few others. By the time that musicologists Ralph Rinzler and Eugene Earle first recorded Watson in the early 1960s, playing with Clarence Ashley and Gaither Carlton (whose daughter had married Watson), Watson could play a variety of styles and a huge collection of songs. Genres meant nothing to Doc. He had played them all, and enjoyed them. Soon after, Doc Watson began appearing nationally at folk clubs and at the Newport Folk Festival.

Within a few years, Merle Watson had joined his father on the road and on stage. Merle first appeared on one of Doc's recordings a mere eight months after first picking up the guitar. Along with being every bit as good on the guitar as his father, Merle brought stability and good advice to his father's career. Doc almost rejected playing on the landmark 1972 album *Will the Circle Be Unbroken* because the band that spearheaded the recording, the Nitty Gritty Dirt Band, invited Doc to the sessions but not Merle. Realizing what the project might mean, Merle encouraged Doc to play on the album. The resulting double album brought Doc Watson to a whole new generation of listeners.

When Merle Watson died in a tractor accident in 1985, his father almost gave up playing entirely. Yet the outpouring of love from fans encouraged Doc to keep playing. Picking up another guitarist from North Carolina, Jack Lawrence, Doc continued on. The outpouring of love also helped to spawn Merlefest. For many years, many like myself returned to Merlefest to hear the music and to see Doc. Merlefest will go on, of course, as will the music. Doc Watson may be gone from this physical plane, but his music will continue.

In 1994, the cable TV company I was working with at the time was slated to videotape a two-day music festival at Carowinds. What night did I want to work?

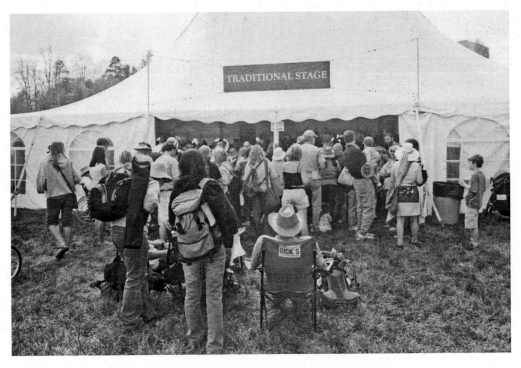

Music tent at Merlefest, Wilkesboro, April 2008.

they asked me. Friday night, I said. I want to see Doc Watson. So of course they booked me for Saturday and spent the day telling me how great Doc had been the night before. Such was that job, which nearly drove me out of the business before I ever really started. Thankfully, that job did not deter me in the long run.

In the summer of 1998, I finally got to see Doc Watson. It had been a bad month, as I had recently survived a car accident. Seeing Doc gave me a reason to be happy, and be happy to be alive. It was also the first time I photographed Doc, and it would not be the last. I remember how still Doc seemed to sit in his chair, picking out notes and phrases with remarkable precision. I set my camera up on the back wall of the theater and took a long-exposure photo. In the photo, everyone in the crowd, and Doc's grandson Richard, who was playing alongside of Doc, is moving. Doc sits perfectly still.

I honestly cannot tell you how many times I've photographed Doc. I have photos of him with so many great musicians — Ralph Stanley, Earl Scruggs, Jim Lauderdale, David Holt, and so many more. Seeing Doc sitting alongside Earl Scruggs at Merlefest in 2006 was just awe inspiring for me. I met him on more than a few occasions, listening to him tell stories about his rockabilly days and just growing up in Deep Gap, North Carolina. One of Doc's old classmates in school told me that Doc had been a bit of a troublemaker, and he never lost that sharp streak. He also never lost that independent spirit and that wish to play what he wanted.

Doc Watson influenced so many of us with his playing, with his shows, and with his life, whether you're Seth Avett, who visited Doc's house when he was a young teenager, or that fan who always looked forward to Doc's annual show in your hometown, or that person who discovered so much music and more each year at Merlefest. Above all else, Doc Watson meant something to all of us who call North Carolina home. The statue of Doc that sits in Boone, North Carolina, has one phrase on it, at Doc's request: "One of the people." He always was, and yet so much more.

I have seen so much at Merlefest over the years: legendary fiddler Joe Thompson playing with the Carolina Chocolate Drops; sitting down to watch a band and realizing that the guy sitting next to me is Bernie Leadon, a founding member of the Eagles; meeting John Paul Jones of Led Zeppelin, who was thrilled to be in North Carolina at Merlefest.

"Merlefest is a really big festival that keeps a low-key mood and atmosphere to it," says Dom Flemons. "As a performer, it's nice to be able to talk with the people in the audience. There's room to do that there."

Merlefest is the festival where many North Carolina musicians are discovered by a larger audience, or where the legendary musicians of the state come home. In 2005, Merlefest held a reunion for the numerous musicians who had been a part of Bill Monroe's Blue Grass Boys throughout the years. The Blue Grass Boys were the starting place for many of the best country and bluegrass musicians in the last 60

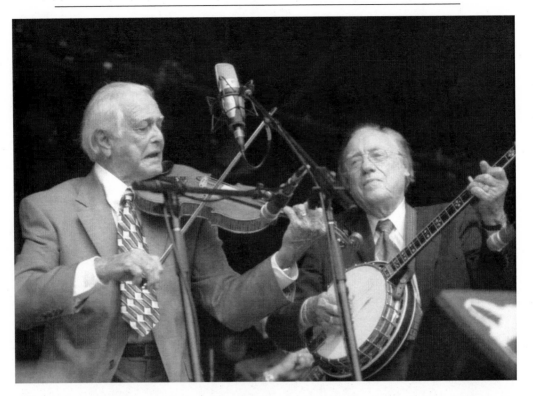

Jim Shumate (left) and Earl Scruggs, original members of Flatt & Scruggs, reuniting at Merlefest, Wilkesboro, April 2005.

years. In 1945, the band's fiddler, Jim Shumate, told Monroe about a banjo player from Shelby, North Carolina, which was close to where Shumate grew up. Earl Scruggs would revolutionize how many played or thought about the banjo and would help to define what was soon known as "bluegrass."

As with any band that has had a 60-year life span, the number of Blue Grass Boys alumni was impressive. They fanned out across the main stage at Merlefest, stretching two rows deep from end to end. A couple of songs into the set, Earl Scruggs walked out on stage as a roar began to rise from the crowd. Scruggs hit his first note on the banjo and immediately broke a string. Scruggs waved to the crowd and walked offstage to replace the string. You could hear a collective groan come from the audience.

Soon after, Scruggs reemerged. Standing on the opposite side of the stage from Scruggs was Jim Shumate, the man who had originally gotten Scruggs into the Blue Grass Boys. A few years later, Shumate would join Scruggs in the Foggy Mountain Boys, later changed to just Flatt & Scruggs. It was their version of "Foggy Mountain Breakdown" in 1948 that redefined what bluegrass could be, and how many people it could reach.

For much of the show, Shumate and Scruggs seemed to follow along with every-one else on stage, letting others take the lead. At one point, Scruggs acknowledged Shumate, which led to Shumate telling the story of how Scruggs joined the Blue Grass Boys and the response to Scruggs' three-finger style of banjo playing. "I wasn't with the Blue Grass Boys when Earl first played the Opry," Shumate recalled, "but I tuned in that night, and Earl burned that place down!"

Shumate and Scruggs then joined together at the center microphone. "We used to do this one with the Blue Grass Boys," said Shumate, "and with the Foggy Mountain Boys. Why don't we do 'Turkey in the Straw'?" Shumate and Scruggs started playing that song, and standing in front of those two, it was like an emotional lightbulb turned on. They were playing it at Flatt & Scruggs speed, which was lightning fast. Suddenly all of the other musicians who had been leading the show were trying to keep up with Shumate and Scruggs. It was that moment that made me realize how good the Flatt & Scruggs band had been, and how that bond of music still existed between the two of them. It was a breathtaking moment to have witnessed, and I loved every minute of it.

The last time I saw Earl Scruggs was also at Merlefest, in 2006. The festival was honoring Doc Watson by having him play with various luminaries. At the end of the

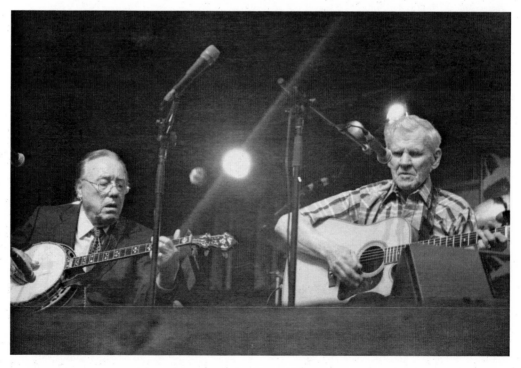

Earl Scruggs (left) and Doc Watson performing together on stage at Merlefest, Wilkes-boro, May 2006.

show, Earl came out and sat next to Doc. The sight of these two legends of North Carolina, on stage together at Merlefest, was really something to see. Getting a good shot of it, however, was a different matter. Both were sitting down as they played, and the main stage of Merlefest is so high that you could not see them above the stage monitors. I had to dive three or four rows deep into the crowd just to get a good view. There are so many photographers now at Merlefest that patrons get easily annoyed if a photographer gets in their line of sight or anywhere near their seat. I'm sure that I had a couple of people yelling at me when I took this shot, but once again, I was not going to leave Merlefest without this photo. Sometimes history must win out over momentary consequences. I don't ever wish to be nasty about getting the photo I want, but I knew then that I might not ever see this again.

Merlefest has given rise to some of the most prominent names in the bluegrass, country and Americana genres. If you do well one year on the cabin stage, which sits alongside the main stage, chances are you'll be on the big stage the following year. Sometimes just getting a Merlefest slot can keep a band going. In 2004, the Avett Brothers had been starting to attract attention, but the big break hadn't happened yet. At the same time, Scott Avett was thinking about going back to college for his art studies. I knew at the time that the group was weighing some options, but I didn't know until later that an agreement had been made. If they got an invitation to Merlefest, they would continue on. If not, Scott would go back to school. They got the invitation to Merlefest, and I photographed their first appearances at the festival. Even then, I knew that they would come back again to North Wilkesboro, as would their fans.

Special mention should also go to the Chris Austin songwriting award, given every year to the best up-and-coming songwriters. Previous winners have included Tift Merritt, Michael Reno Harrell, and David Via. One year when I was at Merlefest, I happened upon the awards ceremony. The second-place winners were a duo from the Chapel Hill area whose song was really good. However, I'd missed their names when they were introduced. A few years later, I was photographing a Chatham County Line album, and the subject of Merlefest came up. Suddenly, I realized that the mystery duo was Dave Wilson and John Teer, who were now the most prominent members of Chatham County Line. I should pay better attention to those awards, I thought to myself.

"Merlefest, Carolina in the Fall and Eno River, all great festivals, each with its own vibe," says Si Kahn. "I think I first performed at the third Merlefest, however many years ago that was, and I've played most years since. I especially appreciate that Merlefest asks artists to go into the local schools and share our music with the students. I've probably played at a dozen different schools in Wilkes County. I've talked songwriting and poetry with senior high English and theater classes, performed for 500 K–4 kids in a gym, and shared songs with developmentally disabled children. It's a great thing to do, for them and for us as artists.

"Carolina in the Fall, hosted by Robert and Brenda Shepherd and the Kruger Brothers, is a true family festival, both backstage and out in the audience. There's a sense of closeness and community. When I'm there, I'm playing for my peers, for my friends and neighbors, even if I don't really know all of them. It's music the way it used to be played, and maybe the way it still ought to be played.

"Both Merlefest and Eno River give back to their communities at a high level, something that matters a lot to me as a musician and as an activist. The Labor Day Festival in Boone organized by Joe Shannon and Mountain Home Music is a great event. I go even when I'm not playing."

"I think Merlefest is my favorite North Carolina festival, maybe my favorite festival anywhere," adds Tift Merritt. "It gave me my start. Everyone is so friendly and we just have such a wonderful time there. It always has its heart in the right place. I've got so many good memories playing there over the years — solo with songs for my first album, with my band in a thunderstorm in the theater, watching bands side stage, and then having our own main stage show. It means a lot to us."

"For me at least, [festivals are] a lot more fun," says Si Kahn. "There's much more chance for interaction with other musicians, which is one of my favorite parts of playing music. Sometimes I'll put together a band of friends just for a workshop or a main stage appearance. In the workshops, I'm on stage and working together both with artists I know well and with artists I've never met before. I've never played a festival where I didn't come home with at least two or three artists I've just discovered whose work I love.

"In a funny way — and this may just be my own experience — festivals are less work. The settings are less formal and more relaxed, so there's more chance to experiment. The audience is often more at ease than when it's locked into chairs and not able to move for 45 minutes, and that feeling floats up to the stage. The times on stage tend to be shorter, in general 15 to 30 minutes, so it's a challenge to reach out to an audience and pull it in within that time period. But in between those times, it's pure pleasure."

As for some of the advantages of playing festivals, says Kahn, "I love being in the same place for three or four days, without airplanes, rental cars, hotels, restaurants, getting lost, getting hungry, losing baggage, losing instruments and everything else that goes with life on the road. It's easier to get a good night's and, in my case as a lifelong napper, a good afternoon's sleep than when I'm racing to the airport at 6:00 A.M."

"Doing a concert as a solo artist, the only music I hear is my own, which by now I know pretty well. At a festival, I get to hear artists I've never met, kinds of music I've never heard before. Which is to say, at a festival, I'm as much audience as performer. Sure, a couple times a day I get up on stage and go to work. The rest of the day and night, I'm just having a wonderful time. I've come close to missing per-

formances because I was deep in a conversation and almost lost track of the time. That's one of the greatest attractions of playing festivals."

Mountain Dance and Folk Festival and Charlie Poole Festival

When you look at festivals throughout North Carolina, one is struck by the diversity and the sheer number of them. You have to start with the grandaddy of them all, the Mountain Dance and Folk Festival, which began in 1928 and still runs today. You also have the Charlie Poole Festival in Eden, North Carolina, which honors one of the founding fathers of country and bluegrass music.

Poole was the original trailblazer in so many ways: the first to fuse the roots of what became country, Americana and bluegrass; one of the first to find nationwide success via a recording contract; one of the first to play a three-finger style of banjo; one of the first to raise hell like a rock star. Charlie Poole was only on this earth for 39 years, but he packed as much living, and as much music, into that time as he possibly could.

Charlie Poole was born in 1892 in Spray, North Carolina, which is now part of the town of Eden. Like many in the area, Poole worked in the local textile mills for much of his life. This was something that Poole did not enjoy, and music was a way out of this life. Poole also played baseball as a youngster. At one point, Poole broke his thumb while catching a ball barehanded. This gave Poole's thumb a distinctive arch, which would help in his use of the three-finger style of banjo.

While many banjo players at the time used the older styles of clawhammer or strumming the banjo strings with a pick, Poole developed his own version of banjo playing. Utilizing his arched thumb, Poole played using his thumb, index and middle finger. Poole may not have realized how unique his fingerpicking style was. Even today, his weaving of melody and rhythm sets his playing apart from both older forms of banjo playing and the playing of Earl Scruggs some two decades later.

By the late 1910s, Poole had formed the North Carolina Ramblers with fiddler Rosey Rorer, whose sister had married Poole. The band name was appropriate. Poole, Rorer and guitarist Norman Woodlieff traveled all over, gathering money from dances and wherever an audience could be found. By 1925, the trio had signed with Columbia Records, and their recording of "Don't Let Your Deal Go Down Blues" became a major hit. The song went on to sell over 100,000 copies, and Poole and the Ramblers were soon on the road again.

The tales of Poole and his exploits are numerous: coming home with a wad of money tied in a knapsack, leaving his wife to count the bills; breaking a banjo over a policeman's head when the cop tried to break up a dance; disappearing on drunken excursions for days on end. Both Rorer and Woodlieff would later leave the band, but Poole would continue to record for Columbia for several years, leading various configurations of the Ramblers with a consistent hand.

Poole rarely wrote songs, preferring instead to put his own distinctive stamp on songs that he found. Much like A.P. Carter and the Carter Family, Poole's rearrangements of traditional songs became the versions of that song that people knew and then passed on to the next generation of musicians.

In 1931, Poole received an offer from a movie studio to go to Hollywood and record background music for films. When Poole was found several weeks later, the train ticket that the studio had sent was still in his pocket. Giving in to one last bender, Poole's heart gave out, and Charlie Poole passed into history.

During the 1960s, a whole new generation of musicians discovered Charlie Poole. That interest continues to this very day. Artists such as the Grateful Dead, Joan Baez, the Chieftains, and John Mellencamp have since covered Poole's songs. The Grateful Dead's Jerry Garcia paraphrased a Poole song title for the name of his bluegrass group, Old and in the Way. In 2009, another native North Carolinian, Loudon Wainwright III released *High Wide and Handsome*, a CD dedicated to the music and tales of Charlie Poole. In 2010, it received the Grammy Award for Best Traditional Folk Album.

When you look at their longevity, the aforementioned Mountain Dance Festival really has to be commended. Recognized as the longest-running traditional music

Young performers at the Mountain Dance Festival, Asheville, August 2007.

festival in the country, Mountain Dance has carried the traditions of mountain music, in all its voices and variations, to multiple generations. The festival also sponsors the Shindig on the Green, an annual collection of summer shows that also helped to bring this music to the masses.

Any discussion of the music of North Carolina is not complete without Bascam Lunsford, dubbed by some as the "Minstrel of the Appalachians." Born in Mars Hill, North Carolina, in 1882, Lunsford collected songs for years while teaching in various colleges across the state. Lunsford made recordings during the 1920s, two of which were featured in Harry Smith's fabled *Anthology of American Folk Music* in 1952.

In 1927, the city of Asheville invited Lunsford to organize a festival. Beginning in 1928, Mountain Dance and Folk Festival has continued for 75 years. Lunsford performed at every festival until he suffered a stroke in 1965. Lunsford also performed for President Roosevelt and King George VI of England during a trip to the White House in 1939.

Every year, the Mountain Dance Festival enjoys huge crowds at their events. That's one thing that should be said about these festivals. A select group of people put these festivals together, but it's the audiences that have supported gatherings like

Avril Freeman and Ralph Lewis share a moment backstage at the Mountain Dance Festival, Asheville, August 2007.

the Mountain Dance Festival and helped to give it the stature that it now enjoys. Music can give so much, but the concertgoers help to give these festivals the opportunity to keep going.

One photo from the Mountain Dance Festival wasn't taken anywhere near the stage. At one point, I wandered deep into the garage area that sits at the back of the Diana Wortham Theater. A few musicians were scattered around, picking bits of songs. In one corner stood Arvil Freeman talking to Ralph Lewis. Ralph was preparing to head out on the road, and Arvil wanted to wish him well. Arvil spoke quietly and sincerely, and Bobby listened.

There was a lot of history in that conversation. Freeman is a mainstay of the Mountain Dance Festival, teaching countless young fiddle players. Ralph Lewis toured for years with Bill Monroe, and both men are still out there playing today. As I said before, there was a lot of history, and living history, in that conversation, and I'm really glad that I got a photo of that as it happened.

That's one of the things that you can gain from festivals like the Mountain Dance Festival, the chance to learn from the best and to pass on the music. "The mentoring from the master musicians, that's a huge part of what goes on here," says Laura Boosinger, who has taught classes at the Mountain Dance Festival since 1999. "One thing about the Mountain Dance and Folk Festival is that all the musicians are accessible. That is what folk festivals do. They put the musicians right there with the fans. This is a real person-to-person experience. It's a real hands-on experience. Part of our mission is that people get involved in any way they can. We're about preserving."

Swannanoa Gathering

One festival that holds a special place in my heart is the Swannanoa Gathering, held annually at Warren Wilson College, in Swannanoa, North Carolina. Every summer, the Gathering brings together some of the best musicians in the world for classes, jam sessions and concerts. Traditional song, Celtic, violin, and guitar are some of the subjects of the weeklong classes.

Alice Gerrard onstage at the Swannanoa Gathering, Swannanoa, June 2009.

Along with meeting a lot of great musicians, I have learned

Teacher and student performers at Swannanoa Gathering, Swannanoa, June 2009.

so much just by witnessing the classes and concerts. Playing on a violin like a hammered dulcimer, while someone else is playing the violin; shape note singing, which is still used by some church congregations in North Carolina — these are some of the things I had heard about but had not seen until I went to Swannanoa. One year, after photographing a great concert, I went to my car to grab some more film. When I came back, the legendary singer Jean Ritchie was sitting in the lobby of the college's theater, taking part in shape note singing with a group of local singers. Everywhere you turn at Swannanoa, you can find something remarkable.

Ola Belle Reed

In August 2007, I decided to search out a festival I had heard about. Ola Belle Reed was a remarkable woman, a feisty songwriter who had an energetic banjo-picking style, a vibrant "hillbilly" twang, and had written more than 200 songs in her lifetime. When Reed passed away in 2002, her family founded the Ola Belle Reed Music Festival, held in Reed's hometown of Lansing, North Carolina. Lansing is an old railroad town that is now home to Fort Awesome, an art enclave in the town's old high school building.

As I arrived, I was immediately welcomed in by Reed's sons, who were running the festival. "Have you seen the guitar?" they asked. No, I replied. What was special about it? The day before, the festival had begun an attempt to set the world record for the world's longest jam session. All of the festival's musicians took turns throughout the night, and just as I arrived, the record had been set — 24 continuous hours jamming. The Reed family had passed around a guitar that had been used during the jam and had gotten everyone who had taken part to sign it. By the time I saw it, there wasn't space to fit another name. "Here, hold it," the family said. Within a matter of minutes, I had met the Reed family, photographed the commemorative guitar for a world-record-setting event, and then photographed the family with the guitar. Needless to say, I felt honored to be there.

Signed guitar at the Ola Belle Reed Festival, Lansing, August 2007.

Black Banjo Gathering

Not all festivals in North Carolina are annual events but are still very special events that need to be mentioned. The Black Banjo Gathering was put together in 2005 as a way to celebrate the history of Americans and the banjo. The first gathering proved to be a watershed event and introduced many musicians to the possibilities of traditional folk music. Three of the

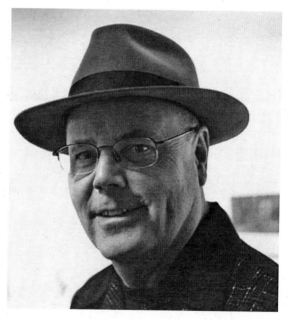

David Holt at the Black Banjo Reunion at Appalachian State University in Boone in 2010. Holt is a respected musician, historian and folklorist. He and I had just been talking about the importance of photography when I had him pose for this shot.

Musicians jamming backstage at the Black Banjo Gathering, Appalachian State University, Boone, March 2010.

event's attendees, Dom Flemons, Rhiannon Giddens Laffan, and Justin Robinson, discovered a common love of this music, and with the tutelage of another attendee, Joe Thompson, the Carolina Chocolate Drops were soon born.

In 2010, many of the key members of that original Black Banjo Gathering returned to Appalachian State University for a reunion and a continuation of those ideas. David Holt traded stories with the Chocolate Drops, while others met, traded songs, and the circles grew again. It was a remarkable event, with musicians from all walks of life sharing a common bond of influences and song. Sitting in the audience before the show, I heard this music coming from the stage area. It was a simple song, yet strangely hypnotic. At first, I thought it was coming through the stage's PA system, but I started to listen closer. No, this hypnotic music was coming from just off stage. Making my way through the curtain, I found the entire cast of that night's performers, all gathered around a table, jamming together on this one song. This continued for another ten minutes. At one point, I realized that one of my photography heroes, John Cohen, was also sitting at the table. I felt like I should hand him my camera, but he was enjoying the music, just like me. So I smiled and let the music continue.

I should also mention that folk music societies are a great way to learn about music festivals and who is playing them. Organizations such as the Charlotte Folk

Society, the Fiddle and Bow Society in Winston-Salem, and the Piedmont Council of Traditional Music — these present monthly concerts that feature music from throughout the region, but also information on where else you can find music throughout the state.

Red, White and Bluegrass Festival

I'm also a fan of festivals such as the Red, White and Bluegrass Festival, held every July in Morganton. The festival is held on the town's baseball fields, and its fun to watch the musicians share space with pickup baseball games. That being said, the festival is really a bluegrass institution and features many local groups, as well as national acts. The Big Lick Bluegrass Festival, held near the town of Big Lick, is also a fun event to just walk through, listen and take photos. At one point during my trip there, I heard music coming from behind a barn. It turned out to be the next scheduled band to play, rehearsing their set. The band was busy, so they didn't pay attention to me. There was something pure about shooting that scene. There was no audience, just musicians trying to get their sound right.

Skip Cherryholmes, Red White and Bluegrass Festival, Morganton, July 2009.

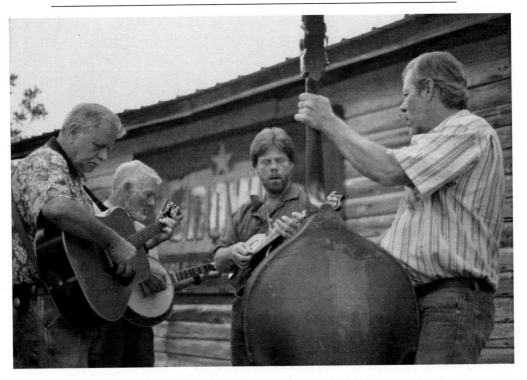

Southern Junction (left to right: Jim Sanders, Bob Shue, Todd Shue and Terry Shue), rehearsing, Big Lick Bluegrass Festival, Big Lick, May 2009.

Mount Airy Fiddler's Convention

One of the oldest traditional music festivals in North Carolina is in Mount Airy, which began their Fiddler's Convention in 1972. Everywhere you turn at that festival, you'll find music — coming from the main stages, where the competitions are held, and out of every camper and tent, and sometimes in front of the campers and tents. Walk up the hill, to the shaded areas overlooking the ball fields, and you'll find more tents, and more people making music, three or four in one place, 20 people in another. Some are professional musicians; some aren't. Some are there for the day, and others are there for the weekend. It may be hot out in the sun, but there's always something to listen to.

My schedule doesn't always allow me to go to a music festival for multiple nights. Sometimes a few quiet moments at a festival is all I need. One night, I was in Union Grove, photographing some friends, when I decided to check out Fiddler's Grove, which was setting up for another great festival. I walked down the street and found everyone gathered in the main office. For these people, it wasn't about attendance numbers. On this night, it was meeting up again with old friends and playing songs together again, before the larger crowds showed up the following day. No one said

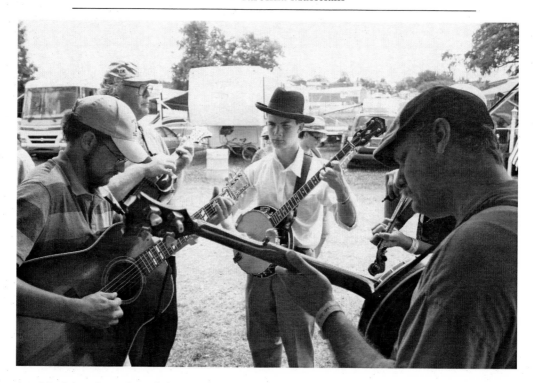

Musicians jamming while preparing to go on stage at the Mt. Airy Bluegrass and Old-Time Fiddlers Convention, Mount Airy, June 2011.

anything to me, and I didn't want to spoil the moment. I took some photos, listened to the music, and walked back to the Cook Shack, where RC Colas and more music awaited me.

Shakori Hills and Hoppin' John

I have a lot of great memories of the Shakori Hills and Hoppin' John festivals: Tift Merritt being reunited with her Bramble Rose–era touring band, and the ecstatic crowd reaction to their set; Johnny Irion performing with his wife Sara Lee Guthrie, while at the same time keeping track of their two young kids, who were wandering on and off stage; wandering through the different tent areas and hearing the different music that everyone was playing, or trying to play. Do you know this song? Doesn't matter. You'll learn it soon enough.

"I've always enjoyed playing at the Shakori Hills Grassroots Festival in Silk Hope," says Dom Flemons. "It's just such a fun and funky festival that brings in great people from the surrounding communities."

"I've enjoyed Shakori each time we've played, although we seem to make it rain there," says Caitlin Cary.

"We always have a killer time at Shakori," says Mandolin Orange, "and really enjoyed playing Beaufort Music Festival. They set you up right on the water. It was awesome to be a part of Hopscotch Music Fest. There's so much energy and momentum surrounding that festival.

"In some ways, festivals are more relaxed, everyone's already there and you're usually well taken care of. But the pressure to perform well at a festival seems a little higher. For a quieter band on a big outdoor stage, it's hard for the sound to not just dissipate, and it can be harder to engage a crowd outdoors. That said, there's usually a great vibe at festivals. Everyone's in a good mood and there to enjoy music."

"At a festival," says Dom Flemons, "you have a few things that clubs and theater do not have. You're usually outside. That's a nice thing

Signposts at the Shakori Hills Festival, Shakori Hills, May 2009.

most of the time unless the weather is miserable, and then that can be hard. The set times can be different. Some fests have you in the afternoon, some at night, but it can vary, which is a nice changeup. There are other acts, not just an opener. Based on the festival, there are acts that you can watch. This can be great if you play at a festival which has several acts that you might want to see or maybe have heard about. And every once in a while, you are performing with mutual friends who are musicians, and that's the best. See your friends, hang out, and jam if you have time.

"As our group has gotten bigger, we rarely stay more than one day at a festival. This is a sad reality because some festivals are great all the way around, and it is a pain to miss a day. At the same time, a festival is fun but you are at work, and we just move on with your day. It's nice talking to other musicians on the bill even if you have a 'How's work going?' conversation. The job of a musician is a very different style of work, and it can be comforting to talk to others who are in your field compared to your friends and families who may not completely get it."

"You tend to see a lot of music before and after you play," adds Caitlin Cary, "which can be inspiring and intimidating, both. I tend to find festivals exhausting, because I always want to see everyone else. One big advantage of festivals is financial.

You're assured of what you're going to make, and the pay tends to be pretty good. It's also really great in terms of building an audience. You're pretty certain to play in front of lots of people who haven't heard you before. It's also a great opportunity to network with other artists, since you're often thrust together, staying in the same hotels, sharing hospitality, doing workshops together, et cetera."

I have discovered so much good music and musicians at festivals. For years, I had heard the name of Benton Flippen. I first heard about Benton through other fiddle players, who spoke about him in revered terms. Flippen was the last of a special group of musicians who had come from the Surry County area of North Carolina.

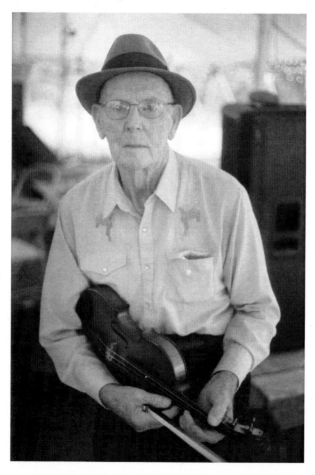

Tommy Jarrell, Fred Cockerham, Flippen and others popularized a sound that mixed Celtic, African banjo and gospel influence. Flippen also approached his fiddle playing like few others. He preferred to slide his middle and index down the neck of the fiddle, rather than fingering the notes.

In 2009, I heard that Flippen would be at the Hoppin' John Festival, a fall festival held on the grounds of the Shakori Hills Festival. It had rained the night before, so the air was cool and one had to watch for mud patches. I found Flippen in a tent in the back of the festival, surrounded by swaths of trees. The crowd that had gathered to see him was not large, but it did not seem to matter to him. Folks called out songs; he played them. You would not have thought that Flippen was 89 years old, as he was that fall. He played until the next scheduled band appearances, and then he sold CDs to the fans that stuck around to talk to him.

Benton Flippen posing for a photograph after a performance at the Hoppin' John Festival, held on the grounds of the Shakori Hills Festival, near Silk Hope in 2009. Flippen had a distinctive rhythmic quality to his playing and was the last of his generation of trailblazing fiddlers.

Flippen was not a conversational man, but he was generous enough to pose for my photos. I was still shooting on film at the time, so while I did take some color photos of him, I took special care in getting good photos of him in black and white. Black-and-white film photography is still very close to my heart, no colors to worry about. Black and white feels less cluttered, more direct. I wanted the photos of Flippen to feel timeless, like they could have been taken at any point in the last 50 years.

I asked Flippen where he was off to, and he said that he was heading back home that evening and then was planning to go out to another festival. No plans to retire. Flippen played until he left this earth in 2011, and somewhere I believe that he is still traveling, off to another show.

"Festivals are a ramped-up version of everything," says Justin Robinson. "Faster sound checks, shorter sets, more running, more waiting." As for the advantages of playing festivals, he mentions "being able to reach a larger audience and having people be exposed to your music who otherwise would not have listened."

Rock and Roll and Beach Music

Matthews Alive

When I started photographing festivals, I naturally went to the ones around Charlotte or nearby towns. I remember being very excited to photograph the Spongetones at the Matthews Alive festival in the early fall of 1996. The Spongetones are legends in the Charlotte area, having carried the banner of Beatlesesque pop for over three decades. Looking back, I knew so little about the camera that it's remarkable I got any good photos at all. I later went on to photograph a couple of Spongetones records. Matthews Alive has also continued to present music of all kinds, as have many small festivals throughout the state.

Center Cityfest

In the late 1990s, Charlotte had its own music festival called Center Cityfest. The local magazine I was with at the time was always offered photo passes, which I would immediately grab. The festival featured a number of national acts, as well as a fair number of regional acts. Several local bands I worked with early on, such as Lou Ford, Mercury Dime, Violet Strange, Laburnum, and others, would play before the "big acts." I learned to give every artist I shot my fullest attention and tried to get something different out of each set of photos. When you shoot 15 to 20 bands in a day, all of the photos can blend into one another. Trying something different with each artist makes you think about the photos and try to make them reflect something in the subject.

Steve Stoeckel (left) and Jamie Hoover of the Spongetones enjoy some rock and roll at the Matthews Alive festival, Matthews, September 1996.

One fantastic North Carolina band that I first saw at Center Cityfest was Superchunk, who are from the Triangle area. Superchunk has been at the forefront of the American indie rock movement for over 20 years, and their record label, Merge Records, still represents what every fledgling record label wants to be — fearless, proud to be themselves, and successful in both critical and commercial terms. In 2011, one of the bands on the Merge label, Arcade Fire, won the Grammy for Album of the Year. For many years, it seemed an impossibility to think that an independent label might ever win the most coveted award in music, but Merge pulled it off.

By the time I first saw Superchunk in 1998, Merge Records had begun to outgrow the small homes and living rooms that it had first been based out of, but its staff still consisted of the band and a few of their loyal friends. I sent my photos from Center Cityfest to Superchunk, which led me to doing more photos of the band. Eventually they hired me in 2001 to do their promo photos. "You're the first photographer we've ever hired to take our photos," their bassist, Laura Ballance, would later tell me, "so we're a little nervous." "You're nervous?" I remember thinking. "You're nervous? You're Superchunk! I'm as nervous as heck." That being said, the band was great to work with, and I'm proud to have been hired to work with them.

Superchunk (left to right: Laura Ballance, Mac McCaughan, Jim Wilbur and Jon Wurster), Charlotte, May 1998.

"I loved Troika Fest in Durham," says Chandler Holt. "Unfortunately, it is no more. It was the perfect size and had a really great thing going. It wasn't corporate or glitzy in any way. Just hardworking bands and a lot of folks who really love music."

As for bringing your music to bigger crowds, "You can definitely deliver your music to a much larger audience," says Holt, "and to a lot of folks that wouldn't normally be able to hear you." And as for sharing the stage with many other artists, "That's a big part of the fun for musicians. You get to see people you've met on the road and meet lots of new musicians. There's a lot of great volunteers that make these things happen, too."

Bele Chere

Special mention should also be made about Bele Chere, one of the largest free music festivals held in the country. Every July, people flock to the streets of Asheville to enjoy three days of music. Traditional music, rock music, whatever you're into, it's there. Some of my favorite bands to see there have included the Sons of Ralph and David Holt and the Lightning Bolts, among others.

Speed Street

Every year, the city of Charlotte holds SpeedStreet, a free celebration that coincides with the Memorial Day NASCAR race at Concord Motor Speedway. One year, the festival dedicated an entire stage to beach music in the Carolinas. It's still one of the most impressive lineups in this genre that I have ever seen. The Fantastic Shakers, the Tams, Billy Scott, Maurice Williams, and South Carolina–born Bill Pinckney, all playing within a three-hour set. I happened to have another gig that in another part of town. When that gig finished, I walked over to the show, took lots of photos, and went back home. All for free admission.

Billy Scott performing at the Don Gibson Theater in Shelby in 2011. Scott was a pioneer in the beach music scene and one of the nicest musicians I ever had the pleasure to work with. His sudden passing in late 2012 has left a void in the hearts of many of us that knew him.

Festival of the Eno

When asked about his favorite festivals in North Carolina, Joe Newberry names "Festival for the Eno in Durham, Merlefest in North Wilkesboro, Eastern Music Festival and Fringe Festival in the Triad, and Seafood Festival in Morehead City." As for the difference between festivals and shows in other venues, Newberry says, "There is usually not as much place and privacy to prepare at a festival, lots of fans and folks who want to visit. So I warm up before I head to the festival grounds! Playing festivals allows you to stretch out a bit because the audience is outdoors, feeling good, and ready for fun. I get a lot more people singing along at festivals. It is always fun to run into old friends on the bill at festivals, but they work us pretty good. Still, there is usually a little bit of time to catch up before we head off to the different stages."

"We always had fun in Wilmington at the WE Fest," adds Sara Bell. "And the Eno Festival is great because you are contributing to such a good cause. I am a Gemini, which means I have a powerful attention deficit disorder, and endless hours of hanging around in anonymous bars gets old really fast. The cool thing about playing at festivals is you can wander around and see all the other bands and eat new food and shop for homemade jewelry like everyone else, so it's very stimulating."

Valient Himself, of Valient Thorr, plays with the crowd during an appearance on the Warped Tour. Charlotte, June 2004.

There is one thing that you have to prepare for with summer festivals in North Carolina: the summer heat. Granted, this state does not have a monopoly on hot summer days, but when you're photographing musicians for several hours straight in the blazing sun. I photographed the Warped Tour, an annual national tour of punk and rock bands, the first few times they came through the state — nine hours straight of music, a band on a different stage every half hour. I saw a lot of good music at those shows, including North Carolina's own Valient Thorr, but it's an endurance test that I try not to do every day.

Blues and Jazz

While many festivals throughout the state are devoted to traditional music, there are many that offer other genres. For jazz, there are large festivals in Asheville, Wilmington, Charlotte and Durham, as well as smaller fests in other cities. Festival of the Eno, held every year in Durham, offers three days of music of all genres. A good numbers of local musicians are featured alongside national acts, and it is a great place to discover new music. Special mention should also go to the Hopscotch festival in

Raleigh, which also showcases rock-and-roll acts from all over, as well as spotlighting acts from the Triangle area. For the blues, there's the Bull Durham blues festival, held in Durham every September.

Gospel Music

Happy Valley Music Festival

One of the great joys of music festivals in North Carolina is just finding them, and the musicians that you discover there. A few years ago, I happened to find a flyer for the Happy Valley Music Festival, held near Lenoir. The Happy Valley Music Festival shares the same land with the grave of Laura Foster, who was killed by her lover, Tom Dula, in 1866. Decades later, a folk song about the murder, renamed "Tom Dooley," became a major hit for the Kingston Trio. A full day of music, and Laura Foster's grave? Sign me up, and off I went.

Popas Ferguson preparing to play at the Happy Valley bluegrass festival near Lenoir in 2009. Ferguson was 82 years old when I took this photograph, and to this day, he is dressed to the nines every time I see him. Ferguson learned to play while busking on the streets of Lenoir. It has been great to watch his fanbase grow in recent years.

I arrived just before noon on Sunday as their "gospel day" was about to start. What I love about smaller festivals is their lack of pretense. The lines between performer and fan are much more relaxed. I decided to wander into the backstage area, which was just a couple of small tents behind the stage.

In one tent, tuning and talking to another musician, was an older gentleman, elegantly dressed in a Sunday-best suit. It was like walking into a waiting photograph, where the visual idea of a great bluesman matches what you're hearing. I took several photos, with the musician paying little notice of me. I later introduced myself, and the musician introduced himself as Pop Ferguson. Pop, or Pops, as he's sometimes known, began playing on the street corners of Lenoir in his early twenties, playing a mixture of Carolina country blues that he grew up hearing. Pops is now 85 years old and has been recognized nationally as one of the last of the old-school country bluesmen. Ferguson now even holds his own annual festival in Lenoir, and I'm thrilled to see him get his due.

In another tent, I ran into Laura Boosinger, whom I knew from playing in David Holt's band. Soon after, I fell into a long conversation with a gentleman about photography. I was still shooting film at that point, so we talked about the pros and cons of that and the best places to find older camera gear. The gentleman turned out to be one of the Kruger Brothers, whose music has reached audiences all over. The Brothers are in a rare class that can jump easily from traditional music into symphonic pieces. Their "Appalachian Concerto," written for banjo, guitar, bass, and string quartet, has been performed the world over. But on this day, the Brothers were enjoying a local gig and playing for those who had come to the festival. I spent much of the day taking photos, hav-

Laura Boosinger and her banjo backstage at the Happy Valley festival in Lenoir in 2009. Boosinger is a respected musician and historian and often plays in David Holt's band. She doesn't always like posing for a photograph, but I was determined to get this shot.

ing fun, and wading in the nearby stream while eating ice cream. Needless to say, I had a lot of fun.

Gospelshout

The city of Charlotte also has its annual celebration of gospel music. Gospelshout grew out of an annual event called Charlotte Shout, which has various events going on throughout the city every September. For one night a year, the Charlotte home base of the United House of Prayer for All People opens up their doors for a free event and an evening of shout band music.

Shout band music grew within the church as a mixture of gospel music and New Orleans–style marching bands. It's loud, rhythmic, and amazingly cathartic. For Cedric Mangum, this is a family event in many ways. His wife leads her own choir for the church, and his son now leads the Mighty Clouds of Heaven, which also features several second- and third-generation performers of this music.

Many of those in the shout bands will have their children carry on this tradition. They grow up in the church, surrounded by this music. The first year I went to Gospelshout, there was a little boy walking around with a little horn, trying to emulate

Young musician at Gospelshout, United House of Prayer for All People, Charlotte, September 2006.

Gospelshout, United House of Prayer for All People, Charlotte, September 2006.

the musicians, and you knew that someday he would join the shout band. He even carried a towel with him to wipe off the sweat from playing this joyous music, just like many of the older musicians do. That kid is now just a few years away from joining the band full time, and I'm sure I'll photograph him when that day comes.

Best of the Rest

It's almost impossible to attend all of the music festivals in North Carolina in a calendar year. The same goes for myself being able to mention all of the festivals that this state contains. That being said, I would like to list several that deserve more than the mention I can give them: Moogfest, the Carolina Blues Festival, LEAF, the Outer Banks Bluegrass Festival, Lil' John's Mountain Music Festival, the Bascom Lamar Lunsford Festival, Hopscotch, the Charlotte Sunset Jazz Festival, the John Coltrane Jazz and Blues Festival, the Blue Ridge BBQ and Music Festival, and the Beaufort Music Festival. There are numerous other fairs and street parties through North Carolina that feature music in some capacity.

There is so much more that this state offers every year. Yes, I haven't even

Benton Flippen heading home from the Hoppin' John festival, Shakori Hills, September 2009.

scratched the surface, and I hope that you'll do some searching on your own. Part of what drives me is the knowledge that I have not seen everything there is to see. I have not gotten to every festival, seen every band I want to, or gotten every photograph I want. And I hope that I always feel that way.

At the end of every festival, there is that moment when the last note of music is played and the crowds begin to make their way to the exits. The musicians exchange contact info and then exchange good-byes. Everyone relaxes and then prepares to hit the road again. Many of the musicians will continue on to their next gig. Sometimes it's another festival or a show in a venue across the state, or across the country. But for a few others, it is the end of their tour, or just time for a break. They make their way through the front gates of the festival and make their way home.

CHAPTER 5

At Home

The musicians of North Carolina often travel the world, but sooner or later they return home, to homes in the mountains, near the beaches, or somewhere in the foothills. Sometimes it's a brief trip home before another tour begins again. Other times it's for a longer spell, to write, record, or perhaps take care of their families. Whether they are at home or halfway across the world, the music from North Carolina continues to flow from its borders, be it from new musicians or those that are the last of their kind.

Joe Thompson

Joe Thompson's home sat in the middle of a row of small houses, down a narrow road near Mebane, North Carolina. The first couple of times that I went there, I had to find Joe's house in the evening, after dark. There was very little light on Joe's street. You would have to look for the small house number on the mailbox and the cars of other musicians in the driveway. You would park behind the house and enter through the back kitchen door. I honestly don't think I even knew what the house really looked like until the fourth time I was there, when I drove up for a get-together one afternoon between Joe and the Carolina Chocolate Drops.

If you had happened to drive down the street to Joe Thompson's house, you would have never guessed that a world-famous musician lived there, someone who had been awarded the National Endowment for the Arts fellowship in 2007 and had performed at Carnegie Hall, someone who had been a mentor to the Carolina Chocolate Drops and many others. But Joe had lived there before he was famous, and he still lived there when the world came knocking on his door.

Joe was one of the last that played old-time string band music, a form of traditional music that predated bluegrass, with its roots in African American songs. At different times in his life, he was often on the road, but Joe Thompson always returned

home, to his family, to that home near Mebane, and to North Carolina. Like many other musicians I've been lucky enough to meet and work with, they may have been known the world over, but they still came home to North Carolina.

Even when Joe Thompson was home, his fiddle was never too far away. "Joe is the one in his family that decided to keep on the older style," remembers Dom Flemons. "There has to be one person who holds on to the traditions and keeps them going. It's very important that people celebrate him for that. It's building a community of people who want to play the old-time music.

"I first met Joe at the Black Banjo Gathering. At the time, I had been playing a lot of old-time blues and country music. When I saw Joe, all those elements of blues and country and also early jazz, I saw how all those things came together with string band music in Joe. They're all interconnected. That's what Joe gave me first. He really laid that concept out for me. It was a real pleasure to be able to sit down with him and learn those old wonderful tunes."

Thompson and the Drops would sit together in Joe's living room. The Drops would ask about songs, or ask to play a song that they had recently learned from Thompson. Joe would then lead the group through that song and occasionally recall things about it, where he had learned it, where he had played it. Watching them all play together was something special, and something I'll always cherish.

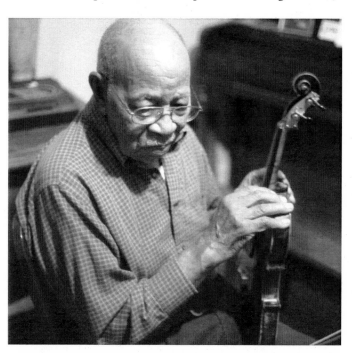

Joe Thompson tunes up his fiddle while sitting in his living room in Mebane in 2007. Thompson's career is an amazing story, and he deserved every accolade that he received. He also helped to preserve many old-time songs that might have otherwise been lost. He helped to bring together the Carolina Chocolate Drops and his music lives on through them and each of us that spent time around him.

In 1973, Joe Thompson was working at a furniture factory near his home of Mebane. He was still playing the fiddle, but his days of touring and playing North Carolina seemed like a distant memory. When folklorist Kip Lornell came to visit Thompson, he was in

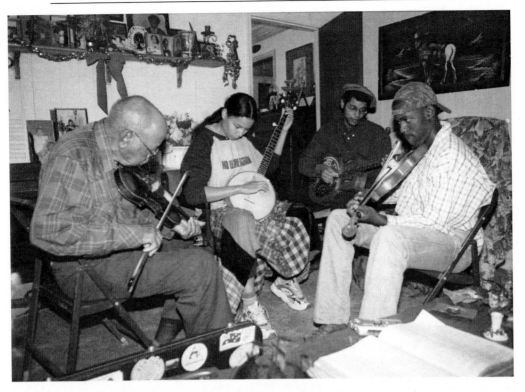

Joe Thompson and the Carolina Chocolate Drops (left to right: Rhiannon Giddens Laffan, Don Flemons, Justin Robinson) rehearsing in Joe's living room, Mebane, June 2008.

search of the old-time string band music that Thompson played. Thus began Thompson's second career, as one of the last to carry on the music that he loved to play.

Joe Thompson grew up in central North Carolina. His father had learned to play the fiddle from his own father, who had been a slave. Joe took the wires from the screen door for his own first fiddle and was playing a real fiddle at dances by the time he was seven years old.

A few years later, Joe formed a string band with his brother Nate Thompson and cousin Odell Thompson. They toured as much of North Carolina as they could, playing dances and wherever a good audience could be found.

"Joe Thompson is special," says Dom Flemons, "because he was an example of a musical style that is rare in the old-time community, and even more rare in the black community. He played a set of tunes that he learned in his family and played in the square dances in his community of Mebane, North Carolina. He also sang very old Primitive Baptist songs that have nuances in the singing that reflect the church singing in his community growing up. During Joe's lifetime he saw the way that the music in his community changed from the more community-based string band and spiritual styles to the more individualistic blues and gospel styles. The fact

that he kept playing the fiddle during that time is a rare and important link to an era that has faded in the black community."

Joe served in World War II, driving a bulldozer in a segregated outfit in Europe. When he returned home, the days of playing and touring had changed, and he took a job at a local furniture company. When Lornell came calling in 1973, Joe's brother had moved away to Philadelphia, so it was Thompson and cousin Odell who played that day for the young folklorist.

Lornell encouraged the Thompsons to start playing again, which they soon did. In the interim years, the music that Joe had grown up playing with had fallen from the memories of many. While the music that Thompson played shared some of the same roots as what grew into country and bluegrass music, black fiddlers tended to play in a style that was more rhythmic. As other fiddlers began to play more country blues, that older influence was not passed on to many. Thompson did not know the importance of the tradition that he carried, but he recognized the chance to bring his music to a new audience.

Joe and Odell, and sometimes accompanied by Nate Thompson, played wherever they could, from Massachusetts to Washington State. They played Australia. Famed folklorist Alan Lomax featured the three Thompsons in one of his documentaries. In 1990, Joe and Odell took their show to Carnegie Hall.

Through the years, Joe Thompson suffered many hardships. But he carried on. When his wife Hallie passed away in 1985, when Odell Thompson was killed in a car accident in 1994, and when Joe suffered a stroke in 2001, he carried on, as did the music. And more came to recognize his music. In 2007, he received the National Endowment of the Arts Fellowship and performed at the Kennedy Center.

I first saw Joe in 2005, playing in Charlotte as he was given an award by the Charlotte Folk Society. The stroke had affected his playing, but his voice rang through the room with remarkable strength. I then got to know Joe through the Carolina Chocolate Drops, who had started playing together through informal jam sessions at Joe's house. Every December, several people in Mebane would hold an annual birthday party for Thompson. Joe and his second wife, Polly, would sit on a couch while many gathered around him for birthday cake and conversation. Soon the instruments would come out, and the songs would begin again.

Joe inspired a lot of love from those who knew him, played with him, and listened to him. He was a quiet man, but determined. He did not need to say a lot of words. His life spoke for him. The last time I saw Joe, he had his fiddle in his hands. He was at the veterans' hospital in Mebane, playing with other musicians as part of a Martin Luther King holiday event. Rhiannon and Justin of the Chocolate Drops played alongside him. A month later, the Drops won the Grammy for Best Traditional Folk Album.

Dom Flemons: Reflecting on Music

Dom Flemons was not born in North Carolina, nor does he live here currently. However, he has spent much of his life exploring the roots of North Carolina music. Through the Carolina Chocolate Drops and work with the Music Maker Relief Foundation, Dom has helped to bring the music of this state out of the past and bring it to the world. With that in mind, Dom and I spent some time talking about music and what interests him now.

COSTON: *How did you first hear some of the music that you play now?*

FLEMONS: I first heard folk songs in choir in elementary school, but I didn't really take any interest in playing the music I play now till I was about 22 years old or so. It was my third year of college and I had been playing guitar, harmonica and banjo for about six years and had gone through many musical and artistic phases. I first got into '50s, '60s and '70s rock, and from there I got into Bob Dylan and that led to me getting into the '60s folk revival and the different musicians that formed the whole of that music scene. Also, I began going to the local folk festivals in Arizona and began learning songs from the older players that jammed in the parks. I had also picked up records and songs of various genres and tried my best to play in those styles. I got into singer-songwriters and I wrote my own songs for quite a while, but by the time I reached college I had lost most of my inspiration to write songs.

Looking for new means of expressing myself through writing I began to write prose and short stories. As it happened I began to get interested in doing slam poetry and became a part of the local poetry scene in Flagstaff. I helped form the NorAZ poets and performed in two National Poetry Slams. I enjoyed my time performing my poems but I really wanted to play music again. I began to pursue different old-time blues, jazz and country music and began to perform those. I had a few years of playing in those styles until the Black Banjo Gathering, where I found a new outlet to explore the music that I loved.

What instruments did you play first?

I started out playing percussion in the school band. I also played the bass drum in the marching band. When I was 16 that was when I began playing guitar and harmonica.

Early on, which performers did you hear or see that just blew you away?

The first musician that made me want to play was Bob Dylan, whom I first saw in the documentary *The History of Rock 'n' Roll.* Also in that documentary I saw two musicians who visually took me to another level. That was Louis Jordan and Muddy Waters who were featured in the first episode. Their exuberant performances in the film footage made me want to look up their music in the library. In an era of

'90s rock, I had never seen such dynamic performers before and had to pursue their music.

Would you say that American music is not a genre per se but a collection of various sounds and influences, much like America itself?

I'd say it's both. American music can be very specific in some ways. American music is a collection of various sounds and influences, but those various sounds can come out very different from one another. There is always a thread that goes through each of these styles, but jazz, blues, country, zydeco, native and Chicano music are all very distinct genres of music even though they all fly under the American music genre banner.

How did American music change from the era of Stephen Foster and Dan Emmett to the jugband music of the '20s and '30s?

There was a huge transition that happened between Stephen Foster and Dan Emmett's era (1850s–1860s) to the jug bands of the '20s and '30s. I mean there were big events that changed the way Americans lived in general, and the music also reflected those changes. The minstrel show had grown from a small string band creating a caricature of what was perceived to be black life on the plantation to an overblown international phenomenon. Though this institution was known as a white musician's institution, blacks all the while were building up ways to express themselves on the popular stage, including making their own minstrel troupes. Over the years, blacks found different styles of music to adapt to create new forms of music that would influence American culture. Ragtime and coon songs would make way for jazz, blues and black musical theater. There is a great book called *Stomp and Swerve* which talks about this transition.

In the teens, folks like James Reese Europe and W.C. Handy had established bands and orchestras to play for various events in the communities, and this practice was used all over the country. The jug bands were an offshoot of this musical practice. Though they were based more on the novelty of using unconventional instruments, these groups were actually well-trained orchestras that were prepared to play at whatever social events were needed for the upper crust of society. These groups were found all over the South in particular, but the most famous ones to record were from Louisville, Kentucky, and Memphis, Tennessee.

How much did the mainstream discovery of American and "hillbilly" music in the 1920s and 1930s, via performers such as the Carter Family, Jimmie Rodgers and Charlie Poole, change American music itself?

It changed everything. One thing that is hard to imagine is that at a certain point human beings had no way to preserve their music. Also folks had never heard themselves either, so they had no idea to know the way they sounded when they sang

or played music. With the invention of the audio recording, people had an infinitely useful way to preserve their culture. Like all technology, the rich and elite were the only ones who had access to this technology. Over time, it made its way into the hands of regular folks, but for the first few decades, the records made were records of classical music and elite music. It was only by accident that PR people from the record companies began to find out that there was interest in these musicians that were a little rough around the edges. Nowadays these recordings made in the early part of the century, along with the many field recordings made by scholars over the years, are now the foundation of what we as modern people define as our American folk music.

It's obvious that while some wanted to separate black and white music, the two shared some similar influences and often converged. What are the common bonds in black music (for lack of a better term) and white music?

The easier way to approach this question is to make the answer a little broader. Black and white people have had common musical cultures in America just because they have needed to live side by side for so long in both hostile and not hostile situations. Because the context of the music making in American society was and is so varied, you have different combinations of musical cultural everywhere you go. Before there were definitive musical genres that defined a culture, people played music that reflected their local culture, which in many cases were far more varied than we would think today. The common bonds are the cultures that the musicians came from. For example, take a song like "John Henry." The song is found in both black and white culture, but the way the song is approached varies based on the function of the musician in their local culture. Dance bands keep the text at a minimum and the dance beat in the forefront while ballad singers do the opposite. Again, it's all about the function of the musician and the song. The racial implications are not as important as the broader social implications.

Dom, what instrument or instruments have been the most fascinating to you, and why?

I'll name a few different instruments here because one of my great loves are the unconventional instruments used in American culture:

The jug — though it is thought of as a novelty instrument, I have been amazed at the versatility of this instrument. With just the right technique and imagination, one can cover a lot of ground in a group setting with a jug.

Bones — the bones have changed the way I approach my music rhythmically. Taking away the melodic pieces of old-time music can be very liberating. I enjoy being able to join a jam and making the music jump up a whole other level by adding the right rhythm to accentuate the melody instead of just doubling it, which is very common in old-time music.

Quills — first being inspired by Mike Seeger to play this rare instrument, I love

the way this amazing panpipe instrument is just so out there. It has a piercing sound, but it is pleasing to the ear, and the pentaphonic scale that I use makes for another wonderful sound that changes the sound of any song.

I saw the Briarhoppers play at my elementary school when I was 11, and I never forgot it. What do you hope that the kids take away from your shows?

All I hope for kids to take away from our shows is just the experience of seeing this music played live. There is nothing better than experiencing music live. Also, as the teachers are tending to prep the kids for our shows, it is great to be able to give them a history lesson that is accompanied by great music. Also, being black musicians playing this music, it is also great to be able to give kids a real example of blacks playing the music instead of just talking about it.

How have your interests in music evolved during the Drops' history?

My search for interesting and amazing music has just continued to grow as we've gotten out there more and more. I learn little tidbits that just add to my knowledge and love of the music. I first got interested in the old-time music through the old-time songsters, and that search just continues on and has led me to more doors than I can open at one time. With each new discovery I make, my interests have grown to share this information with others as well as promote or make people aware of others that are making similar musical discoveries. Our group is not the only one out there, and the more people that are playing this music, the better.

If you were to recommend an artist to someone that they've never heard, who would that be and why?

I would recommend people to not one but many performers. I would recommend they look up the companies that I looked up and make the decisions themselves. It has always amazed me what I miss when I go through material and what others pick up on when they look through the same material. I would recommend folks look up Yazoo Records, Old Hat Records [in Raleigh, North Carolina], Music Maker Relief Foundation [in Durham, North Carolina] and Sun Records, and that will give anyone plenty to start with and hopefully will lead people to many more discoveries.

Notable Others Who Called North Carolina Home

During the 1930s, a certain twist on blues music began to emerge. This was known as "Piedmont Blues," which took some of its cues from ragtime, or piano-based melodies. One of the most popular musicians of this style was Blind Boy Fuller, who was from Durham. Fuller made over 120 recordings during his short life, including several with another famed North Carolina bluesman, Floyd Council. Although

he was from South Carolina, Rev. Gary Davis worked in Durham throughout the 1930s, influencing Fuller, Preston Fulp, and other bluesmen of the region.

By the mid–1920s, record labels began to look to the Appalachians for the new "hillbilly" sounds. A year before Charlie Poole scored his first hit, Ernest Thompson, from Forsyth County, recorded several songs for Columbia Records. Also recorded around this time were the North Carolina Cooper Boys of Lexington, Matt Simmons and Frank Miller, and others.

North Carolina cannot lay claim to the first country music superstar, Jimmie Rodgers, who was from Mississippi. However, Rodgers was living in Asheville in 1927 when he heard Ralph Peer's recording sessions in nearby Bristol, Tennessee. Rodgers went to Bristol with a group that had joined on a weekly radio show of Asheville station WWNC. When the group broke up the night before the recording session, Rodgers decided to do the session as a solo act. Rodgers and the Carter Family, who would later do several radio shows at Charlotte's WBT radio, became the breakout stars from the Bristol sessions.

One of the first families of North Carolina music hailed from Weaverville. Wade and J.E. Mainer came together while they were working on various cotton mills in Concord. They soon began performing all across the state, billed as J.E. Mainer's Mountaineers. The Mountaineers also performed on numerous radio shows, including ones for WBT radio in Charlotte, WPAQ in Mount Airy, and WPTF in Raleigh.

Wade Mainer left his brother's band in 1936 to work on his own. Utilizing a then-unique two-finger banjo style, he played and recorded 165 songs for the RCA Victor label. Another North Carolina legend, Clyde Moody, was featured in Mainer's Son of the Mountaineers. Wade Mainer also married Julia Brown in 1937. Brown was known to many in the region as Hillbilly Lily, a popular singer and guitar player on Winston-Salem's WSJS radio station from 1935 to 1937. Brown was a pioneering female performer at a time when not many women were featured in the nascent bluegrass and country fields. J.E. Mainer also continued playing through the 1940s, later recording with his sons for King Records.

Another musician that performed with Mainer's Mountaineers was Snuffy Jenkins, whose three-finger style of banjo playing would influence both Don Reno and Earl Scruggs. Jenkins would later team with another North Carolinian, Pappy Sherill, for numerous recordings. Another group with ties to the Mainers was Zeke and Wiley Morris, who recorded 36 songs for RCA Victor in the late 1930s.

In Charlotte, WBT radio's signal stretched over half the United States, reaching listeners as far away as Chicago. When announcer Charles Crutchfield realized the potential for a house band at WBT, he put together the Briarhoppers. Numerous singers and musicians performed with the Briarhoppers, including Arthur Smith, Fred Kirby, and Earl Scruggs. A version of the Briarhoppers continues to this day, carrying on the songs and sponsors that made the Briarhoppers so popular.

Kirby would also emerge as a solo star, striking out as a duo during the 1940s with original Briarhopper Don White. By the 1950s, Kirby had returned to Charlotte to host various children's television shows for the fledgling WBTV. Kids of all ages came to know Kirby through his hosting of these shows, which often included appearances by the Briarhoppers.

In the 1940s, another group to emerge on WBT radio was the Johnson Family Singers. Originally made up of four children and their parents, the family went on to record numerous songs for Columbia and RCA Victor and appeared on *The Ed Sullivan Show* in 1958.

Two other musicians that emerged from WBT radio in the 1930s were Sam Poplin and David Lear. Poplin went on to a long career with acts at WIS radio in Columbia, South Carolina, and back at WBT in the 1940s. Lear's son Roy later joined WBT in the 1940s and 1950s, playing with Arthur Smith, Betty Johnson (of the Johnson Family Singers), and the Briarhoppers.

Roy Lear also played with the Tennessee Ramblers, who were based out of WBT for much of their career. Led by Cecil Campbell, the group also appeared in several movies, including ones with Gene Autry and Tex Ritter.

North Carolina has an amazing roster of jazz musicians. While John Coltrane, Thelonius Monk, and Nina Simone are among the most famous jazz musicians that were born in this state, the list also includes Max Roach, Woody Shaw, Tal Farlow, Lou Donaldson, and Percy Heath. Several other jazz musicians spent some of their formative years in North Carolina. Trumpeter Dizzy Gillespie attended the Laurinburg Institute, in Laurinburg, North Carolina, while composer and arranger Billy Strayhorn spent summers in Hillsborough with his grandparents.

Two of the best-known bandleaders of the 1940s also came out of North Carolina. Kay Kyser was born in Rocky Mount and lived much of his life in North Carolina. Les Brown formed his first band while at Duke University in the 1930s, and singer Kate Smith lived in Raleigh during her final years.

During the 1940s, the Round Peak community, located in Surry County, began to produce an impressive collection of musicians. This group focused on their variation of old-time string band music. This included the Camp Creek Boys, which was made up of Fred Cockerham, Verlen Clifton, Ernest East and Paul Sutphin. The Camp Creek Boys were sometimes featured on Mount Airy's WPAQ radio station, as were Tommy Jarrell, Kyle Creed, and Benton Flippen. Jarrell is now cited as an influential banjo player for having developed his own style of clawhammer banjo. Jarrell was recognized with a National Endowment of the Arts Heritage Fellowship in 1982, and his banjo is now in the collection of the Smithsonian.

Curly Seckler began playing on the radio in Salisbury, North Carolina, in 1935. This brought him to the attention of Charlie Monroe, brother of bluegrass pioneer Bill Monroe. In 1949, Seckler joined Earl Scruggs and Lester Flatt in the Foggy Mountain

Boys. Seckler played with Flatt & Scruggs until 1962 and played an integral part on their best recordings. Another key member of the Foggy Mountain Boys was Jim Shumate, who grew up near Hickory, North Carolina. Shumate joined Bill Monroe's band in 1943, and before leaving in 1945, he encouraged Monroe to hire Earl Scruggs, whom he had known for some time. When Scruggs and Flatt formed the Foggy Mountain Boys, Shumate joined up as the group's fiddle player. Shumate is recognized for creating the fiddle intro sound that is a hallmark of bluegrass music.

In the early 1950s, Winston-Salem's Royal Sons Quintet decided to move away from gospel music and changed their name to the 5 Royales. Combining blues and doo-wop, they paved the way for what would later be called "soul music." Their songs have been covered by everyone from James Brown (who modeled his first band on the Royales), the Mamas & Papas, Ray Charles, and Mick Jagger.

Several great singers emerged from North Carolina during the 1950s. Clyde McPhatter was born near Durham and went on to be the original lead singer of the Drifters. Another singer who was born in North Carolina, Ben E. King, would later follow McPhatter as the Drifters' lead singer. Alden Bunn, who was born in Rocky Mount, had begun recording as "Tarheel Slim" by 1956, and he recorded an influential series of rockabilly and blues records. Wilbert Harrison was born in Charlotte and had a number-one hit in 1959 with the song "Kansas City." Maurice Williams, a longtime resident of Charlotte, wrote two enduring standards, "Little Darlin'" (a hit for the Diamonds in 1957) and "Stay," which was a number-one hit for Williams and the Zodiacs in 1960.

One of country music's greatest songwriters came from Shelby, North Carolina. Don Gibson wrote a number of classic songs throughout the 1950s and 1960s and had success as a singer, as well. Another top country singer of the 1960s, Stonewall Jackson, was born in Tabor City, North Carolina, in 1932.

In the early 1960s, a particular brand of music began to be heard in the Carolinas. While Myrtle Beach is recognized as the home of beach music, many of the top groups of the genre's first and second wave came from North Carolina—the Catalinas, the Tassels, Harry Deal and the Galaxies, the Embers, the O'Kaysions, as well as the next generation of beach bands, the Fantastic Shakers, the Band of Oz, Billy Scott and many more. Another group that played in the beach music scene, the Spontanes, saw their song "Where Did I Go Wrong?" released nationally by United Artists Records in 1968.

Shirley Alston Reeves and Doris Kenner Jackson, founding members of the Shirelles, both originally hail from Henderson and Goldsboro, respectively. Fellow pop singer Oliver, who would have a major hit single in 1968 with "Good Morning Starshine," was born in North Wilkesboro and attended UNC–Chapel Hill.

Throughout North Carolina in the early 1960s, there was a loose collection of young musicians in every town. Some played early rock and roll, while many played

beach music, or surf rock. And then 1964 hit. Suddenly the radio and TV exploded with music from England, and America. Suddenly a whole generation heard the Beatles, the Rolling Stones, and other groups and wanted to do the exact same thing.

There are so many rock-and-roll bands that emerged from North Carolina in the 1960s. Many played dances in their hometowns. Several more toured North Carolina and into the Southeast. Most of these groups only lasted a couple of years, before college and the Vietnam draft broke them up. Despite that, some great music came out of those times, and it is worth searching out. I highly recommend the Tobacco A-Go-Go series, three volumes of North Carolina–born 1960s rock compiled by Ken Friedman. Compilations like these have led music fans all over the world to rediscover these records.

With that in mind, here is a partial list of some of the great bands that came out of North Carolina in the 1960s: the Corsayers, featuring James and Alex Taylor, the Tamrons, Sacred Irony, the Young Ages, the Hodads, the Teen-Beets, Words of Luv, the Scotsmen, Mike & the Dimensions, Clear Blue Sky, Counts IV, the Huns, the Symbols, Sound System, the Bondsmen, the Challengers, the Lost Souls, and so many more.

In Charlotte, two groups stood out. The Paragons released their sole single, "Abba," in 1966. The song had nothing to do with the Swedish super-group, but it had everything that a great single should have: a great song, originally written by Jim Charles and reworked by the band; lots of shouting in the chorus; and great guitar work by future Spongetones member Pat Walters. After the Paragons, Walters led another great Charlotte group of that era, the Good Bad & the Ugly.

The Grifs only played in Charlotte for about a year, but during that time they recorded "Catch a Ride." Featuring more fuzz-tone guitar than even the Rolling Stones could release in 1965, the single found an audience in the Midwest, and the band relocated there soon after. Both this single and "Abba" are available on the Tobacco A-Go-Go compilations.

Very few bands in North Carolina got to record an entire album due to production costs. The New Mix, which was based out of Charlotte, saw their sole album released by United Artists in 1968. But there were other exceptions. Based in Winston-Salem, Justice Records was essentially a "pay to play" label. For $800, they would record your album in a day, print up 500 copies, and send you on your way. Due to the limited number of these albums, most of which were made by North Carolina artists, these records are now worth hundreds of dollars to collectors of 1960s music.

While we're discussing the Winston-Salem area, I want to put in a special word for Sam Moss. Sam was the owner of Sam Moss Guitars for over 20 years — and was an amazing guitarist to witness — in the Winston-Salem area, where you were either inspired by Sam's guitar playing or he sold you your first guitar. Sam had a rock-and-roll heart that is missed in this world, and no description of North Carolina musicians is complete without him.

Throughout the 1960s and 1970s, several TV shows sprouted up to spotlight the music that teens and adults were playing. *Kilgo's Canteen, Carolina Calling,* and *The Villagers* TV show all broadcast from Charlotte to stations throughout the Southeast.

The year 1969 saw the creation of a band that would last well into the next two decades. Arrogance, founded by Don Dixon and Robert Kirkland in 1969, became one of the most popular acts in the Southeast, while Sugarcreek, formed in Charlotte the same year as Arrogance, also became a popular touring act.

Musician, activist and Lumbee Indian Willie Lowery was born in Robeson County. In 1969, he spearheaded the sole album by the band Plant and See, one of the first inter-racial bands on the East Coast. The album was recently reissued and is a valuable document of that time.

The name of Shirley Caesar is known to gospel fans all over the world. Caesar was won 11 Grammys and 18 Dove Awards, among numerous other honors. She has released 40 albums and pastors the Mount Calvary Holy Church Word of Faith in Raleigh. John P. Kee has sung and produced numerous hit albums on the gospel music charts. Born in Durham, Kee has led the New Life Fellowship Center in Charlotte for many years.

Johnny Bristol was originally from Morganton, North Carolina, and wrote and produced some of Motown's biggest hits during the 1970s. The last few decades also have seen a resurgence of Piedmont blues artists. None may have been more important than Etta Baker, who carried along the Piedmont blues sound to new generations. As a photographer, I do not have many regrets, but I really wish that I had gotten the chance to get photos of Etta Baker. I missed the chance to photograph her too many times, and that is truly my loss.

Alice Gerrard released four albums with Hazel Dickins in the 1960s and 1970s and has helped to spread the word of folk music through the publication of the *Old-Time Herald*, which celebrates Appalachian string band music. Gerrard now calls Durham home, and much of her archives are now part of the Southern Folklife Collection at UNC–Chapel Hill.

Wayne Erbsen has recorded 18 albums and performed at numerous festivals around the country. He has appeared on *Sesame Street* and has hosted a radio show on WCQS for nearly 30 years.

A number of country music stars emerged from North Carolina during the 1970s. Billy "Crash" Craddock, Ronny Milsap, Charlie Daniels, Donna Fargo, and song-writing legend Don Schlitz all called North Carolina home. Fargo hosted a nationally syndicated TV show in the late 1970s and has had a portion of the highway named for her near her home of Mount Airy. Charlie Daniels, who found success on both the country and rock and roll charts during the 1970s was born in Wilmington. On the rock-and-roll scene, Nantucket emerged from Jacksonville, North Carolina to record three albums for Epic Records and tour with everyone from Kiss to AC/DC.

On the disco charts, Lawndale native Alicia Bridges had a huge hit with "I Love the Nightlife" in 1978.

Christian music superstar Michael English was born in Kenansville, North Carolina, and sang in church in nearby North East, North Carolina, until after high school. Two prominent opera singers have also come from North Carolina. Victoria Livengood has starred with the Metropolitan Opera and has been nominated for a Grammy. Anthony Dean Griffey is originally from High Point and graduated from Wingate University. Griffey has been recognized for both his singing talents and his acting ability. Both Livengood and Griffey have been inducted into the North Carolina Music Hall of Fame.

Eugene Chadbourne, who resides in Greensboro, has been recognized as an influential banjo player and has collaborated with numerous artists. Tori Amos has sold more than 12 million records worldwide and was born in Newton, North Carolina. The Moody Brothers, sons of longtime fiddler Dwight Moody, have received two Grammy nominations and continue to work in venues all over the world.

Millions of television viewers have found themselves drawn to several North

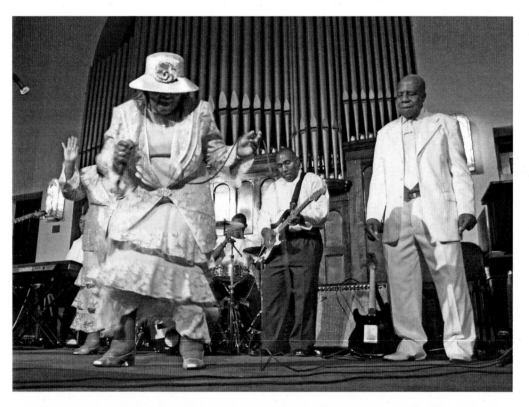

Bishop Dready Manning and family let it loose onstage. Great Aunt Stella Center, Charlotte, 2011.

Carolina singers via the *American Idol* TV show. Two singers from North Carolina, Fantasia Barrino and Scotty McCreery, have won the show's annual competition. Other North Carolina singers who have gained fame from the show include Clay Aiken, Bucky Covington, Kellie Pickler and Daughtry.

One of Charlotte's best-known exports is Anthony Hamilton, who was born and raised in the Queen City. Hamilton's second album, *Comin' from Where I'm From*, sold over a million copies in 2003. Hamilton still lives in and records in Charlotte, and along with Calvin Richardson has been an important part of North Carolina's R & B scene.

There are so many more artists that I should mention: the Bluegrass Experience, the Shady Grove Band, Mayflies USA, Love Language, Jon Lindsay, the Bowerbirds, the Rosebuds, Bishop Dready Manning, Big Ron Hunter, Cool John Ferguson, George Higgs, Boo Hanks, Gideon Smith and the Dixie Damned, Virginia Reel, Simplified, Wednesday 13, Joe Firstman, the Moaners, North Elementary, Kenny Roby, the Electric Owls, Adam Lazzara (singer with Taking Back Sunday), Yo Mama's Big Fat Booty Band, Rey Norteno, Laurelyn Dossett, Between the Buried and Me, Will Ray, Delta Rae, and many others. This list can, and should always be, added on to. I look forward to doing just that.

Writing and Recording from Home

These days, Dom Flemons spends much of his time on the road, both with the Chocolate Drops as well as other projects. "I am home maybe three to five months out of the year," he says. "The rest of the time is spent out on the road.

"I am proudest of the way I can inspire others. When I started out there were not many people doing what I was doing, and I find it great to be a part of a music scene where I can be a positive force that can build it up. I'm also proud to have created more awareness in my field for a type of music that when I started was very specialized."

One thing that many musicians struggle with is finding time to write new songs. Some prefer to write at home, removing themselves from the rush of traveling and performing. Others prefer to write on the road, feeding off the creative energy that one can get from performing. The answers vary, depending on whom you talk to.

"I find it difficult to write lyrics at home, but it's much easier to compose more complex things at home because you can put something down and come back to it," says Justin Robinson. "There's no real preference, but the results are often very different. The road puts you in a very particular emotional state and that comes across fairly easily, but writing at home feels more grounded, like I actually know what I'm writing about."

"I prefer the road," adds Justin's former bandmate, Dom Flemons. "A hotel is a sterile place where everything is almost mundane, and that helps me write. They also have the small notepads that are perfect for writing notes and song lyrics if the moment hits me.

"I guess I'd say I do most of my writing at home," says Caitlin Cary, "although I've had a few memorable writing sessions in hotel rooms, in the back of busses. In fact, I guess the truth is that my first solo record was written primarily on the Whiskeytown tour bus."

"I'd say about 75 percent of my writing is done at home," says Si Kahn. "This is particularly true when I'm working on a project, a concept CD or a musical. My writing away from home is mostly individual songs that don't have a relationship to each other."

David Childers performing in his kitchen, January 2012.

"There's no real preference," says Emily and Andrew of Mandolin Orange. "You just have to write when you can and when it comes to you. But it's definitely easier to find the necessary solitude at home."

As a photographer, I'm surprised how varied my photos have been of musicians at home. Sometimes it's just the musician relaxing at home, or playing whatever came to mind. When I visited David Childers at his house one evening, we were all talking about music when David grabbed his guitar and started playing. We were all sitting in David's kitchen, and I suddenly realized that this backdrop made for a good photo. There's no pretense in that shot, just a musician I greatly admire playing songs that he enjoyed.

I'm often asked about

the digital medium of photography. Most of the photos that you see in this book were taken on film. When many photographers started rushing to digital cameras, I went the other way. Part of it was for artistic reasons, and partly out of my own truculence. I am a fan of older photography, particularly of black-and-white film photography. For a long time, a digital image did not look or feel right to me. This was the medium that I liked to work through, so I stayed with it. I was also proving a point. If you tell me repeatedly that I can't work with film in a digital world, I'll go ahead and keep working with film. Don't tell me how to work, especially when it is the way I prefer to work.

I finally switched to digital photography in 2010, when I felt that I had taken my ideas with film as far as I could do. It also had to do with working with a different set of cameras. I had essentially shot with the same camera for 13 years, and was ready to rethink my creative process. New camera, new possibilities, new ways of working. It's a digital camera, too? Okay, let's go. I am happy to say that I still keep my film cameras with me at all times, and use them when the moments and the subjects inspire me to.

One thing that working with digital cameras has changed is the time I spend editing my photos. When I started taking photos, I wanted to be on the road all of the time. I would shoot something and would find the best printers in that town. I would then get prints made of my best photos, pick out my favorites, and mail them on to the clients. Working that way made me a better photographer. The shot had to be right when I took it. No Photoshop to rely on, just whoever was doing the printing. And then, on to the next shoot.

It used to be a big deal if I shot more than four rolls of anything. At 24 shots per roll, that would have been nearly 100 photos to choose from. With digital, you can take 300 to 400 pics in a matter of moments, and then take more. However, that also means that you didn't have to edit that many photos and then e-mail them out to your clients. I spend more time at home now, working on my photos, than I ever have. Yes, I have more options now for editing and cutting down on printing and mailing costs. However, you can spend a large number of hours on a shoot that took you less than 60 minutes to shoot. The medium of technology has not only changed how photographers take photos, but how much time they spend every day on their work.

Some photographers like to take all of their electronic equipment with them on the road and edit and e-mail as they go. That can be a lot of expensive gear to have with you at all times, and a lot can go wrong. I largely still work the way I started, just me and my camera on the road. This allows me to cut down on the clutter that you might bring along with you, but I have also found that I prefer to edit at home, removed from where I shot the photos.

How you feel about how a shoot is going can sometimes cloud your critical eye

of the photos themselves. Sometimes I have done better than I thought I did at the time of taking the photos, and every once in a while, not as well as I would have liked. What says to you, "That's great," the day you shoot it isn't always the case the following day. My usual plan of action is to shoot and pick out my favorites on site. I then come home and start editing with my original favorites, and work from there. Photography, like music, is often a 24/7 job, whether you're traveling or at home.

One of the first bands I worked with in the Chapel Hill area was Jennyanykind, held by twin brothers Michael and Mark Holland. The brothers had once spent an entire day in the rain for a photo shoot, so when I asked about locations, Michael said, "Just come to my house." Michael had built a home studio in the shell of an old schoolhouse that was on his property. We took the promo photos for their album in his basement. I learned a lot from working with Jennyanykind. They came at their

Michael Holland of Jennyanykind in his basement, near Chapel Hill, January 1999.

music like painters, always changing their canvas and their perspective. It was also the first time that I had worked with twin brothers, which is a very different dynamic than most duos that one works with. They threw out ideas, and I interpreted them through my own ideas. Much like their music, genres didn't limit ideas. Whatever we liked, we went toward it.

That experience served me well in my future work with the Avett Brothers, as well as other family acts. Scott and Seth Avett are not twins, but they view each other as equals. And when families see themselves as equals, you know that they will work things out among themselves and go from there.

One time, I had booked a photo session with the Avetts at Seth's house, which was just down the road from where the brothers had grown up. When I arrived, the band was hard at

Avett Brothers (left to right: Seth Avett, Bob Crawford and Scott Avett) writing "Talk on Indolence" in Seth Avett's kitchen near Concord, August 2004.

work in the kitchen, working on a new song they had just written. They had written out the words on a giant poster board, which sat between them on the floor. Avett Brothers fans would later come to know this song as "Talk on Indolence." The group already knew that they would be rapping in the verses of the song. At this point, they played the song at half speed to get the cadences right. I never said anything the whole time they worked on the song. I just started taking photos, figuring that the posed photos could wait.

One really has to think about the look of the background when you're shooting around someone's house. The trick is to not make them look like they're at someone's house. There's a small forest behind the house where the Comas rehearse? Let's take the photos out there. Django Haskins has been in two bands that I've photographed at homes, once with International Orange, a great band that featured Haskins, Snuzz, and former Ben Folds Five musician Robert Sledge, and once with his current band, the Old Ceremony. I do not need big spaces for the photos, just little corners, and backgrounds that are open to interpretation. Is it someone's house? A studio? It doesn't matter, as long as it does not overtake the subjects in the photo.

Sometimes a photo shoot at home is the comfortable alternative. When Roman Candle asked me about getting some posed photos of the band, they were worried

The Comas (left to right: Margaret White, John Harrison, Nicole Gehweiler, Andy Herod) standing behind their house and rehearsal space in Carrboro, December 1999.

International Orange (left to right: Britt "Snuzz" Ussell, Jason Faggminster, Django Haskins and Robert Sledge) in the backyard of Robert Sledge's house near Durham, June 2004.

Roman Candle (left to right: Jeff Crawford, Nick Jaegar, Timshel Matheny, Skip Matheny and Logan Matheny) in the front yard of their house, September 2005.

about how they would look in the photos. Skip Matheny does not come to posing for photos naturally, so I suggested that we do photos in their front and back yard.

"Do you have a stereo in the house," I asked? "Play one of your favorite records, and play it loud enough to be heard in your yard. When you start to worry about the camera, sing along to the song." I also knew that the faster I took my photos, the less the band would feel pressured. The photo that their record label came to choose as the promo photo was shot number 14 on the first roll.

Cliff Retallick of Mercury Dime at home, Faith, September 1999.

Some of my favorite photos have also been the most unplanned: a rehearsal between Chatham County Line and visiting Norwegian musician Jonas Fjeld, taking photos of Mercury Dime singer Cliff Retallick while he played me some new songs he had just recorded, Jack Lawrence playing guitar on his back porch, taking photos of Caitlin in her living room as she relaxed after a day of photos or other parts of preparing a new album. "These days I'm home most of the time," says Caitlin. "I've had a few years of being away more than home, but not for quite some time now.

"It's really amazing to know that I'm leaving some tiny mark on this world with my songs. Whenever someone takes the time to let me know they've been affected by my music, that one song has really spoken to them or helped them through something hard, or helped them get their head around something, it moves me very deeply."

Many musicians make more use of their time at home by recording, either by working with a small setup or building a recording studio. Chris Stamey has a fantastic studio within walking distance of his home. You can be home, as was the case for

Chatham County Line and Jonas Fjeld rehearsing in John Teer's living room. Left to right: Dave Wilson, Chandler Holt, visiting Norwegian musician Jonas Fjeld, John Teer and Greg Readling. Raleigh, May 2008.

Peter Holsapple (left) and Chris Stamey pose together at Stamey's home near Chapel Hill, January 2009.

photos I took of him with longtime musical partner Peter Holsapple, but the recording studio is never too far away.

When I visited Tift Merritt at her home in 2002, I was there to do photos of her for a magazine, but it was also a great chance to take photos of and catch up with someone that I don't get to talk to often enough. For the photos, I said, "What do you do during a day at home?" Write in the living room and take her dog Lucy for a walk in the field behind her house. We talked all day, I took photos of her in both locations, and it was a really great way to spend a day.

"I do all my writing in concentrated periods wherever I've made a home to write at that moment," says Merritt. "Sometimes it is where my pillow and socks are. Sometimes it is a new place where I can clear out and have some distance. Lately I have been writing more at home. I have a wonderful studio where working seems very natural. A tree full of birds out my window, enough grounding in my own life present, and also a city to get lost in, should need be.

"I never, never write while touring. Performing and writing draw, somehow, from the same energy, and there is only so much of it to draw from. You have to be careful with tending it. Sure I collect ideas on tour. But I don't think I can really have the right access to a writer's point of view when in a performance frame of mind. They are just opposite in the way they behave, even if they are getting at the same thing." When I asked Merritt what made her proudest to be a musician, she replied, "Doing a good job."

"Home is where I do most of my writing," says Sara Bell. "I have a hard time writing songs on the road, because there are always people around. At home, my piano is here and I can stay up until 4 A.M. if I have to while the song is coming."

Joe Newberry told me that he prefers to write "on the road, while driving in the car. I keep a little recorder that I can sing into. I also have had a number of songs drop down in my head in venues while waiting for the show."

Tift Merritt going for a walk with her dog Lucy, in eastern North Carolina, February 2003.

Much like Joe Thompson and the Chocolate Drops, one's home is always a great place to learn about music. When Clyde Wright grew up in Charlotte in the 1940s, he performed in a series of gospel groups. This included the Gospel Jubilators, which included Wright and his cousin, Nappy Brown, who would eventually forge a career in the rhythm-and-blues scene. Among the groups that Wright followed was the Golden Gate Quartet, a gospel group that recorded a number of albums in Charlotte in the 1930s and 1940s. Wright also got to see the Golden Gates perform at WBT in the 1940s and learned as much as he could.

When the Golden Gate Quartet moved to Europe in 1954, they took Wright along with them. Wright has since become one of the most famous gospel singers in Europe and still sings with the Quartet to this day. I first met Wright in 2008, when he flew in for Nappy Brown's funeral. "We need to stay in touch," Wright told me, and I've been happy to do so ever since.

In 2011, Clyde returned home to Charlotte, visiting family and where he had spent some of his youth. Among the people who came to see him was Kevin Johnson, who teaches music at Spelman College in Georgia. Kevin is also the son of Willie Johnson, one of the founding members of the Golden Gate Quartet. Kevin knew that his father had helped to found the Quartet, but his father's time with music was long gone by the time Kevin was growing up. But the music was already inside Kevin, and he found his way into the profession.

When I came to visit Clyde, he was staying at the home of a relative. Standing in the living room with Clyde was Kevin. Kevin had come to learn more about the music of the Golden Gate Quartet and the work of his father. Kevin would play a song, and Clyde would demonstrate how they sang it, phrasing, short cadences. Here was Clyde Wright, a singer who had come "home" to Charlotte, bringing the work of Willie Johnson alive to show his son. It was a remarkable thing to witness.

North Carolina is also the spiritual home for many musicians, either as a place to play or a place that supports them. Since 1994, Tim Duffy and the Music Maker Relief Foundation has helped blues and roots musicians across North Carolina and around the country. The label provides the musicians with money to repair their

Clyde Wright (left) giving singing pointers to Kevin Johnson at the home of Clyde Wright's niece, Charlotte, January 2011.

homes and pays for instruments and studio time. So many musicians have benefited from Music Maker. John Dee Holeman, Benton Flippen, Captain Luke, Boo Hanks, Joe Thompson, Cool John Ferguson, George Higgs, Ron Hunter and others have all released albums through Music Maker.

Home Is the Place for Music

For others, their home is their place for music. House concerts have always been an outlet for the music to be heard away from concert arenas and in the cozy comforts of one's living room. Over the last several years, the number of people holding concerts in their houses has grown in tremendous numbers. Tickets are sold, and the musicians are paid with the money from those tickets. Some of the places I mentioned earlier, such as The Rooster's Wife and the

Captain Luke prepares to head out to his next gig in Winston-Salem in 2007. He is one of a handful of musicians who have benefited from the Music Maker Relief Foundation, which helps blues musicians with funds to keep recording, touring, and day-to-day living expenses.

Tosco Music Party, grew out of house concerts. I really like photographing house concerts, although as a photographer it is a challenge to be unobtrusive to the people and performers. I often hide in the back, usually near the kitchen, which also means I'm closer to the food, which, given that many concerts also hold a potluck, is usually not a bad thing.

For others, the home is a place to dance, make music, and have fun. The origins of Contra dancing goes back to the 1700s, where groups of men and women would dance together in the patterned style of several folk dances. Interest in contra dancing continue to thrive throughout North Carolina, with several musicians specializing in playing contra dances.

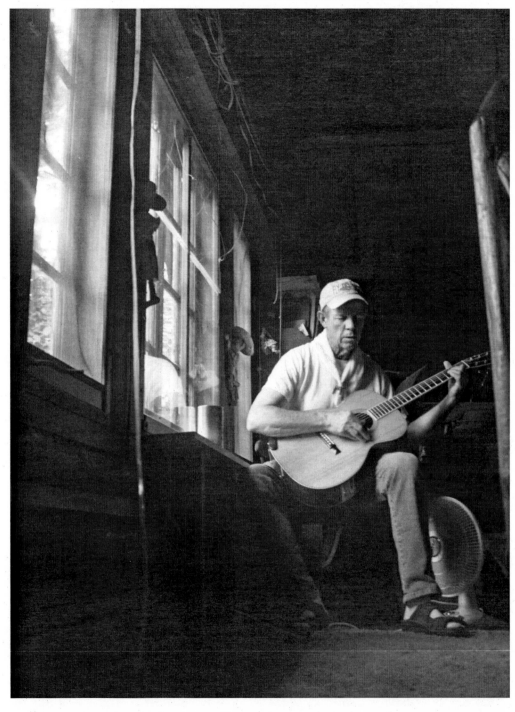

Rick Bouley rehearsing before a contra dance concert at the home of Nancy Howe, Charlotte, April 2012.

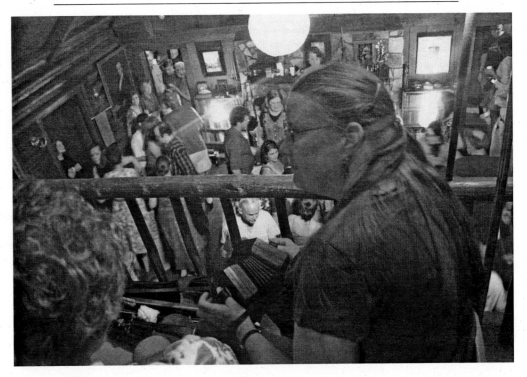

Contra musicians perform in the loft area of Nancy Howe's home, Charlotte, April 2012.

In Charlotte, a special place for contra dances was the home of Nancy Howe, who opened her large log cabin to dancing in the 1970s. People met there, they danced together there, and some even feel in love there. In 2012, Howe announced that she was moving, but there would be one more dance held at her house.

The evening began with a potluck supper, with many patrons bringing food. Soon, Howe grabbed the arm of a friend and proceeded to lead everyone in the house in a chain. This was a long-standing tradition of dances at Nancy's house. Soon the chain of people ran through one end of the house, out the back door, and into the front, ending in the living room.

The evening was a wonderful, and emotional blur of emotions. The house was full of dancers, while the house's loft was full of musicians. They danced, laughed, hugged, and danced some more. When the dancing ended with a waltz, the entire room took turns dancing with Nancy Howe. When the song was over, everyone cheered and then helped put everything in the home back in place. The music and dancing will go on elsewhere, but for those who attended that night, the home of Nancy Howe will always mean something special.

Final Thoughts

I have so been lucky to work with so many great musicians of this state. As I've stated before, I may not have been born in North Carolina, but this music of this state has embraced me, and still gives me inspiration. While I cannot thank, or feature every musician that I would like to in one book, let me leave the rest of this book to the musicians themselves. They can tell you best about what makes them proudest to be a musician, and being a part of the great collective that is the musicians of North Carolina.

"Here is a list musicians that have inspired me," says Dom Flemons. "The reason they inspire me is either by their music itself, and other times they were people I observed from a distance and admired them from that far away without really getting too close. No reason, just enjoyed and didn't want to interrupt that."

John Dee Holeman	Boo Hanks
Joe Thompson	Wayne Martin
Tim Duffy	Rob Van Velt
Vic Lukas	Hugh Crumley
Justin Robinson	Bob Carlin
Patrick Sky	Marvin Gaster
Captain Luke	Doc Watson
Arthur Grimes	

"I've always loved working in the Triangle music scene," says Caitlin Cary. "From the first Whiskeytown shows, right through to today, I've felt a lot of support and encouragement from lots of folks — Chip Robinson, Kenny Roby, Lynn Blakey, Tonya Lamm, Dave Bartholomew, Chris Stamey, Ray Duffey. This list could go on for pages. And now, watching younger artists 'come up' in the scene, it's really exciting to watch the amount of collaboration that continues. I'm truly grateful to be a part of it."

When I asked Si Kahn what made him proudest to be a musician, he replied, "Two things. The first is our high work ethic. What we do is judged every minute

we're doing it. There's no place to hide. But the best musicians deliver at a seriously wonderful level. The second is what we give back to our audiences, our fans and our communities. We help them keep on keeping on, often in the face of hard times and adversity. We help them celebrate, mourn, laugh, cry, get through tough stuff. We help create a sound track for their lives. What more could you ask for in a job? North Carolina has always overflowed with great musicians. It's a privilege, an honor, and a lot of fun to share music with them."

"I love being able to make a difference in people's lives," says Joe Newberry, "whether it is at a show or on a record. Some of my sacred songs are being sung at funerals, and that is about the highest honor. The North Carolina music scene is a national music scene, really. So many astounding players in every genre. I love being part of it and like to think that I have a good reputation. I am blessed to have played with some great musicians who make North Carolina home—Jim Collier, Ken Jackson, Bobb Head, LaNelle Davis, Laurelyn Dossett, Rhiannon Giddens, Riley Baugus, Bill Hicks, Jim Watson, Mike Craver, Margaret Martin, Branford Marsalis, Danny Gotham, Jane Peppler, Alice Gerrard, John Worthington, Gail Gillespie, Gene Knight, and have been influenced by lots more, Doc Watson, Whitey and Hogan, Wade Mainer, Hash House Harvey, Big Boy Henry, John Dee Holeman, the Gospel Jubilators, and more."

"It's the best job there is, along with any other art form or anything you're passionate about," say Andrew and Emily of Mandolin Orange. "Being self-employed is empowering. It's really all we know. But it does seem to be a pretty exceptional scene and hotbed for so many kinds of music—indie, folk, old time, bluegrass, jam band, what have you. it's an incredibly supportive and motivating environment to play in; it doesn't seem competitive. Being surrounded by so many other talented musicians we admire also keeps us on our toes. We're constantly trying to become better instrumentalists and songwriters. A few of our favorite North Carolina bands are Megafaun, Jon Stickley Trio, and Brand New Life."

"Lots of folks have influenced me," says Laura Boosinger. "David Holt, Arvil Freeman, Leonard Hollifield, Doc Watson and the Kruger Brothers. You can learn something from everyone."

"Music is such a spiritual language," says Sara Bell. "It's alchemy. It's one of the ways we can continually experiment with manifesting all these great mysteries without having to over-think them too much. So it's a gift to be able to communicate with people through music and have other people remark that something you communicated moved them in a good way, being a part of a class of artists that have essentially lived this way since music began. It's like a guild."

As for the musicians of North Carolina, Bell says, "There are too many to name! I grew up in Raleigh, when bands like Corrison of Conformity and the Stillborn Christians were starting to play, and that scene was really powerful and influential

when I was just starting to play in bands. My friends Jeb Bishop and Dana Kletter had a huge influence on me when I was young; they were great mentors and had faith in me at a time when I was really shy and insecure about my abilities. But since then, everyone I've ever played with or shared a stage with or just watched play has had an affect on me. Jeffrey Dean Foster, Lud, everyone in Shark Quest, Tres Chicas, Dish, everyone who has ever been in Regina Hexaphone. All great friends and musical comrades. If I started naming names I would forget too many people, but there are some really unique songwriters and powerful performers that I really admire like Ash Bowie, Dexter Romweber, Melissa Swingle, Ron Liberti, and more."

"I think it is very important to grow good things in your own backyard," says Tift Merritt. "The North Carolina community is always so supportive and kind and also is a lot more real to me than the kind of communities that grow up around the Music Business rather than playing music for the sake of playing music.

"What makes me proudest to be a musician," says Justin Robinson, "is seeing thoughts form into notes and colors and emotions; knowing I had a hand in its creation is just marvelous." As for musicians in North Carolina, "This may be a bit biased because I've never been in any other scene, but North Carolina has everything you could want to do in music—classical players, jazz guys, old-timey, hip-hop, country, Latin, nearly everything. Its wonderful to be a part of the community with so many other creative voices each doing their own particular thing, but it's still being produced here. North Carolina has quite a bit to be proud of: Shana Tucker, Shirlette Ammons, Beverly Botsford, Joe Thompson, Evelyn Shaw, Marvin Gaster, Pura Fe, Boo Hanks, Dark Water Rising, Midtown Dickens, Greg Humphreys, Etta Baker, Randy Travis, the list could go on forever.

"We are incredibly blessed in North Carolina with a scene that is thriving," says Django Haskins, "but also tightly knit enough that eventually you get to meet everyone. Chris Stamey is a great nexus of various strands of North Carolina music, as is Mitch Easter. Some of my favorite artists anywhere came out of North Carolina. It's a great feeling to be a part of all that."

Index

Page numbers in **_bold italics_** indicate illustrations